WINCKELMANN

WINCKELMANN
WRITINGS ON ART

SELECTED & EDITED BY
DAVID IRWIN

PHAIDON

Phaidon Press Limited, 5 Cromwell Place, London sw 7

Published in the United States of America by Phaidon Publishers, Inc.
and distributed by Praeger Publisher, Inc.
111 Fourth Avenue, New York, N.Y. 10003

First published 1972
Introduction & Chapters 2, 3 & 5 © 1972 by Phaidon Press Limited
All rights reserved

ISBN 0 7148 1508 X
Library of Congress Catalog Card Number: 78–172993

Printed in Great Britain by Western Printing Services Limited, Bristol

Contents

Preface

The Introduction has been planned to give first of all a basic outline of Winckelmann's life (Section I). This is followed by two sections devoted to background against which to set Winckelmann's writings selected for the anthology. Section II is chiefly concerned with the knowledge of classical antiquity before Winckelmann's day with the intention of briefly tracing his antecedents and the large body of knowledge at his disposal. The same section also discusses the state of contemporary archaeology. Section III is mostly devoted to the sources of Winckelmann's ideas, especially in the seventeenth and early eighteenth centuries. As some of this important source material is not readily accessible, or is not available in English, part of this section is almost a miniature anthology in itself with long quotations. These are essential in order to evaluate the Winckelmann texts themselves. Section IV considers Winckelmann's place in the Romantic movement, and Section V his importance as an art historian. The Introduction is not intended as an independent essay, but has been conceived in direct relationship to the anthology. Frequent cross-references will therefore be found between the Introduction and the Texts: the two parts should be treated as an integral whole.

Advice from friends and discussions with my students over a period of years have contributed to my ideas about Neoclassicism and Winckelmann, in a manner too imprecise to define, but it is none the less a contribution for which I am grateful. My interest in Winckelmann goes back to my post-graduate days when I was carrying out research on Neoclassical art in Britain, with the help of stimulating supervisions with Sir Anthony Blunt, Professor Leopold Ettlinger and Dr Margaret Whinney. In the preparation of this particular book I would like to thank especially Mr Keith Andrews, who very kindly read the Introduction in manuscript and made valuable suggestions. I am also grateful for the care that Miss Susan Powell has taken in her translations of three of the texts in the anthology. Help in tracing some of the footnote information has been very kindly given by Mr Kenneth Garlick, Dr Jennifer Montagu, Dr Eva Schaper and in the Witt Library by Mr John Sunderland. As always with my writing I have had the constant support of my wife.

Balmichel, July 1971 D. I.

List of Illustrations

Plate 6 is reproduced by gracious permission of Her Majesty The Queen. Grateful acknowledgement is also made to other private owners and museum authorities for allowing works in their possession to be reproduced. Photographs have been supplied from the following sources: Alinari, Florence 9, 10, 11, 12, 14, 16, 17, 18, 24; Annmary Brown Memorial Museum, Providence, R.I. 19; John R. Freeman, London 22; Gabinetto Fotografico Nazionale, Rome 1; University of Glasgow 2, 3, 5, 7, 8, 20, 21, 23; Graphische Sammlung Albertina, Vienna 4; Vatican Museum 13; Warburg Institute, London 15.

INTRODUCTION

I Winckelmann: Life and Reputation

IN THE EIGHTEENTH CENTURY a key figure in the knowledge and interpretation of the classical past was Johann Joachim Winckelmann, one of the principal writers to influence the development of Neoclassicism (Plates 1, 2). A century after his death his name is typically evoked in Flaubert's *Sentimental Education* (1869) by the fictional artist Pellerin, who becoming scornful of his own earlier style inspired by Callot and being now 'for the grand manner ... pontificated eloquently on Phidias and Winckelmann'.

Winckelmann's name in his own lifetime and since has been inseparable from that of classical antiquity. His widely read books were highly praised in the eighteenth century. It was largely with the eyes of the 'immortal' Winckelmann—as he was often called—that the second half of the eighteenth and the earlier nineteenth centuries looked at Greece and Rome. Goethe praised him highly; Lessing's *Laocoon* was inspired by him. Several generations were to benefit from Winckelmann's consciously evolved new technique for describing a work of art. Winckelmann was also important as a theorist, not so much for originality as for his distillation of earlier concepts which he put to the service of his antiquarian scholarship. Winckelmann is also significant as a forerunner of modern art historians, recounting the art of a past culture not merely as a chronological sequence of events or of artists' lives, but in terms of evolving styles. As Goethe wrote in his Italian diary, in 1787: 'It was Winckelmann who first urged on us the need of distinguishing between various epochs and tracing the history of styles in their gradual growth and decadence. Any true art lover will recognize the justice and importance of this demand.'

Winckelmann rose to contemporary fame from the obscure and poor origins of a cobbler's son born in Prussia, at Stendal, in 1717. His development was slow but consistent, not meteoric. The only dramatic incident in his life was his death, at the hands of a murderer.

As a penniless student, he first studied theology at the university of Halle (1738–40), followed by a shorter period devoted to medicine and science at the university of Jena (1741–2). The blind rector of the Lutheran church at Halle asked him to be his reader, which gave Winckelmann his first acquaintance with Greek texts and a desire for wider education. He

then held a minor teaching post, as associate rector of a village school at Seehausen in the Altmark district (1743–8), where he taught children to read and write. Only in 1748 does his life start on the path that led eventually to his reputation as a scholar and antiquarian. In that year he was appointed librarian and assistant to Count Heinrich von Bünau at Nothnitz, near Dresden, and although the count did not possess any significant art collection, the post was more suited to Winckelmann's scholarly leaning, with stimulus from an employer who was himself a scholar and had been working on the history of the Holy Roman Empire. Winckelmann was able to consolidate his earlier, wide reading in classical literature, which he had started to master whilst a schoolteacher.

Winckelmann left Count von Bünau's employment in 1754 in order to go to Dresden, which was to be a momentous step in his career. Continuing his profession as librarian, now as Cardinal Passionei's, Winckelmann was at last in a cultural centre. In Dresden he could for the first time study fine paintings (including Raphael's *Sistine Madonna*) and a modest range of antiquities, and he was also granted access to the royal library. As guide and mentor he had his contemporary, the enthusiastic painter Adam Friedrich Oeser, who studied with him antique sculpture in the royal collection and was to contribute illustrations to some of his publications. Oeser was later to be equally influential in forming the taste of the young Goethe. Winckelmann's deep knowledge of Greek literature, on which his interpretation of Greek art was based, together with the stimulus of Oeser's love of simplicity in art, led to the writing of one of the essays which was to remain one of his most famous works, his *Gedanken über die Nachahmung der griechischen Werke in der Malerey und Bildhauerkunst* (1755). The essay's ecstatic passages were composed before Winckelmann had ever set foot in Rome itself. The general principles and interpretations in this early work were to remain crucial for all Winckelmann's subsequent writings.

Winckelmann consciously constructed a new style of German. His first writings show an educational and reforming purpose, expressed through a new use of language: it is clarified in order to be interpretative, whereas previously it had been largely rhetorical. Winckelmann's new language was influenced by his contact with writings in French by such seventeenth-

century theorists as Félibien, Chambray and de Piles, and in English by the Richardsons, the Duke of Buckingham's *Poetical Reflections* (1681) and Thomas Blackwell's *Life and Writings of Homer* (1735).[1]

Winckelmann became increasingly determined to go south to Italy, but realized that as a Lutheran (although only a nominal one) he had no prospects of a scholarly appointment in Rome. More from practicality than from deep conviction, therefore, Winckelmann became a Roman Catholic in Dresden, a decision influenced by Cardinal Archinto, papal nuncio to Augustus III, King of Poland and Elector of Saxony. Winckelmann became, in name at least, an abbé. In the autumn of the following year he set out for Rome, initially financed by Augustus III and Cardinal Archinto. He arrived in November 1755, as librarian to Archinto. After Archinto's death Winckelmann held the same appointment with Cardinal Albani (1758), to whom he had been enthusiastically recommended by Baron Philip von Stosch, the collector of gems. Under such circumstances, Winckelmann was able to lead the scholarly life of research that made his famous publications possible.

He was singularly fortunate in having Cardinal Albani as his main Roman patron. The Cardinal, nephew of Clement XI (who had been Pope at the beginning of the century), was one of the most outstanding collectors of classical antiquities in Rome, and this collection was put in Winckelmann's charge in addition to the library. A wealthy patron of the arts, Albani had started to build in 1746 on the outskirts of Rome a new, lavish residence for entertaining and for the display of his collection: the Villa Albani. His architect, Carlo Marchionni, added about 1760 three classically inspired temples, two forming part of the older structure, one freestanding in the grounds. These additions may well reflect the influence of Winckelmann's taste. The fanciful, artificial ruin, the Tempietto Diruto, is actually composed of genuine antique fragments (Plate 16). Winckelmann's taste can also be detected in frescoes in the Villa itself. He achieved the enviable contemporary reputation of having become one of the leading figures in circles of classical studies in Rome, whose services

1. Several of these writers are discussed in the Introduction below, pages 31, 42–4, 50, and in the Texts, pages 68, 105, 128, 152, 157 note 5.

as adviser and guide were much sought after by distinguished visitors to the city. Friends whom he frequently met to discuss mutual problems with included the painter Mengs.

Whilst in charge of Albani's antiquities, as well as being his librarian, Winckelmann published all his main essays and volumes on the art of classical antiquity. In 1759 he published several essays, including one on the *Torso Belvedere* (Plate 11) and another on the *Apollo Belvedere* (Plate 9), previously two of the most frequently described and admired of classical sculptures, which he writes about again in a similar rapt manner in his *Geschichte*. 1759 also saw the publication of an essay on grace, *Von der Grazie in den Werken der Kunst*, a not very original discussion of the concept. At this time he also published an architectural essay on the important Greek site of Agrigento in Sicily (Plate 3), based not on his own researches, however, but on those of the British architect Robert Mylne (*Anmerkungen über die Baukunst der alten Tempel zu Girgenti in Sizilien*).

Winckelmann's first really scholarly, detailed book followed in 1760, when he published his catalogue of the collection of gems that had been assembled by Baron Stosch earlier in the eighteenth century, one of the most important and representative groups at the time of antique engraved gems. The catalogue, *Description des pierres gravées du feu Baron de Stosch*, dedicated to Albani, was published in the hope of finding a purchaser for the entire collection, which had recently been inherited by Stosch's nephew. The largest portion was eventually purchased by Frederick the Great. The volume was published without illustrations, but Winckelmann supplied meticulous, clear descriptions of each gem, preceded by a terse, matter-of-fact introduction.[1] Winckelmann adopted a similar bluntly factual approach for his essays on Herculaneum, the first of which he dedicated to his former patron Brühl: *Sendschreiben von den herculanischen Entdeckungen* (1762), and *Nachrichten von den neuesten herculanischen Entdeckungen* (1764). These essays are amongst the earliest descriptions and discussions of the immensely influential site of Herculaneum. In 1762

1. Important though the catalogue is in Winckelmann's oeuvre, it has not been anthologized here because it is too factual and technical, concerned neither with ideas nor interpretation.

he also published his interesting and interpretative essay on ancient architecture, his *Anmerkungen über die Baukunst der Alten*. In 1763 came Winckelmann's ambitious attempt to write a general essay on the concept of beauty. It is the only work in which he allows himself space for extensive comments on post-classical art. He elaborates on themes of Renaissance and Baroque art which had only briefly been touched upon in his famous 1755 essay. This 1763 essay was entitled *Abhandlung von der Fähigkeit der Empfindung des Schönen in der Kunst, und dem Unterricht in derselben*.

All these publications were to be overshadowed at the end of 1763 by Winckelmann's most important work, his *Geschichte der Kunst des Alterthums* (dated 1764 on the title page), his long, detailed and systematic account of ancient art on which he had been working since 1756. Winckelmann's contemporary and subsequent fame was to derive primarily from his *History* rather than from any other work; its publication gave him a European reputation. He was himself aware of the importance of its appearance, as he wrote in a letter in 1764: 'Perhaps a century will pass before a German will successfully follow me in the path I have taken.' He published additional notes and thoughts to it in 1767, *Anmerkungen über die Geschichte der Kunst des Alterthums*. In 1766 he published a long discussion of allegory, because he believed many modern artists held misconceived ideas about allegory and its importance in history-painting. He discussed earlier uses of allegory, and invented new ones where the history of art or literature could not supply a precedent (*Versuch einer Allegorie, besonders für die Kunst*). Although in some ways a muddled book, in which he confuses allegory with symbolism, Winckelmann did attempt to supply contemporary artists with a good catalogue of what he regarded as significant images. He gave a great deal of thought to the problem, and himself regarded his *Allegorie* as an important late work. His final publication, in the year before his death, was the two-volume *Monumenti Antichi Inediti* (1767), the only one of his works published in his own lifetime with extensive, and indeed handsome, engravings (Plate 20). Even the *History* was unillustrated, until the publication of posthumous editions. The *Monumenti* were selected either because Winckelmann thought they had been discussed inadequately in previous

publications, or because they had so far not been published at all. His analyses of works are preceded by general discussions of beauty, which reiterate the main arguments of his 1763 essay on beauty.

Most of Winckelmann's works were published originally in German, chiefly in Dresden. The Stosch catalogue, however, was written bilingually, in German and French, and the *Monumenti* was written entirely in Italian. However, few of the non-German eighteenth-century intellectuals, collectors and artists read German, so that translations of Winckelmann's writings were extremely important in disseminating his ideas. The English-speaking world in the eighteenth century had access to Winckelmann in a few cases in English, but most of the translations were in French or Italian. The great *History* was not translated into English in full until 1880. (The Greek art section only was available from 1849.) It was however translated into French as early as 1766, and into Italian in 1779. Of the other important essays, the 1755 *Gedanken*, together with Winckelmann's own anonymous attack on it and his own reply (the attack and reply had been intended to draw more attention to the original essay), as well as the essay on grace and instructions for connoisseurs, were published in English by the artist Henry Fuseli in 1765, and reissued in 1767. Fuseli's father had collected money to help Winckelmann in Italy when he was in financial difficulties, had arranged for Angelica Kauffmann to paint his portrait in 1764, and was to publish a posthumous edition of his letters. The younger Fuseli also translated the essay on the *Apollo Belvedere*, in the periodical *Universal Museum* in 1768. The *Gedanken* was translated a second time into English, anonymously, and published in Glasgow by Urie in 1766. French translations were speedier than English. The *Gedanken* had already been translated in Paris the same year as it was published in Dresden. The essay on beauty appeared in French in 1786, but never in English.

Winckelmann's publications were based on wide reading and also on extensive familiarity with original works of art and architecture in Italy, especially in Rome itself. In 1758 he spent several months touring the sites and collections in Naples and at Herculaneum, as well as the temples at Paestum. Naples and Herculaneum were visited again on no less than three occasions (1762, 1764, and 1767). It is significant that he never went

to Greece, although he had several opportunities of doing so, on each occasion with all expenses met by patrons.

His stature as an archaeologist was rewarded in 1763 when he was appointed prefect of antiquities at the Vatican (see Plate 4), which gave him power over excavations and export—an influential post, since important discoveries on papal territory (where in fact many of the sites were) had first to be offered to the Pope before purchase by another collector or export permission would be granted. Winckelmann's services were courted by Frederick the Great, who offered him the post of librarian and directorship of his cabinet of medals and antiquities. But he was encouraged to stay in Rome by an increase in his salary from papal coffers. In recognition of his scholarship Winckelmann was elected a member of the Academy of Inscriptions in Rome, and of the Society of Antiquaries of London.

In 1768 Winckelmann journeyed north to Germany and Austria, accompanied by the Neoclassical sculptor and restorer Cavaceppi (see Plate 15). He was honoured by the Empress Maria Theresa at the Viennese court, and presented with gold and silver medallions. On his way back to Rome, Winckelmann made friends in Trieste with an ex-criminal, Arcangeli, forming a relationship which might have been homosexual. It is believed that Arcangeli was on one occasion shown the medallions, and out of avarice plotted to stab the antiquarian. The murder took place on 8 June 1768, and Winckelmann's body was buried in the churchyard of San Giusto in Trieste.

Winckelmann's contemporary reputation was considerable. When, for instance, he published his essay on ancient architecture in 1762 he was praised in a Parisian periodical: 'Perhaps there is no one today who knows the ancients better than Winckelmann, who has better studied the admirable monuments which remain to us, who is more sensible to their beauties, and who knows how to describe them with more justice, taste and fire' (*Bibliothèque des Sciences et des beaux arts*). Typical of adulation later in the century is the *Rudiments of Drawing* of Giovanni Battista Cipriani, published in 1796. In it the artist tells readers that they should be familiar above all with two key publications: Leonardo da Vinci's *Treatise on Painting* and Winckelmann's *History*.

Introduction

So influential had Winckelmann's interpretation of classical art become, particularly his great stress on simplicity and calmness, that Reynolds found it necessary in his eighth and tenth Academy discourses to warn his audience that the art of the ancients had 'something beside mere simplicity' to recommend it. Winckelmann, of course, had not stressed only simplicity, but Reynolds obviously has Winckelmann in mind in these passages. Any hostility to Winckelmann in the eighteenth century is usually directed not towards his general assessment of antique art but to other aspects of his ideas. The irascible James Barry was furious with Winckelmann over his assessment of the importance of climate in determining the particular character of Greek art. Barry wrote his *Inquiry into the Real and Imaginary Obstructions to the Acquisition of the Arts in England* (1775) to prove that England too could produce good artists, that the climate for those living on the banks of the Thames should not be detrimental to the growth of a great art in Britain. Although Henry Fuseli had translated Winckelmann as a young man, he too became hostile later in life and talked of Winckelmann's 'frigid reveries' (in the Introduction to his Academy lectures), but Fuseli had in mind the unfortunate stultifying effect of Winckelmann's theories on the development of German painters and sculptors. With the extroverted, Romantic Benjamin Robert Haydon, one finds him referred to in a diary entry as a 'useless rhapsodist' (1809). A writer who could be called both 'useless' and 'immortal' by different writers within a few decades of his death must undoubtedly have had a considerable impact.

II Classical Antiquity and its Interpretation

WINCKELMANN'S ANTIQUARIANISM was the descendant of a long and distinguished line of archaeological scholarship and collecting. His texts, footnotes and letters contain countless references to writers, publications and collections of earlier generations, whose ideas will form the largest part of this section.

From the early Renaissance until the latter part of the nineteenth century, each generation of artists accepted the art and thought of classical Greece and Rome as their guides. Even throughout the Middle Ages, too, the classical influence is evident, but not as strongly. But each generation did not accept identical aspects of the classical past; each selected only that part relevant to its own ideas.

Winckelmann and his generation knew little at firsthand of pre-fifth-century Greek sculpture.[1] A rare instance of Archaic work appearing in Neoclassicism is in one of the engravings for Flaxman's edition of Aeschylus. By about 1820 a few Minoan and Mycenaean pieces had been discovered, but nothing was really unearthed until the later excavations of Schliemann and Evans.

Until the late eighteenth century, the major part of Greek art of the fifth century onwards was only known from Roman copies, not originals, or from the descriptions in Pausanias, Pliny the Elder and other ancient writers. Because Greek art was seen through Roman eyes, so to speak, its style was judged by Roman characteristics, so that for example it was believed by Winckelmann and by his contemporaries that ancient sculptors often generalized their anatomy and omitted facial features. Reynolds echoed this misconception when he said in one of his Royal Academy discourses: 'The face bears so very inconsiderable a proportion to the effect of the whole figure, that the ancient sculptors neglected to animate the features, even with the general expression of the passions.'

The turning point in the influence and assessment of Greek art was to come with the importation into Britain in 1808 of the Elgin Marbles from the Parthenon. Winckelmann's generation, and all those before him, did not therefore know Phidias at first-hand, the only visual records being inadequate drawings and models. Cyriacus of Ancona (who died about 1457), for example, a commercial traveller in the eastern Mediterranean,

1. See Texts, page 106.

reported in the letters he sent back to Italy on many of the things he saw, unfortunately in a somewhat fanciful manner. His drawings included the Parthenon. But such poor, secondhand visual material could never have had the impact of either the accurate engravings of the eighteenth century or, even more so, the sight of the sculptures themselves. The very few Greek original works that did exist outside Greece were too rare to be influential. The antique collector Cardinal du Bellay had in his garden in Rome in the latter part of the sixteenth century some acroteria from the fifth-century B.C. Greek temple of Bassae on the Greek mainland, which had probably originally been carted off by the invading Romans. However, so varied is the art of classical antiquity, that even with this important limitation, every age had an abundant field of antique styles from which to choose. From the Renaissance onwards not only were Roman works known, but also Etruscan, Romano-Egyptian and early Christian.

Winckelmann, and all those who fell under his spell, stressed above all other characteristics in ancient Greek art those of 'noble simplicity' and 'quiet grandeur'.[1] But these were not necessarily the essential elements of ancient art for earlier artists and writers.

The two early Renaissances, the Carolingian and that of the twelfth century, although borrowing motifs from classical art, were more sporadic both in scope and in their uses of antiquity. A Carolingian crown incorporates genuine Roman cameos. A twelfth-century English illuminated manuscript of Terence presents actors in Roman masks. Villard de Honnecourt in the thirteenth century copied into his sketchbook Roman statues, including a Mercury, seen on his travels through Europe. Neoplatonism was an important factor in medieval thought: the philosophers at Chartres were even accused of equating mathematics with God.

The fundamental, consistent establishment of European art and thought on a classical basis really dates from the fifteenth-century Renaissance. As early as about 1375 a member of Petrarch's circle measured Christian and pagan monuments in Rome and collected inscriptions. Drawings became an extremely important medium for the dissemination of the knowledge of classical art, so much so that it is sometimes difficult to

1. See Texts, pages 72–3; compare pages 95, 102, 124.

know whether a fifteenth-century artist has seen the original work or someone's drawing of it. Pisanello has left some beautiful drawings of a well-known *River God*, several of a *Venus*, and a *Hercules*: yet they are all interpreted in an unmistakable early *Quattrocento* idiom. Pisanello and his contemporaries had knowledge of a few freestanding large Roman sculptures, among them the *Horse Tamers* or *Dioscuri* (on the Quirinal) and the *Marcus Aurelius* (then near the Lateran, now on the Campidoglio, Rome). Few new discoveries were made in this type of ancient art in the course of the fifteenth century. Knowledge of Roman sculpture derived primarily from relief panels, both on sarcophagi and triumphal arches, with the additional influence, later in the *Quattrocento*, of the columns of Trajan and of Marcus Aurelius. Smaller objects of antiquity were to play a very important role in disseminating the classical influence, once they were collected from the mid-fifteenth century onwards. Coins, gems, medals and small bronzes were assembled by Cosimo and Piero de' Medici and by the future Pope Paul II, Cardinal Pietro Barbo. These smaller, easily transportable, and much less expensive relics of antiquity were increasingly gathered together in order to give many a young artist his initial, first-hand acquaintance with antiquity before he made the pilgrimage to Rome and other Italian centres to see larger works. Antique gems were still of major importance in Winckelmann's day, and so skilful are the many copies and forgeries which the eighteenth century produced under almost factory-like conditions to supply the demands of the current market, that it is often impossible to tell genuine from fake. (Unlike bronzes, gems do not acquire a patina.)

Throughout the fifteenth century painters and sculptors borrowed compositions and motifs from classical antiquity, mixing many sources that are easily discernible. Antique patterns only became more fully assimilated in the course of the sixteenth century, when it becomes increasingly difficult to identify prototypes. Mantegna was one of the most knowledgeable of fifteenth-century painters on the subject of antiquity, and his trip on Lake Garda in 1464, when he was accompanied by three friends, one of them a well-known antiquary, clearly shows the Renaissance realm of antique experience based both on an attitude of mind as well as on practical research. The friends looked at many antique remains on the lake, and

during the course of the trip one of them, crowned with laurel, assumes the role of 'Emperor' playing a cither, whilst two others (one of them Mantegna) become 'consuls'. Mantegna had his own collection of antiquities, and in creating (about 1486–94) the large cartoons of the *Triumph of Caesar* (Hampton Court Palace), which are amongst the finest 'antique Roman' recreations of the Renaissance, he follows Livy's description of Roman Republican triumphs.

Contemporary with Mantegna, a limited number of important artists were looking at a quite different aspect of antiquity, at the delicate volutes and calligraphic detailing of Neo-Attic work. From it Botticelli created forms of agitated movement, strongly linear in character, as in the famous *Primavera*. Neo-Attic sources provided forms with which to interpret Alberti's theory formulated earlier in the century, when he had argued in his *On Painting* that this art 'ought to have pleasant and graceful movements . . . hair . . . waves in the air like flames. . . . Folds act in the same way, emerging like the branches from the trunk of a tree.' Botticelli, Agostino di Duccio and a few of their contemporaries were alone in looking at Neo-Attic patterns. The contrast between the style of Botticelli's *Primavera* and that of Mantegna's *Triumph of Caesar* clearly demonstrates how two artists can select quite different aspects of antiquity as the most suitable for their purposes. High Renaissance, Mannerist and Baroque artists continued this process of antique assimilation. Leonardo da Vinci wrote in a notebook, 'It is better to imitate the antique than modern work.' Although no drawings by Leonardo after the antique survive, a Roman sarcophagus panel, for example, influenced part of the composition of his *Battle of Anghiari*. Giulio Romano concentrated for his source material on sarcophagus relief panels of the period of Trajan, Hadrian and Antoninus. Michelangelo looked to the more flamboyant aspects of Flavian and Antonine sculpture. Such sculptures as the *Torso Belvedere* (Plate 11), *River Gods* and *Farnese Hercules* are the basis of the Sistine Ceiling.

The *Laocoon* (Plates 10, 14), on which Winckelmann later wrote extensively and which was so important for his contemporary Lessing, was discovered in 1506 in the Golden House of Nero.[1] Known from Pliny's

1. See Texts, pages 72–3, 125, 135–6.

Natural History as 'a work superior to any painting and any bronze', this large sculptural group became one of the formative influences on Michelangelo's muscular style of anatomy. The *Laocoon* was frequently drawn by artists from Raphael and Andrea del Sarto onwards.

By the mid-sixteenth century archaeological knowledge had become so vast that it was difficult for one man to master all its aspects. Slowly, archaeology emerges as a science and some writers start to specialize. The first published corpus of inscriptions appeared in 1534 with Petrus Apianus's *Inscriptiones Sacrosanctae Vetustatis*, and although it included many fakes and was a jumble of information from unselective sources, the *Inscriptiones* represented a new development; and in spite of the crudity of its engravings, the selection showed a good variety of tombs. Far more critical was a later publication by a Spaniard resident in Rome, Antonio Agustin, whose posthumous *Dialogues on Medals, Inscriptions and Other Antiquities* appeared in 1587. Agustin wished to prove that literature was not as reliable a source for antique art as were coins, inscriptions and other visible remains, and his text is illustrated with many engravings. His Roman archaeological friends included Pirro Ligorio, who was also an architect, epigrapher, historian and topographer. Ligorio (to whom Winckelmann refers with approval) compiled a large body of valuable material, in spite of the fact that some of the monuments he records have either had missing pieces replaced or details omitted. A votive relief to five gods (now in the Vatican), for instance, is shown in his drawing with the missing head and wings of Mercury completed, the bull's head at Hercules's feet omitted and a scyphus instead of the Hesperidean apples. Ligorio compiled a corpus of material of coins and minor antiquities, inscriptions and plans. He attempted—and was probably the first antiquarian to do so—to put together an encyclopaedia of archaeology and epigraphy.

The sixteenth century saw the publication of many antiquarian works, some of importance. In the 1540s and 1550s a series of separate engravings under the general title of *Speculum Romanae Magnificentiae* was issued by Antonio Lafreri, a vast compilation of visual material. Between 1570 and 1594 four volumes, containing 100 plates of ancient statues, was published by Giovanni Battista de Cavalieri as *Antiquarum Statuarum*

15

Urbis Romae. This was a very influential publication, and formed the basis of several works issued in the course of the seventeenth century.

Throughout the 1600s archaeological publications and collections extended the work of the previous two centuries. Several outstanding collections were newly on view in Rome. The placing of many antique reliefs on the façade of the Villa Medici in 1590 set a new pattern for the display of collections. When the Cardinal Scipione Borghese built the Villa Borghese between 1613 and 1615, he too had antique sculptures incorporated on the outside of the building. His collection (most of which is still in the house, other pieces being now in the Louvre as part of the Napoleonic plunder) was well known to contemporary artists, especially Bernini. The Marchese Vincenzo Giustiniani, patron of Caravaggio, had a very important collection in his houses, with many of the reliefs actually built into the architecture. A large number of artists drew the marbles in his collection (now dispersed), which was published in the sumptuous *Galleria Giustiniani* of Joachim von Sandrart (1631). The collection of the Mattei brothers (also now largely scattered) was rich in decorative marbles and architectural fragments, and artists were encouraged to study these works. A survey of the collection was not published, however, until much later in the *Monumenta Mattheiana* (1776–9). Two of the leading sculptors of the seventeenth century in Italy, Algardi and Duquesnoy, restored antique sculpture, and the painter Carlo Maratti restored an iconographically influential late Roman fresco discovered in 1650. Several other important finds in the course of the seventeenth century included the famous Ludovisi battle sarcophagus, whose composition several artists were to adapt in their own works. The most important single site to be opened up was that of Hadrian's Villa at Tivoli, a site that was to produce many sculptures up to and beyond the time of Winckelmann.

Winckelmann knew and studied in detail the collections just mentioned, which were then still intact. In addition to this large body of sculpture, to which eighteenth-century collectors were to add considerably, Winckelmann's scholarship was further aided by the enormous collection of drawings after the antique in the possession of Cardinal Albani (sold in 1762), which had been assembled between 1620 and 1650 by Cassiano dal Pozzo, a patron of Poussin. This invaluable collection of nearly 1,500 items, the

Museum Chartaceum, also known as the Dal Pozzo–Albani volumes, is now divided between the Royal Collection at Windsor Castle (twelve volumes) and the British Museum (two volumes) (Plate 6). The drawings are often large, some being more than two feet wide. The greater part of the collection had belonged to Pozzo, but Albani continued to add drawings up to about 1760. Winckelmann therefore had easy access to the largest, single collection of archaeological information anywhere in Europe, a mine of material not only for archaeologists, but also for painters and sculptors. Most of the drawings were executed in the early seventeenth century, some by artists such as Pietro da Cortona. The collection, however, also includes older drawings, some as early as about 1480, while others date from the sixteenth century, and include the work of Polidoro da Caravaggio. The variety of subject-matter is encyclopaedic, ranging from important reliefs to minor bronzes, from gems to epigraphy.

Seventeenth-century classicism in art owed much to this great variety of sources of the antique, from drawings, engravings, publications and the works themselves. This antique corpus prepared the way both for eighteenth-century Neoclassicism and for the achievement of Winckelmann. As in the Renaissance, different artists showed preferences for different classical sources. Rubens, for instance, was attached to the *Torso Belvedere*, and Bernini to the works of the first and second Pergamene schools of the third and second centuries B.C. Whereas Bernini was not interested in sarcophagi and Graeco-Roman reliefs, Poussin relied heavily on these. Indeed Poussin's interpretations of antique reliefs was an important influence on earlier Neoclassicism in the 1750s and 1760s, which Winckelmann encountered in Rome.

At the end of the seventeenth century the library of archaeological books was further enlarged by several important publications, including the influential folios of engravings by Pietro Santi Bartoli,[1] of which the most important was the series of Roman reliefs he gathered together, with Bellori, under the title *Admiranda Romanorum Antiquitatum* (1685) (Plate 8). None of Bartoli's volumes was accompanied by text; they were merely visual records. Bartoli and his son Francesco were keen on

1. See Texts, page 96.

17

the visual dissemination of antique knowledge, and they studied wall paintings, which had been largely neglected until then in preference for other antiquities, making coloured drawings of Roman *grotte* frescoes (published 1706). In 1680 Joachim von Sandrart published his *Admiranda Statuarum*, which illustrated many pieces of sculpture in reasonably accurate engravings, occasionally with pleasantly imaginative backgrounds such as a *Nile* figure in a setting of pyramids, sphinxes and palms. The slowly emerging importance of archaeological collections outside Italy is shown by the first German catalogue which Lorenz Beger published, his *Thesaurus Brandenburgicus Selectus* (1696–1701). The Brandenburg collection was primarily devoted to gems and coins, first housed in Berlin, but eventually partially in Dresden.

By the time Winckelmann was writing in the middle of the eighteenth century, the body of archaeological literature had expanded even further. Montfaucon had published his great *L'Antiquité expliquée* between 1719 and 1724, folios to which reference was frequently made in the eighteenth century. Montfaucon's work was to a very large extent an elaborate iconography of classical art, rather than a scientific history. Images of gods and goddesses, regardless of the date of the original sculptures and medallions, crowd the many plates (Plate 5). Because it was so well and profusely illustrated, Montfaucon's work was widely influential, and Winckelmann made scathing comments on this predecessor more than once.[1] Other writers had attempted iconographies, including Ripa, whose *Iconologia* (1593, first illustrated 1603) was continually republished throughout the seventeenth and eighteenth centuries, with the engravings changed from time to time, reflecting contemporary taste.[2]

Winckelmann's archaeological publications were therefore a continuation not only of a long tradition of literature on classical art but also iconographical literature, and it was especially this latter tradition that he had in mind when writing his *Allegorie*.

The French antiquarian and collector Mariette is one of the few of Winckelmann's precursors on whom one finds him commenting favourably. He singles out for special praise for its thoroughness the Frenchman's important treatise on gems, *Description sommaire des Pierres gravées*

1. See Texts, page 105. 2. See Texts, page 83.

du Cabinet du feu M. Crozat (1741). Important archaeological publications contemporary with Winckelmann's own included the volumes of the Comte de Caylus's *Recueil d'Antiquités Egyptiennes, Etrusques et Romaines* (1752–67), which covered the art of three different civilizations in a wide, if not thoroughly scholarly way, and supplied many illustrations of often unfamiliar material. The other major work of the period, which started to appear from 1757 onwards, was the series of lavishly illustrated folios published by the Accademia Ercolanese of Naples, reproducing the discoveries of the Herculaneum site. First the paintings started to appear (*Le Pitture Antiche d'Ercolano*, 1757 onwards) and then the bronzes (*Bronzi d'Ercolano*, 1767 onwards) (Plate 7).

By the middle of the seventeenth century, all the great private collections of sculptures and other portable antiquities had been assembled. Rome had been, and was to remain, the main centre for archaeological excavations, and even portable discoveries tended to remain in Rome, with the exception of the classical works which the Medici family transported up to Florence, and the occasional Roman sarcophagi which found their way to Pisa as a result of being used as ballast in the empty corn ships returning north. Rome and Florence, with the additional exception of Pisa, were the main centres for the study of classical sculpture. By about 1650 most of the works of classical antiquity known for the next hundred years had been collected, until the corpus of antiquities was considerably increased by the eighteenth-century discoveries at Pompeii, Herculaneum and elsewhere. The greatest collections had been assembled by the influential families of the Borghese, Barberini, Mattei, Ludovisi and Giustiniani. Winckelmann throughout his writings frequently has occasion to refer to works in these collections.

The Renaissance had few antique painted decorations from which to derive inspiration. The largest body of illusionistic imagery was the fifth-century A.D. mosaics in Santa Maria Maggiore in Rome, which influenced Perugino and others. Raphael and his pupils' work in the Loggie of the Vatican (about 1517–19) was influenced by newly discovered 'grottesque' decoration: 'Excavations were made', Vasari tells us in his life of Raphael, 'among the ruins of the Baths of Trajan with the hope of finding statues, when certain subterranean chambers were discovered, and these were

decorated all over with minute *grottesque*, some figures, stones and orna-
ments, executed in stucco in very low relief. These discoveries Raphael
was taken to see, and Giovanni da Udine accompanied his master, when
they were both seized with astonishment at the freshness, beauty and
excellent manner of these works.' Two and a half centuries later the same
'grottesque' patterns were to influence Robert Adam's interior decoration
style. In Rome in 1590 was found the wall painting of the *Aldobrandini
Wedding*, which not only influenced early seventeenth-century painters,
especially in Bologna, but was to continue to be influential in the eigh-
teenth century. A copy appears, for instance, in the dining-room at Syon
House, Middlesex. Before the discovery and publication of the wall
paintings at Herculaneum in Winckelmann's lifetime, therefore, little
attention was paid to this aspect of ancient art, with the exception of such
antiquarians as the Bartolis.

Antique paintings were apt to be subjected to curious antiquarian
speculation. Baldinucci, famous for his life of Bernini, had indulged in a
doubtful pursuit when he gave two lectures in 1690–1 comparing ancient
and modern painting, to the advantage of the latter. George Turnbull in
his *Treatise on Ancient Painting* (1740) compared Apelles with Raphael,
undeterred in his claim that Apelles was superior by the total disappear-
ance of Apelles's works.[1] Spence in his *Polymetis: or an Inquiry concerning
the Agreement between the Works of the Roman Poets and the Remains of the
Ancient Artists* (1747) was also interested both in ancient painting and in
sculpture. The lack of knowledge, together with a certain lack of interest,
in ancient wall painting accounts for the paucity of literature on the sub-
ject before Winckelmann, and also accounts for the somewhat unsatisfac-
tory passages in his writings when he himself deals with paintings.[2] He is
lukewarm about such famous paintings as the Herculaneum *Theseus*, but
more enthusiastic about the series of dancing women. The reason is that
Winckelmann's prime and deep interest was in sculpture, and to a lesser
extent in architecture. Subsequent writers are rather more enthusiastic
than Winckelmann about the Herculaneum paintings. Writing an article
in the *Analytical Review* in 1794, Henry Fuseli was to say that, although
the frescoes give 'no idea of the times of Apelles, yet the painters of many

1. See Texts, page 81. 2. See Texts, pages 80–1, 129–30.

an antique picture at Portici [where the antiquities were exhibited before their removal to Naples], though they must be considered as little better than house-painters of municipal towns, have left in those works specimens of art, which for *franchezza* and boldness of touch, equal glow and freshness of colour, allowing for the ravages of time, bid defiance to any comparison with modern art.'

The painting on Greek—or, as they were erroneously called, Etruscan —vases was of prime importance to the development of the Neoclassical style. These vases were seriously collected, and published, for the first time in the eighteenth century, chiefly by Sir William Hamilton. Winckelmann himself has little to say about such objects (Plate 20).[1] Very few of these vases were known in the Renaissance, though it is recorded that Vasari's grandfather owned one. Before the discoveries and collecting of these vases from about 1750 onwards, not more than about fifty examples were in circulation.

Two collections of vases which Sir William Hamilton formed were lavishly published in engraved folios, the first publication (1766–7) having handsome coloured engravings. Because of financial difficulties Hamilton was obliged to sell the first collection, and this formed the foundation of the department of Greek and Roman antiquities at the newly established British Museum, which had been opened to the public in 1759. The second collection was published in uncoloured engravings (1791–5), and contains a preface in which Hamilton praises such vases very highly as the most important antique source for the modern artist to use.

The drawings on these vases greatly influenced the drawing style and compositions of many artists; their subject-matter was freely used; and their shapes as well as their decorations were adapted by the artists working for such industrial potters as Wedgwood, who were leaders of taste as well as men of enterprise in supplying goods in the fashionable Neoclassical taste. Reynolds wrote a letter to Hamilton praising the first collection highly, recognizing they were 'useful to antiquarians and will tend to the advancement of the arts, as adding more materials for genius to work upon'. The outline drawings on these vases intensified the Neoclassical tendency towards a two–dimensional art.

1. See Texts, pages 112–13.

Introduction

The Greek vases emphasized, even more than Winckelmann did in his writing, the important characteristic of contour as an aspect of antique art. Winckelmann continually stresses contour.[1] He did not respond to, and hardly ever described, mass, chiaroscuro or colour.[2] Access to very few classical originals in Dresden led Winckelmann to base his linear concept essentially on a High Renaissance painting, chiefly Raphael's *Sistine Madonna*.[3] Subsequently, in Rome, the stress on contour derived more first-hand justification from the antique itself. The linear quality of the decoration on Greek vases, together with the two-dimensional compositions of Roman sarcophagi and other relief panels, were important factors in determining the development of the Neoclassical style.

The influence of pure Greek architecture and sculpture in the eighteenth century was slow to materialize. In the case of sculpture the delay is mainly due to the lack of first-hand visual material. As the full impact of sculpture is only possible in confrontation with the original, it is not surprising that even the reasonably accurate engravings of the Parthenon Marbles that appeared in the second volume of Stuart and Revett's *Antiquities of Athens* (1787) did not exert a decisive influence. The artistic stir amongst painters and sculptors only occurred when the Marbles arrived in London in 1808. Lord Elgin's triumphant plunder was eventually, after niggardly negotiations, purchased by the British government for the British Museum. The same museum was also successful in acquiring, in 1814, the equally important fifth-century B.C. Phigaleian Marbles. Until these two sets of marbles were removed from Greece, the many eulogies of Phidias and his age had been based on secondhand visual and literary evidence.

The slowness of the initial development of the Greek Revival in architecture is less easy to explain. Up to the middle of the eighteenth century the Grand Tour extended no further south than Rome and Naples. Aristocrats and other patrons of the Roman classical architectural revival had seen much of the same material themselves when young men, so that the first generation of Neoclassical architects had sympathetic patrons. It was only in the second half of the century that the Grand Tour was exten-

1. See Texts, pages 68–9, 71, 80–1, 112. 2. See Texts, pages 94, 100–1, 118.
3. See Texts, pages 74–5.

ded, under the impact of some of the Greek archaeological publications, down to Paestum and Sicily, and eastwards to Asia Minor, to Baalbek and Palmyra.

The second half of the eighteenth century saw the publication of several important volumes on the Greek mainland and islands, and their architecture. These volumes not only had detailed texts but, even more important, very accurate engravings of the principal buildings, presenting not just picturesque views, but also meticulous elevations, plans and details drawn to scale. The outstanding folios were those published by James Stuart and Nicholas Revett, *The Antiquities of Athens*, of which three volumes appeared in 1762, 1787 (devoted to the Parthenon Marbles, already mentioned) and 1794. Two further volumes were published posthumously in 1816 and 1830, edited mostly by the architect C. R. Cockerell. The volumes of the *Antiquities* provided ideal pattern books for architects and designers like Stuart himself, who could now erect a pure Greek Doric temple in the grounds of Hagley Park, Worcestershire, in 1758. The majority of the pioneer publications on Greek architecture were by Englishmen. Revett on his own published two additional volumes, his *Ionian Antiquities* (1769 and 1797). Richard Dalton's *Museum Graecum et Aegypticum* had appeared in 1751, Robert Sayer's *Ruins of Athens and other valuable antiquities in Greece* in 1759, and Stephen Riou's *Grecian Orders of Architecture Delineated and Explained* in 1768. Of the several books on the Greek Doric temples at Paestum, the most important was Thomas Major's *Ruins of Paestum* (1768).

On the continent, the outstanding publication was Le Roy's *Les Ruines des plus beaux monuments de la Grèce* (1758), conceived in rivalry to Stuart and Revett. Although Le Roy visited Greece after them, he succeeded in publishing his findings before them, without acknowledging their pioneering visit.

In comparison with much of the architectural literature just discussed, Winckelmann's two published essays in this field may appear slight in length, but not in the significance of his main theory, propounded in the second essay of 1762 in which he unites two different interpretations of classical architecture current in the eighteenth century: on the one hand the belief that the beauty of Greek architecture was timeless and absolute,

and on the other hand that beauty was relative.[1] In elaborating relative beauty Winckelmann traces a progression in Greek architecture from Paestum to Athens, followed by a decline under the Romans, especially in the ornamentation found at Palmyra and Baalbek.

Only after Winckelmann's death did the Greek Revival gather momentum, culminating during the early nineteenth century in the austere architecture of Schinkel and Klenze in his native Germany, of Ledoux in France, and of Smirke, Wilkins, and Dance in Britain. Winckelmann would have approved of this uncompromising elimination of ornament, reducing architectural forms to their uncluttered essentials. His 'noble simplicity' in ancient Greece finds an echo in the theories of the Greek Revivalists. Smirke, for example, was to write: 'As the moral character is corrupted by luxury so is art vitiated by the exuberance of its ornaments. . . . As excess of ornament is . . . the symptom of a vulgar and degenerate taste.' Smirke and his fellow architects were heirs to the theories of such French architectural philosophers as Cordemoy, Laugier and Blondel, and the concepts of pure geometry of Boullée and Ledoux. Laugier in his *Essai sur l'architecture* (1753, enlarged 1755) had approved of the abandonment of the 'ridiculous baubles' of the Gothic revival in favour of 'the manly and elegant ornaments of Doric, Ionic and Corinthian', reviving 'these magnificent creations of Greece'. This eighteenth-century rationalism, founded on a profound understanding of classical, especially Greek, antiquity was exactly parallel to what Winckelmann himself wrote about sculpture.

The Greek Revival in architecture after Winckelmann's death also coincided with the full flowering of Romantic Hellenism in Germany and in Britain, which was to include the poetry and actions of Byron, and a spiritual affinity with ancient Greece claimed by German nationalists. Winckelmann had successfully turned eighteenth-century eyes away from Rome in the direction of Greece. Classically inspired literature and erudition in the earlier part of the eighteenth century throughout Europe had derived from Rome. To help supplant this dominance by that of Greece was one of Winckelmann's great achievements, which must be set to some extent against the background of hostility between French and German

1. See Texts, pages 86–8, 97–8; compare page 120.

literature and culture. French eighteenth-century writers were apt to regard themselves as the embodiment of the Roman tradition. This attitude found expression in a particularly controversial book (published in 1740) by a Frenchman who argued that the Germans were incapable of artistic creativity. The work, Eléazar Mauvillon's *Lettres françaises et germaniques sur les Français et les Allemands*, stimulated the German romantic poet Klopstock to write his great epic poem *Messias*. Winckelmann and his literary contemporaries helped to create the heady enthusiasm of German Hellenism. Winckelmann, Goethe, Schiller and Hölderlin all agreed that the ancient Greeks in all aspects of their life and thought were more perfect than the modern European:[1] more perfect in art and literature and religion, and more perfect as specimens of men.

Closely connected with the emergence of a Greek, as distinct from a Roman, Revival was an acrimonious debate on the subject of Greek versus Roman supremacy. Such a controversy was possible in the eighteenth century because of the large amount of newly available information, which ranged from the austerities of the Greek Doric order at Paestum, to the Roman complexities of Diocletian's Palace at Split, which Robert Adam published in his *Ruins of Spalatro* (1764). Winckelmann, of course, was on the side of the Greeks, but none the less he approved of Adam's book on Split.[2] Generally speaking, the whole academic tradition had also regarded Greek civilization as superior to the Roman. Shaftesbury had earlier written in his *Characteristicks* that it was in Greece that 'music, poetry and the rest came to receive some kind of shape, and be distinguished into their several orders and degrees. Whatever flourished, or was raised to any degree of correctness, or real perfection in the kind, was by means of Greece alone, and in the hands of that sole polite, most civilized, and accomplished nation.' The pro-Greek camp included Le Roy, whose influential *Ruines* advocated Greek supremacy. The Scottish painter Allan Ramsay had helped to start the mid-eighteenth-century debate with his essay entitled *Dialogue on Taste* (1755), in which he argued that the canons of Greek Taste would not be overthrown 'unless Europe should become a conquest of the Chinese'. Typical of late eighteenth-century statements on Greece was Lavater's assertion in his *Essays on Physiognomy*

1. See Texts, pages 61, 63. 2. See Texts, page 143.

(1775–8): 'Among the works of art the first rank has always been assigned to the Greek statues of the refined ages of antiquity: art has never produced any thing more sublime, or more perfect. This is a truth generally admitted.'

Robert Adam considered Stuart's interiors for the Earl Spencer in Spencer House, London, 'pitifulissimo', and thought the ceilings were 'Greek to the teeth . . . but by God they are not handsome'. Stuart's contemporary architects disliked the 'new-fangled "Doric" without a base, as much as they did a shirt without ruffles, or a wig without two good portly curls over each ear, and half a yard of tail behind'. Robert Adam and his friend Piranesi belonged very much to the Roman camp. Piranesi launched his *Della Magnificenza ed Architettura de' Romani* (1761) and his *Parere Sul' Architettura* (1765) against the Greek advocates. He claimed that ancient Rome was supreme in its architecture and other arts, which had derived from their predecessors the Etruscans and been debased by the Greeks. This archaeological nonsense was supported by Piranesi's superb engravings, which were intricately ornate versions of Roman antiquity (Plate 21). Hadrianic art was the finest in ancient times for Piranesi, and works from this period, elaborately restored, can be seen in his *Diverse maniere d'adornare i cammini* (1769) and his *Vasi, Candelabri* (1778). Other Romanists included the architect Sir William Chambers, who even went so far as to write in his notes about 1768 that one might just as well 'oppose a Hottentot and a Baboon to the Apollo and the Gladiator as set up the Greek architecture against the Roman'.

As Greek art was Winckelmann's chief concern, he gives very inadequate treatment to other ancient civilizations, such as the Egyptian and Etruscan. His account of Etruscan art is far more summary than is merited by the state of Etruscan archaeology in the mid-eighteenth century.[1] Although not as much work had been carried out on Etruscan art as on Roman, nevertheless useful preparatory interpretations of Etruscan art had been made before Winckelmann published his *History*. Winckelmann knew the important publication *De Etruria Regali* (1723–6), yet made little use of it. The material had already been collected in the seventeenth century by Thomas Dempster, whose manuscript remained unpublished

1. See Texts, pages 106–7, 109–12.

until it was acquired by Thomas Coke, afterwards Earl of Leicester. Dempster's interests had been entirely literary and epigraphical, which was typical of archaeology at the time. Coke regarded the manuscript as inadequate for an eighteenth-century public, and therefore asked the Italian antiquarian Filippo Buonarrotti to add archaeological evidence on Etruscan monuments. The resulting publication, a fascinating combination of the attitude of two different centuries towards antiquarian learning, was very successful, and stimulated a widening interest in Etruscan art. Etruscan museums were established in Italy (at Volterra and at Montepulciano), and by 1744 there was a room in the Vatican of so-called Etruscan vases. *De Etruria Regali* was followed by the volumes of the *Museum Etruscum* (1737–43) by Gori, who provided a very detailed account of all aspects of Etruscan sculpture, tombs, pottery, mirrors and other works, which are amply illustrated in many plates. Caylus in his important *Recueil d'antiquités* from 1752 onwards was concerned with Etruscan art. But Winckelmann gives Etruscan art scant, and unfavourable, attention: this art did not conform to his ideal. His only exception is the so-called 'Etruscan' vases, now recognized as Greek.

The art of ancient Egypt did not conform either. Winckelmann's account of Egyptian art is especially biased and short-sighted in its interpretation,[1] lacking the foresight to appreciate its peculiar beauties as shown in the contemporary writings of Piranesi. Piranesi, in his *Diverse maniere d'adornare i cammini*, published in 1769, included many plates of Egyptian Revival fireplaces of his own design, which were subsequently to be very influential. In his preface, Piranesi interprets Egyptian art in markedly eighteenth-century romantic terms of mystery and awe, but it is nevertheless the first modern evaluation of Egyptian art. About 1760 Piranesi had decorated the walls of the English Coffee-House in the Piazza di Spagna, Rome, with Egyptian architecture and sphinxes, engravings of which he subsequently published in his *Cammini*. Caylus in his *Recueil* had talked with enthusiasm of 'magnitude' and 'immense grandeur' in Egyptian art, but Piranesi's comments show a deeper understanding. In his preface Piranesi asks: 'Is the character of the Egyptian works so hard as it is generally thought to be?'—a question obviously

1. See Texts, pages 106–9.

asked with Winckelmann in mind. 'Is not this accusation the effect of a certain prevention, which many people are in, that in the arts, the Egyptians have had the advantage of inventing, but have not been able to bring them to that perfection to which they were carried by the Greeks?' Piranesi says the usual answer is that Egyptian obelisks are 'stupendous', pyramids 'immense' and ruins 'vast', but that the Egyptians did not produce a statue or bas-relief showing that 'elegance' and 'beautiful proportion' which are supposedly always found in Greek works. Egyptian sculptures are 'hard'. 'But', continues Piranesi in his argument, 'if we reflect a little we should find that we often accuse of hardness what is only a solidity required by the quality of the architecture. The ancients, as well as the moderns, made statues, and images of all that is to be seen in nature, some to be considered in themselves, and others for the embellishment of architecture, and to be attached to buildings: in the first they were exact in imitating nature, and in giving to each the proportion and graces which were proper to them; not so in regard to the second: these were to be subjected to the laws of architecture, and to receive such modifications as it requires. Now these modifications are what many call hardness, and they are brought as proof of the inexperience of the artificers.' Winckelmann does not explain the peculiarities of the Egyptian style in such persuasive, understanding terms. Neither is he able to compare Egyptian with Greek art and see merits in the former, as Piranesi is able to do when writing of two Egyptian lions on a Roman aqueduct, which he compares with two Greek-inspired lions copied from nature. The 'Greek' lions Piranesi finds weak, whereas he writes ecstatically: 'What mastery in the Egyptian ones, what gravity and wisdom! What union, and modification of parts! How artfully are those parts set off which are agreeable to architecture, while those are suppressed which are not advantageous to it!'

Winckelmann did not live to see the completion of the decoration of the Camera dei Papiri in the Vatican by his beloved Mengs, in the early 1770s, with its hieroglyphs and sphinxes, inspired by Piranesi's engravings. Even Mengs was able to reconcile Egyptian art to his form of Neoclassicism, whereas his prime defender found it, to the last, alien. The full impact of Egypt was not to be felt on European art and design, however, until Napoleon's campaign down the Nile.

Napoleon's expedition, an archaeological and scientific venture as well as a military one, was to have a considerable impact on European taste. Although it was a military disaster for France and the archaeological plunder was captured by the British army (with a result that the Rosetta Stone finished up in the British Museum), the campaign itself aroused the European imagination. Baron Denon, who had led the archaeological side of the expedition, produced a permanent record of it in his account, lavishly illustrated (*Voyage dans la Basse et la Haute Egypte*, 1802). Whereas the mid-eighteenth-century Egyptian Revival had been primarily confined to wall decorations, after 1800 the Revival embraces architecture, furniture and other applied arts.

The Egyptian Revival contributed to the increasing eclecticism of the Neoclassical style. Shortly after 1800, Greek, Roman, Etruscan and Egyptian motifs were joined by Indian and Moorish. The plates in Thomas Hope's *Household Furniture* (1807) show this eclecticism clearly. As the most used of Regency design books, its influence was considerable. Architectural motifs seen by the author in Athens supply the decoration of the Picture Gallery; in the Drawing Room a ceiling based on that of a Turkish palace dominates a room hung with paintings of Indian Moorish architecture; most of the chairs, tables and other objects in the house are either Greek, Roman or Egyptian in inspiration. Winckelmann would not only have disapproved of the Egyptian Revival, but also of the stylistic mixture from many, often disparate, sources. As Neoclassicism developed, it became increasingly removed from the 'calm grandeur' of Greece and Rome which determined the Neoclassical style from its origins in the 1750s and 1760s.

III Art, Theory and Morality

THE MOST FAR-REACHING EFFECT of this vast body of classical know-
ledge was to be on teaching in academies of art and on the philosophy of
artistic creation. Winckelmann himself was closely associated with
several academies, being elected an honorary member of one in Rome in
1760, and of the one in Dresden in 1765. The Academy in Copenhagen
published a translation of his *Gedanken* (1763) and the Academy in Vienna
published a posthumous edition of the *Geschichte* (1776).

Reason was the guiding principle of artistic creation in the eighteenth
century before the full impact of Romanticism. Art was controlled by
rules within definable limits. It was against the overriding control of
reason that romantic artists fought: 'I William Blake, A Mental Prince.'
The marginalia that Blake wrote in his copy of Reynolds's *Discourses* is
one of the most revealing documents of the confrontation of Romanticism
with the academic, classical, tradition. When Reynolds speaks of ideal
beauty in his third discourse, Blake notes: 'Knowledge of ideal beauty is
not to be acquired. It is born with us. Innate ideas are in every man, born
with him.'

The inheritance of reason from the previous century was carried further
in the eighteenth century's materialism. Kant, as a man of the Age of
Reason, was able to declare that the astrologers now knew all there was
to know about the skies. The philosophy that knowledge and creation
were totally encompassable, left no room for the unexplained, the mysti-
cal, or the intuitive. In terms of art this tidy, codified world did not find
room in its academies for the irrational, the intuitional element in man's
mind and therefore for the formation of genius—an element that was to
become so important for Romanticism. The Romantic artists broke
through rules; the artist guided by reason accepted them.

Artists of Winckelmann's generation, as in the case of previous ones,
were taught in academies founded on reason. The artist was regarded as
an intellectual, widely and deeply read.[1] Reynolds, who so often sum-
marized current beliefs in his discourses, said in his seventh: 'A painter
stands in need of more knowledge than is to be picked off his palette, or
collected by looking on his model, whether it be in life or picture. He can
never be a great artist, who is grossly illiterate.' The elder Jonathan

1. See Texts, page 83.

Richardson had said earlier, in his *Theory of Painting*, that a history painter 'must be thoroughly informed of all things relating to it', and must know anatomy, osteology, geometry, perspective, architecture and other sciences 'which the historian or poet has little occasion to know'. Reynolds and Richardson were enunciating a principle born at the time of the Renaissance, when Alberti and his contemporaries in the fifteenth century fought for the acceptance of the fine arts among the Liberal Arts. Until then, the Liberal Arts had excluded them, but Alberti wished to prove that the fine arts (notably painting) were as intellectually exacting as, say, rhetoric or mathematics. By so raising the intellectual aspirations of the artist, Alberti hoped to elevate him above the class of craftsmen to a higher social status. The clearest Renaissance example of the success of this campaign can be seen in the life of Michelangelo, called by contemporaries 'divine', because of his intellectual attainments.

Together with this scholarly apparatus, went the conviction that the creation of art was governed by rules. Rules 'are fetters only to men of no genius', Reynolds said in his first discourse. A hierarchy of genres was accepted with history and religious painting at the top, and still-life at the bottom.[1] Artists were expected to aspire to the highest. Even painters whose main strength lay in portraiture attempted history-painting in the Grand Manner, such as Reynolds and Batoni. Still-life is 'the last and lowest degree of painting', said Shaftesbury in his influential essay on the *Judgment of Hercules* (1712). He went on: 'The merely natural must pay homage to the historical or moral', and by moral he meant representation of human passions such as battle-pieces.

As an aid to the supremacy of history-painting, artists invoked a code of rules which included that of 'decorum'. This concept was mainly developed in writings and teaching in seventeenth-century France and Italy. Historical settings and details were to be as accurately represented as antiquarian and historical knowledge permitted. Poussin expressed concern, in a letter, at the time he was painting a *Rest on the Flight into Egypt* that the pyramids and landscapes should be as correctly Egyptian as possible. The eighteenth-century artists of Winckelmann's generation, and especially the Neoclassicists, were just as particular on such points.

1. See Texts, page 75.

Introduction

If victors at the Olympic games are being crowned, or Hector is bidding farewell to Andromache, the painter would introduce in the background the earliest type of Greek architecture known to him, and paint Doric temples. If Hannibal is swearing his oath or Germanicus lies dying, they are surrounded by correctly dressed Romans with accurate costume, armour and sandals, accompanied by archaeologically faithful furniture. Even if the subject-matter in painting or sculpture is not drawn from classical history or mythology, but from medieval times, artists would turn to cathedral tombs, stained glass and seals for accurate information about medieval life and customs.

The central idea in the canon of academic thought concerned beauty and idealization. Winckelmann's whole concept of antique beauty was formulated from this one particular viewpoint, generally accepted in the eighteenth century, and ultimately deriving from classical antiquity.[1] It was argued that perfect beauty did not exist in nature, that in order to create a beautiful contemporary work of art the artist must select different elements which contain beauty, combine them, and thus produce an idealized image more beautiful than nature itself could ever supply. As an aid to this synthesis of an idealized beauty, the artist should have studied the art of Greece and Rome as the best models of the past, where one finds perfect examples of this idealized beauty. This did not mean a servile copying of the antique, as Winckelmann has been misinterpreted as advocating, but creating in the spirit of, and with the understanding of, the ancients in a contemporary idiom.[2]

The philosophy of classical antiquity was hardly concerned with art where it was not—as in the case of Plato—actively hostile to it. But a few passages reveal the existence in Greek and Roman thought of both the concept of 'idea' and of realism. Pliny and Cicero record the famous story of Zeuxis, wishing to paint a picture of Helen (or Venus), selecting five of the most beautiful women of Croton, from whose various beauties he could form his ideal (Plate 19). The sculptor Polycleitus was praised because his rendering of the human figure had a 'grace surpassing truth'. Plato has a passing reference to idealization, and Cicero in his *Orator* refers to an artist's creation of a Zeus or an Athena, saying that the artist

1. See Texts, pages 62, 65–8, 118–23, 133. 2. See Texts, page 61.

32

does not look at a real human being whom he can imitate, but 'in his own mind there lived a sublime notion of beauty'.

The concept of realism was being evolved at the same time, independently. Classical literature contains many references to a curtain painted so illusionistically that it deceives even the artist himself, a painted horse at which real ones neigh, and painted grapes (by the same Zeuxis) that attract birds. A mosaic floor was known as the 'Unswept Room', because the artist (Sosus of Pergamon) had represented in the mosaic refuse from the dinner table and other sweepings, making them appear as if they had been left there. (A Roman copy exists in the Lateran Museum, Rome.) Winckelmann, however, played down this side of the classical philosophy of art, and preferred to concentrate on the ideal.[1] The male and female nude in sculpture is Winckelmann's prime concern. His ideal will not encompass even Hellenistic narrative sculptures of a playful boy with a goose or a wizened old woman.

The parallel concepts of realism and idealization re-emerged during the Renaissance. Leonardo, in whose writings traces of both concepts can be found, was able to assert that 'that painting is most praiseworthy that has most similarity to the thing reproduced'. On the other hand an earlier Renaissance writer, Alberti, said that a painter should 'not only render a true likeness but also add beauty. . . . Demetrius, the ancient painter, failed to gain the highest praise because he strove to make things similar to nature rather than lovely.' The Renaissance artist was expected not only to portray truth to nature, but also to create beauty. 'But in order to lose time and effort, one should avoid the custom of some fools who, boasting their own talent, seek to win a painter's fame by their own resources alone, completely without a natural model which they would follow with eye and mind' (Alberti).

The most famous Renaissance example of idealization is the letter that Raphael wrote to Castiglione, author of *The Courtier*, in 1516, in which he says that the perfect image comes from 'a certain idea that comes into my head'. The often quoted sentences, concerning his *Galatea*, read: 'In order to paint a beautiful woman I should have to see many beautiful women, and this under the condition that you were to help me with

1. See Texts, page 32 note 1.

making a choice; but since there are so few beautiful women and so few sound judges, I make use of a certain idea that comes into my head. Whether it has any artistic value I am unable to say; I try very hard just to have it [the idea].'

The concept of idealization as understood by Winckelmann and his contemporaries reached its final formulation in the seventeenth century. In 1607 Federico Zuccari published his *L'Idea de' pittori, scultori ed architetti*, the first book devoted entirely to an analysis of 'idea'. A work of art, he argued, must first be present in the artist's mind; he must have an internal design or idea, which is then externalized as the work of art. The source of the internal design Zuccari finds in God. God 'in order to act externally necessarily looks at and regards the internal design in which he perceives all things that he has made, is making, will make, and can make with a single glance.' Beauty therefore does not merely result from the blending of different aspects of nature, but from an understanding of an internal reflection of God's countenance. The artist, as bearer of an inner image of perfect beauty deriving from God, with which the painter or sculptor improves nature when creating his work of art, is also found in the important *Treatise on the Art of Painting* by Giovanni Paolo Lomazzo (1584).

The most influential treatise on the concept of the 'idea' in the seventeenth century occurs in the Introduction to Giovanni Pietro Bellori's *Lives of Modern Painters, Sculptors and Architects* (1672). It was from this source, rather than any other, that Winckelmann derived his theory of idealization, an indebtedness which he acknowledged after he had published his great *History*, in his additional notes to it.

Bellori and the seventeenth-century classicists believed that art had declined since Raphael, with the exception of the Carracci family, on the one hand because of the distortions and exaggerations of the Mannerists who had forsaken the path of nature, and on the other hand because of those artists who had developed naturalism to an exaggerated extreme, notably Caravaggio and his followers. Bellori was therefore fighting on two different fronts, both of which he hoped to conquer by a systematic art theory that would remedy past artistic sins. Bellori's Introduction to his *Lives* is entitled, 'The Idea of the Painter, Sculptor and Architect, A

Choice of Natural Beauties Superior to Nature.' It had first been delivered as a lecture in 1664, and was to be of prime importance for academic theory throughout Europe.

Although at the beginning of his discussion Bellori adopts the earlier concept of the divine origin of the 'idea' (as in Lomazzo), he soon makes it clear—as he indicates in his title—that his main concern is with visible nature. Bellori's opening sentence reads: 'That high and eternal intellect, the creator of nature, in making his marvellous works by reflecting deeply within himself, established the first forms called 'ideas' so that each species was derived from that first 'idea', and so was formed the admirable web of created things.' A few sentences later Bellori says that the 'idea' is distilled from an observation of nature, not from an inherent or divine quality born within the artist. Bellori therefore develops the Renaissance theories of Alberti, Leonardo and Raphael into a system.

'The noble painters and sculptors,' writes Bellori, 'imitating that first creator, form in their minds also an example of superior beauty and, reflecting on it, improve upon nature until it is without fault of colour or of line. This 'idea', or we might say goddess of painting and sculpture . . . unveils herself to us, and descends upon the marbles and canvases. Originating from nature, she rises upon her origin and becomes herself the original of art; measured by the compass of the intellect, she becomes the measure of the hand; and animated by imagination, she gives life to the image.'

Bellori then goes on to cite many classical precedents, including the familiar one of Zeuxis and his maidens. He quotes Proclus in his commentary on Plato's *Timaeus*, 'if you take a man made by nature, and one made by the art of sculpture, the natural one will be less excellent, because art works more accurately.' Bellori substantiates his case with references to Maximus of Tyre, and to the painter Parrhasius discoursing with Socrates. Phidias is extolled for imitating the 'idea': 'Cicero, speaking of him, affirms that Phidias, when he carved Jupiter and Minerva, did not contemplate any object from which to take the likeness, but considered in his mind a form full of beauty on which he concentrated, and to the likeness of which he directed his mind and hand.' Bellori even goes so far as to propose that the Trojan War could not possibly have begun over an

imperfectly beautiful woman but must have been started over the perfect, idealized beauty of Helen in the form of a plundered statue. Bellori also gives many classical precedents for hostility to naturalism. 'Dionysius was blamed for having painted men like unto us.' 'Pauson and Peiraikos were condemned, mainly for having depicted the worst and vilest, as Caravaggio in our times was too naturalistic; he painted men just as they are.'

The two modern artists favoured by Bellori are Raphael, whose famous letter to Castiglione has been partially quoted, and Guido Reni.[1] Bellori refers to the latter's *St. Michael* (Plate 18), still in Santa Maria della Concezione (Church of the Capuchins), Rome, and quotes Guido's letter about it: 'I would like to have had the brush of an angel, or forms from Paradise, to fashion the Archangel and to see him in Heaven, but I could not ascend that high, and I searched for him in vain on earth. So I looked at the form whose 'idea' I myself established. An 'idea' of ugliness may also be found, but that I leave to the devil to explain, because I flee from it even in thought, nor do I care to keep it in my mind.'

Later in his Introduction, Bellori is explicit about the variety of the 'idea' of beauty. 'We do not, therefore, praise only soft Venus as Paris did among the delights of Mount Ida, nor only acclaim tender Bacchus in the gardens of Nysa, but we also admire quiver-bearing Apollo and the archeress Diana on the strenuous mountain ridges of Maenalos and of Delos.' The painter should also bear in mind, says Bellori, the different types of feelings suitable to different actions, 'the irascible, the timid, the sad, the glad.'

A few paragraphs further on, Bellori recommends the study of antique sculpture (in words that are to be echoed in the following century by many Neoclassicists, taken from the pages of Winckelmann): 'We should now explain that it is necessary to study the most perfect of the antique sculptures, since the antique sculptors, as we have already indicated, use the wonderful 'idea' and therefore can guide us to the improved beauties of nature; we should explain why, for the same reason, it is necessary to direct the eye to the contemplation of other most excellent masters.'

Winckelmann was concerned only with works of art created with a

1. See Texts, pages 61, 74–5, 99, 112, 121, 132.

serious intent. He is only really interested in works of art in public places, not in private houses. Paintings and sculptures were to be frivolous neither in subject-matter nor in treatment; architecture was not to be playful. He was therefore unable to see the merits of the Baroque or Rococo. Yet the Neoclassical art of Winckelmann's day could be light and gay (as in the paintings of Angelica Kauffmann or the decorative interiors of Robert Adam) and it could occasionally even be erotic (as in the work of Vien). Painting and sculpture were dominated by a classical morality, often Stoic; architecture, by the sobriety of antique forms, which became increasingly austere. Art was closely connected with morals. It was more important for a work of art to instruct than to delight the viewer. Instruction was far nobler than pleasure; the satisfaction of the eye ought to give precedence to that of the mind. Aristotle's *Art of Poetry* was one of the prime sources for this concept.

Winckelmann's contemporary in France, the philosopher Diderot, discussed the connection between art and morality on a broad basis, saying that the general goal for all arts should be the instillation of a love of virtue and a hatred of vice. Greuze came closer than any other artist to the realization of Diderot's dogma. Greuze interpreted his contemporary scene of *The Wicked Boy punished* (1778, Louvre, Paris) in a compositional manner similar to his earlier *Septimius Severus reproaching Caracalla* (1769, also Louvre). In each picture a worthless, yet penitent son stands beside the bed of his father—the 'wicked boy' beside a recently dead parent, Caracalla in front of an angry, reprimanding emperor. Art, in the hands of a Greuze, serves a moral, didactic purpose. Unlike Diderot, however, Winckelmann discusses art and moralty in less general terms; he constructs his theory within the context of the antique. Aesthetics and ethics are closely interwoven: for Winckelmann the *Laocoon* is the archetype of Stoic virtue.[1]

The culmination of the association of art and morality was to be seen after Winckelmann's death in the explosive climax of the French Revolution. David's famous canvases between 1784 and 1789 are the supreme combination of the three elements. David shows in the *Oath of the Horatii* (1784–5, Louvre) three brothers swearing allegiance to Rome before

1. See Texts, pages 72–3, 125, 135–6.

going off to battle, an incident not actually recorded in Roman histories, but a subject inspired by Corneille and Voltaire. David turns the theme into a great Neoclassical statement of Republican virtue in ancient Rome. Later the painting was interpreted as foretelling Revolutionary struggles in contemporary France, and the gesture of allegiance was re-enacted at a Republican demonstration in 1794 organized by Robespierre and David. David chose a further moral theme in 1789 in his *Lictors returning to Brutus the Bodies of his Sons* (two versions: Louvre, and Wadsworth Atheneum, Hartford, Conn.). The theme is even more austerely Stoical, the father having condemned his own sons to death because of their rebellion against him. This supreme instance in Roman history of a state's welfare taking precedence over personal emotions had a direct contemporary relevance to the state of politics in France. David was to take an active part in the Revolution, which was to witness a unique fusion—in artistic terms—of painting, morality, politics, and classical history.

The source for Winckelmann's ideas on art and morality was the philosophy of the influential and widely read Shaftesbury. Winckelmann was very familiar with Shaftesbury's writings, notably the *Characteristicks* (1711, revised 1714), and transcribed passages when collecting material for his own books.

Shaftesbury described his aim most succinctly in a letter of 1712: 'My charges turn wholly, as you see, towards the raising of art and the improvement of virtue in the living, and in posterity to come.' In a typical passage he writes:

'Of all other beauties which virtuosos pursue, poets celebrate, musicians sing, and architects or artists, of whatever kind, describe or form; the most delightful, the most engaging and pathetic, is that which is drawn from real life, and from the passions. Nothing affects the heart like that which is purely from itself, and of its own nature; such as the beauty of sentiments, the grace of actions, the turn of characters, and the proportions and features of a human mind. This lesson of philosophy, even a romance, a poem, or a play may teach us; whilst the fabulous author leads us with such pleasure through the labyrinth of the affections, and interests us, whether we will or no, in the passions of his heroes and heroines. . . .

'Let poets, or the men of harmony, deny, if they can, this force of nature, or withstand this moral magic. They, for their parts, carry a double portion of this charm about them. For in the first place, the very passion which inspires them, is itself the love of numbers, decency and proportion; and this too, not in a narrow sense, or after a selfish way (for who of them composes for himself?) but in a friendly social view; for the pleasure and good of others; even down to posterity, and future ages. And in the next place, it is evident in these performers, that their chief theme and subject, that which raises their genius the most, and by which they so effectually move others, is purely manners, and the moral part. For this is the effect, and this the beauty of their art; in vocal measures of syllables, and sounds, to express the harmony and numbers of an inward kind; and represent the beauties of a human soul, by proper foils, and contrarieties, which serve as graces in this limning, and render this music of the passions more powerful and enchanting.'

The chapters devoted to taste in Shaftesbury's *Characteristicks* contain some of his most important passages, which left their mark on many subsequent writings on art, including Winckelmann's. Shaftesbury says that he wishes to 'recommend morals on the same foot, with what in a lower sense is called manners; and to advance philosophy (as harsh a subject as it may appear) on the very foundation of what is called agreeable and polite.' And he wishes to show that 'nothing which is found charming or delightful in the polite world, nothing which is adopted as pleasure, or entertainment, of whatever kind, can any way be accounted for, supported, or established, without the pre-establishedment or supposition of a certain taste. . . . By one of these tastes he [a gentleman] understands how to lay out his garden, model his house, fancy his equipage, appoint his table: By the other he learns of what value these amusements are in life, and of what importance to a man's freedom, happiness, and self-enjoyment. For if he would try effectually to acquire the real science or taste of life; he would certainly discover, that a right mind, and generous affection, had more beauty and charm, than all other symmetries in the world besides. And, that a grain of honesty and native worth, was of more value than all the adventitious ornaments, estates, or preferments; for the sake of which some of the better sort so oft turn knaves:

forsaking their principles, and quitting their honour and freedom, for a mean, timorous, shifting state of gaudy servitude.

'A little better taste (were it a very little) in the affair of life itself, would, if I mistake not, mend the manners, and secure the happiness of some of our noble countrymen.'

A few pages later Shaftesbury makes a direct connection between these principles and the creation of a work of art:

'Thus beauty and truth are plainly joined with the notion of utility and convenience, even in the apprehension of every ingenious artist, the architect, the statuary, or the painter. It is the same in the physician's way. Natural health is the just proportion, truth, and regular course of things, in a constitution. It is the inward beauty of the body. And when the harmony and just measures of the rising pulses, the circulating humours, and the moving airs or spirits are disturbed or lost, deformity enters, and with it, calamity and ruin.

'Should not this (one would imagine) be still the same case, and hold equally as to the mind? Is there nothing there which tends to disturbance and dissolution? Is there no natural tenor, tone or order of the passions or affections? No beauty, or deformity in this moral kind? Or allowing that there really is; must it not, of consequence, in the same manner imply health or sickliness, prosperity or disaster? Will it not be found in this respect, above all: That what is beautiful is harmonious and proportionable; what is harmonious and proportionable, is true; and what is at once both beautiful and true, is, of consequence, agreeable and good?

'Where then is this beauty or harmony to be found? How is this symmetry to be discovered and applied? Is it any other art than that of philosophy, or the study of inward numbers and proportions, which can exhibit this in life? If no other; Who, then, can possibly have a taste of this kind, without being beholden to philosophy? Who can admire the outward beauties, and not recur instantly to the inward, which are the most real and essential, the most naturally affecting, and of the highest pleasure, as well as profit and advantage?'

In his essay on *The Judgment of Hercules* (1712) Shaftesbury gives advice and precise rules to an artist attempting a painting of this subject. The selection of this particular theme is a perfect example of the princi-

ples Shaftesbury had enunciated in the *Characteristicks*, and which merited quotation at length on the previous pages. Hercules is to be painted between the goddesses of Virtue and Pleasure, and he is to be silent because his attention is devoted to the goddesses and because he should give 'that appearance of majesty and superiority becoming the person and character pleading virtue'. Shaftesbury has chosen the moment in the discussion between the gods when Virtue is winning over Pleasure: the only moment, as Shaftesbury puts it, 'which can well serve to express the grand event, or consequent resolution of Hercules, and the choice he actually made of a life full of toil and hardship, under the conduct of virtue, for the deliverance of mankind from tyranny and oppression. And it is to such a piece, or tablature, as represents this issue of the balance, in our pondering hero, that we may justly give the title of the decision or judgment of Hercules.'

Virtue is to have the countenance of Pallas and a pose deriving from ancient medals. 'And in our piece particularly, where the arduous and rocky way of virtue requires to be emphatically represented; the ascending posture of the figure, with one foot advanced, in a sort of climbing action, over the rough and thorny ground, must of necessity, if well executed, create a due effect, and add to the sublime of this ancient poetic work.' Shaftesbury also lays down limitations on a suitable background for such a moral subject picture. He dislikes architecture or 'other studied ornaments of the landscape-kind, in this particular piece of ours; That in reality there being no occasion for these appearances, they would prove a mere incumbrance to the eye, and would of necessity disturb the sight, by diverting it from that which is principal, the history and fact. Whatsoever appears in a historical design, which is not essential to the action, serves only to confound the representation, and perplex the mind. . . .'

Shaftesbury was the most important single English influence on Winckelmann. Others include Alexander Pope and the Richardsons. The famous line of Pope's *Essay on Man*, in which Pope reiterates a well-established concept, was well known to Winckelmann: 'The proper study of mankind is man.'

The idea is repeated in Winckelmann's essay *Instructions for the Connoisseur*: 'The highest object of meditation for man is man, and for

the artist there is none above his own frame.' The senior Richardson's essays, including his *Theory of Painting*, were an important channel for the dissemination of such concepts as that of Decorum: 'History must not be corrupted, and turned into fable, or romance,' he wrote. 'Every person, and thing must be made to sustain its proper character; and not only the story, but the circumstances must be observed, the scene of action, the country, or place, the habits, arms, manners, proportions, and the like, must correspond.'

A further writer to influence Winckelmann calls for attention, namely the French political philosopher Montesquieu. Whilst a young man in Dresden Winckelmann had studied Montesquieu carefully, and from the point of view of Winckelmann's theory, that climate influenced the ancient Greeks,[1] the crucial part of Montesquieu's oeuvre is the famous fourteenth to seventeenth sections of his *Esprit des Lois* (1748), in which he deals with 'Laws in relation to the nature of the climate'. Polybius writing in ancient Greece had said that climate shaped national characteristics. Montesquieu, and subsequently Winckelmann, developed the argument much further. Montesquieu uses, as one of his explanations for different characteristics of governments, the variations in climate and their effect on human characteristics and thought, and consequently on political structures, and different types of slavery. His theory however, in the hands of Winckelmann, was to be adapted to the realm of art history, and used as a means of explaining the human characteristics and thought of the ancient Greeks and consequently their superiority. Montesquieu had argued that:

'Cold air constringes the extremities of the external fibres of the body; this increases their elasticity, and favours the return of the blood from the extreme parts to the heart. It contracts those very fibres; consequently it increases also their force. On the contrary, warm air relaxes and lengthens the extremes of the fibres; of course it diminishes their force and elasticity.

'People are, therefore, more vigorous in cold climates.' A couple of pages later Montesquieu is saying that 'in cold climates they have very little sensibility for pleasure; in temperate countries they have more; in

1. See Texts, pages 61–2, 107–8, 113–16.

warm countries their sensibilities are exquisite. . . . You must flay a Muscovite alive to make him feel.'

Kant was going to carry further the belief that climate and geographical factors influenced human development, and Kant in his turn influenced Herder. Herder, in his *Ideas towards a philosophy of the History of Man* (1784–91), writes:

'As a mineral water derives its component parts, its operative powers, and its flavour, from the soil through which it flows; so the ancient character of nations arose from the family features, the climate, the way of life and education, the early actions and employments, that were peculiar to them.' And elsewhere he writes: 'The cultivation of Greece grew with time, place and circumstances, and declined with them.'

Together with concepts of 'idea', of Decorum and of morality went a distaste for Baroque painting, sculpture and architecture and the 'debased' naturalism of Dutch seventeenth-century still-life and genre scenes. As Bellori had written when discussing the 'idea' in architecture, when dismissing Baroque forms: 'they madly deform buildings and even towns and monuments with angles, breaks and distortions of lines; they tear apart bases, capitals, and columns by the introduction of bric-à-brac stucco, scraps, and disproportions; in spite of the fact that Vitruvius condemns similar novelties and puts before us the best examples.' Richardson in his *Theory of Painting* only grudgingly accepted seventeenth-century Dutch genre and other painting:

'There is some degree of merit in a picture where nature is exactly copied, though in a low subject; such as drolls, country-wakes, flowers, landscapes, etc. and more in proportion as the subject rises, or the end of the picture is this exact representation. Herein the Dutch, and Flemish masters have been equal to the Italians, if not superior to them in general. What gives the Italians, and their masters the ancients the preference, is, that they have not servilely followed common nature, but raised, and improved, or at least have always made the best choice of it. This gives a dignity to a low subject.'

Winckelmann's assessment of seventeenth- and eighteenth-century art conforms to these beliefs.[1] He rarely discusses modern art at length, but

1. See Texts, pages 66–7, 73–5, 82–3, 87–8, 99–102, 126–8.

his preferences are clear, if not entirely consistent. In his essay on *Grace*, he defines this quality as 'a general idea: for whatever reasonably pleases in things and actions is gracious', perfect when 'most simple, when freest from finery, constraint and affected wit.' Winckelmann praises Correggio but dislikes Michelangelo. Michelangelo was 'blind' to grace. Bernini is often attacked by Winckelmann, especially for his use of 'heavy garments', which conceal the grace and contour of the human figure (Plate 24). Bernini was encouraged by the 'dastardly taste' of his age. 'Grace had never visited him even in dreams.' Winckelmann inherited his dislike of Bernini from earlier writers, such as the Richardsons, who are hostile to Bernini's work, especially in their guidebook, *Account*. Winckelmann had read Baldinucci's famous seventeenth-century life of Bernini, and was completely antipathetic to an interpretation that saw him as 'not only great but extraordinary', as Baldinucci had written. The biographer had asserted: 'To be ranked with the most splendid and renowned masters of antiquity and of modern times, he lacked little from fortune save the age.' Baldinucci praises Bernini for the 'facility and boldness' with which he 'manipulated marble', giving a 'marvellous softness' to his works, especially to his skilful drapery. Baldinucci reports Bernini's hostility to the concept of 'idea', so central to academic theory and to Winckelmann: 'Bernini wanted his students to love that which was most beautiful in nature.'

Rather unexpectedly Winckelmann admired Rubens, but so had the Richardsons before him: 'Rubens, enabled by the inexhaustible fertility of his genius, to pour forth fictions like Homer himself, displays his riches even to prodigality: like him he loved the marvellous, as well in thought and grandeur of conception, as in composition, and chiaroscuro' (*Answer to Objections to Imitation*). Winckelmann also approves in the same essay of Le Brun, primarily because of his successful use of allegory in his famous ceiling depicting Louis XIV as supreme sovereign in Europe in the Galerie des Glaces at Versailles. Winckelmann was also prepared to make an exception of Duquesnoy's sculptures of children, but only for special reasons: 'For, lustiness and full health being the common burden of the praises of children, whose instant forms are not strictly susceptible of that beauty, which belongs to the steadiness of riper years' (*Answer to Objections to Imitation*).

Winckelmann held a particularly blinkered view of contemporary art, to which the only real exception was his praise of Mengs. 'Most Moderns,' he wrote in his *Instructions for the Connoisseur*, 'like tradesmen in distress, hang out all their wares at once.' In his reply to his own anonymous attack on the *Gedanken* he went so far as to say: 'If the modern artists, with regard to forms and beauty, are not to be directed by antiquity, there is no authority left to influence them. Some, in painting Venus, would give her a Frenchified air.' He disliked a sculpture of a Venus by the contemporary French artist Pigalle because she seemed to 'gasp for breath'.

As soon as he arrived in Rome, Winckelmann had sought out Mengs, who was the son of the Dresden Court Painter and already had an established reputation. Winckelmann thought so highly of him that he dedicated his *History* to him.[1] Both men had similar tastes, and both wrote in ecstatic terms on the art of the Greeks (Mengs in his *Gedanken über die Schönheit und den Geschmack in der Mahlerei*, 1762). They were even going to write a joint book on the taste of the Greeks, but it remained unpublished. But Mengs was more eclectic than Winckelmann, and his aesthetics more abstract. He did not praise the ancients at the expense of the moderns, as did Winckelmann. Frequent conversations and mutual admiration stimulated the connection between the two men. As an artist, Mengs was one of the forerunners of Neoclassicism, but recent researches have shown him to have been a less potent force than used to be assumed.[2]

Mengs's early paintings represent a continuation of the Baroque tradition, and a familiarity with the elegance of Rococo. The increased impact of the antique coincides with Winckelmann's arrival in Rome. His first works executed in Rome include pastels of *Vanity* and *Wisdom*, influenced by the antique, for which the iconography and prototypes may have been suggested by Winckelmann. The pastels (now lost, but known from preparatory studies in the Staatliche Kunsthalle, Karlsruhe) were finished in 1756, the year after Winckelmann arrived in Rome. Winckelmann

1. See Texts, page 106.
2. The principal recent research on Mengs has been carried out by T. O. Pelzel, Ph.D. dissertation, Princeton 1968, *Anton Raphael Mengs and Neoclassicism*, unpublished, to which I am indebted for some of my Mengs comments.

praised these works highly in letters at the time saying that they even rivalled ancient art itself. Judging from the surviving studies, however, the *Vanity* and *Wisdom* were not Neoclassical in the true sense, but rather Rococo.

It was not until after 1760 that Mengs produced more truly Neoclassical works in both style and subject-matter, at the same time that Winckelmann was praising for his 'Greek forms' another important forerunner of the style, in some ways more important than Mengs himself—the Scotsman Gavin Hamilton, important as painter, archaeologist and dealer. In 1761 Hamilton completed his large canvas of *Andromache bewailing the death of Hector* (lost, but known from Cunego engraving, 1764)(Plate 23), one of the very few modern works praised by Winckelmann, apart from those of Mengs.[1]

At the same time, Mengs was working on his first really Neoclassical paintings, two versions of *Augustus and Cleopatra*, the first finished in 1760 and still at Stourhead, for which it was commissioned, and the second, more austere in style and with direct borrowings from the newly discovered paintings at Herculaneum, completed about a year later (now in Galerie Graf Czernin, Vienna).

Mengs's most important and famous commission was the ceiling devoted to the theme of *Parnassus* in the Villa Albani, completed in 1761 (Plate 17). Mengs lived in the villa during the time that he was working on the ceiling. At the same time Winckelmann was living there too, but he never claimed to have helped Mengs with the iconography of the *Parnassus*, which alludes to Albani himself as Apollo-protector of the arts. With only one figure, that of Mnemosyne, Winckelmann may have given help, because of its esoteric iconography. Like the second version of the *Cleopatra*, Mengs borrows compositional motifs from Herculaneum, but altered, or (as he would have said in eighteenth-century terms) 'improved' them. The alterations could have come about because Winckelmann thought the Herculaneum frescoes degenerate and not in the best Greek taste. A further possible Winckelmann influence on the *Parnassus* is to be found in the concept of space: Mengs abandoned Baroque illusionism (which he employed earlier in his life for ceiling decoration), and

1. See Texts, page 93.

painted the central ceiling panel (but not the two flanking, smaller allegorical panels) as if seen at eye-level. Raphael had previously done the same in his *Wedding of Cupid and Psyche* in the Palazzo della Farnesina, Rome. Winckelmann could also have influenced Mengs's great emphasis in his *Parnassus* on undulating contour. He may also have influenced the composition of the central group, which fits into an ellipse, a form which Winckelmann preferred. The final composition and style of the *Parnassus*, however, remains essentially Mengs's own individual work, and one of the major paintings in eighteenth-century Neoclassicism.

In the reverse direction, Mengs could have influenced Winckelmann. It is possible that the Neoplatonic aspects of Winckelmann's discussion of beauty, and its derivation from God, could have come from conversations with Mengs. Mengs's concept of beauty was more theoretically based than Winckelmann's more empirical outlook.

IV Romanticism

As DEFENDER of the classical tradition and a prime influence on the Neo-classical movement, Winckelmann's stance could be interpreted as that of an arch-enemy of Romanticism. In relation to certain fundamental Romantic concepts Winckelmann was indeed in the opposing camp, especially in his attitude to the irrational or the fantastic, and to the belief in original genius. But there are unmistakable Romantic traits in certain aspects of Winckelmann's writings, ranging from a mere sentence to extended passages. An injunction to 'Sketch with fire, and execute with phlegm'—in his *Instructions for the Connoisseur*—indicates Winckelmann's Romanticism. He is particularly Romantic in the subjectivity of his descriptions.

Shaftesbury and the whole body of academic theory before him were hostile to elements of the irrational. Winckelmann accepted this tradition. For him, and his interpretation of art both past and present, the irrational had no valid place in an artistic hierarchy. The gradually increasing interest in irrational elements in the course of the eighteenth century passed Winckelmann by: the growth of the occult; the Masonic movement; mysticism, especially Swedenborgianism; and the eruption of fantasy into literature and art ('Gothick' novels, for example). The irrational was slowly emerging in the Age of Reason itself, to burst forth as one of the many contributory, and diffuse, factors of Romanticism. William Blake was going to pillory Newton and Locke as defenders of reason.

For the eighteenth century, and above all for Winckelmann, the supreme accomplishment of ancient Greece, in its art and thought, was that of noble simplicity and calm grandeur. Such was Winckelmann's influence that when a contemporary German, the writer Wieland, finds fault with one of Euripides' plays, he does so because Admetus (in *Alcestis*) 'wakes from his dazed state and pours out his grief in expressions of despair. This is not a passion which may properly be displayed before our eyes—the Law of the Beautiful is a basic law for all the fine arts, and one which admits no exception; and how could raving despair be depicted beautifully?' Later writers, notably Nietzsche, would not have agreed. But the tortured, Dionysiac aspect of Greek art and literature hardly found a place in the canon of the eighteenth century[1] (although it was not entirely excluded, it was very exceptional). The *Laocoon* is not

1. See Texts, page 12 note 1.

praised for any Dionysiac quality, but as a supreme instance of Stoicism. The first writer to appreciate properly the Dionysiac element in Sophoclean drama was Friedrich Schlegel.

Imitation, so strongly advocated as a concept by Winckelmann, was to become anathema to the Romantics. Although he did not mean slavish copying, but rather creating in the Greek spirit, this was none the less an attitude towards artistic creation opposed to that of Edward Young and J. G. Hamann. The Englishman and the German published important treatises in the early development of Romanticism at the very time that Winckelmann was publishing his—the former his *Conjectures on Original Composition* (1759) and the latter his *Aesthetica in Nuce* (1762). The Romantics coined the slogan of original genius, heralded in the *Conjectures*: 'An original may be said to be of a vegetable nature; it rises spontaneously from the vital root of genius. . . . The first ancients had no merit in being originals: they could not be imitators. Modern writers have a choice to make; and therefore have a merit in their power. They may soar in the regions of liberty, or move in the soft fetters of imitation. . . . Rules, like crutches, are a needful aid to the lame, though an impediment to the strong.'

Hamann was just as dogmatic in his *Aesthetica*, the only *Sturm und Drang* treatise on beauty (an interpretation of poetry in the Hebrew tradition). He wished to sweep away rationalist aesthetics of the past: 'Not a lyre! not a brush! but a shovel for my muse, to sweep the threshing floor of sacred literature!' Winckelmann would never have dreamt of the possibility of such a drastic renewal.

Towards the end of his great *History* Winckelmann was able to write: 'I have already overstepped the boundaries of the history of art, and in meditating upon its downfall have felt almost like the historian who, in narrating the history of his native land, is compelled to allude to its destruction, of which he was a witness. Still I could not refrain from searching into the fate of works of art as far as my eye could reach; just as a maiden, standing on the shore of the ocean, follows with tearful eyes her departing lover with no hope of ever seeing him again, and fancies that in the distant sail she sees the image of her beloved.'[1] Whilst thus

1. See Texts, page 144.

Romantically, nostalgically looking for a boat on the horizon, Winckelmann had written passages, both in the *History* and elsewhere, which are amongst the finest examples of subjective criticism in the eighteenth century. The subjectivity with which he interprets the *Apollo Belvedere* (Plate 9) and the *Laocoon* (Plate 10), bringing them to life before the reader's eyes, are far removed from a canon of rationality.[1] If Winckelmann's passages on such famous statues are put beside other descriptions, his subjectivity is particularly noticeable. The *Apollo*, ever since its display in Rome from the late fifteenth century onwards, had been one of the half-dozen most frequently drawn and described ancient statues. But never had it been described with the passion of Winckelmann: he composed enthusiastic word pictures. In the much used guidebook by the Richardsons, their famous *Account of some of the Statues* . . . (1722), the repairs and damage to the *Apollo* are first recounted, references given to its reproduction in several earlier publications, and then follows one evaluative sentence only: 'He has just discharged his arrow at the python, and has an air, particularly in the head, exquisitely great, and awful, as well as beautiful' (Plate 13). Winckelmann's passages do not belong to the Age of Reason but to the Romantic movement. His descriptions give full rein to the imagination, especially facial expressions. Laocoon, according to Winckelmann, expresses a range and depth of feelings in his eyes which only the writer himself can really detect (Plate 14). With Winckelmann's writings as a guidebook, some subsequent travellers have recorded their disappointment that the antique statues are not as fine as Winckelmann's descriptions led them to expect. Winckelmann's subjectivity comes at the beginning of a century or more of similar writing, which was to include the magnificent prose-poem on the *Mona Lisa* by Walter Pater (1869). It is perhaps significant in this context that Pater, in his essay on Winckelmann, quotes Hegel: 'Winckelmann, by contemplation of the ideal works of the ancients, received a sort of inspiration, through which he opened a new sense for the study of art. He is to be regarded as one of those who, in the sphere of art, have known how to initiate a new organ for the human spirit.'

Winckelmann did not see a fundamental contradiction in his own

1. See Texts, pages 139–40 and 135–6 for longest passages.

theory. The conviction that climate and local geographical characteristics determined a nation's development, and therefore its art, undermined the universal applicability of one, supreme concept of beauty. Montesquieu and Winckelmann, followed by Kant and Herder, dealt a death blow to the timeless beauty of ancient Greece. If Greek art and its greatness in the fifth century B.C. had been made possible by the whole of Greek civilization, its total unity—its politics, its drama, and its art together with its climate—how could a study of Greek art help to make the art of contemporary Europe great if such cultural conditions were no longer operative there? What existed in the Greece of Pericles did not and could not exist in the Europe of Louis XVI and Frederick the Great. Winckelmann's belief in the totality of a culture brings him close—although he would have been surprised at the closeness—to the theories of Herder and the Romantic beginnings of historicism. Herder argued, in his *Ideas towards a philosophy of the History of Man*, that any work of literature or art could only be understood in the context of its own civilization, without which one is unaware of the formative influences that made possible the creation of that work. Winckelmann is interested in the thought and life of ancient Greece, but in his final analysis of Greek art he distils its essence into a series of abstract phrases which he hopes will be applicable to the present. Herder, however, and the subsequent Romantic development of historicism, went further than Winckelmann. They argued that culture grows out of the roots and surroundings of a people, and that these circumstances for each people—whether ancient Greeks or Babylonians or Chinese—are different. As the circumstances of one people are not applicable to another, concepts of one culture are not valid for another. Winckelmann's Periclean Athens is therefore not timeless in its applicability. And unlike Winckelmann, Herder and his successors were able to look at many different cultures and find self-justifying merit in them, including the medieval (which Winckelmann ignored). Herder and the Romantic evolutionists undermined the timeless academic concepts for which Winckelmann and the classicists stood. At the same time they produced a valid philosophy to vitiate—in theory—the classical, and any other revival (Gothic or Indian, for instance) of the eighteenth century in the arts. The philosophy only remained in theory, however, since Herder's

influence—perhaps fortunately—was negligible on the progress of the visual arts themselves. To Herder's eyes the *Oath of the Horatii* would have been meaningless.

Although Winckelmann has little to say on primitive life, beyond a comparison of Homer's heroes with swift-footed Red Indians,[1] he influenced other writers' interpretations of the primitive. Johann Georg Forster, who sailed with Captain Cook on his third voyage, recorded his impressions in his *Voyage round the World* (1777), in which several passages on the Tahitians reflect Winckelmann's writings on the Greeks. Because of their climate and healthy diet the Tahitians have a strength and elegance of form, and are so well-proportioned that 'some would have been selected by Phidias or Praxiteles as models of masculine beauty'. The drapery of the women's clothing is almost like that of ancient Greeks 'much more advantageous to the human figure than any modern fashion we had hitherto seen'. The Tahitians above all, for Forster, lived a simple way of life, free from cares, happy in their ignorance. With the Greek eyes of Winckelmann, Forster looks on contemporary South Sea island life as a Romantic state of nature, almost a lost golden age.

1. See Texts, page 62.

V Winckelmann as Art Historian

WINCKELMANN'S INTERPRETATION of ancient Greece was not based solely, or even primarily, on his knowledge of its art. He looked at Greek culture as an integral whole, and extracted his general principles of noble simplicity and calm grandeur initially from ancient drama and philosophy, principles which he then found in sculpture. His analysis of Greek cultural unity marks Winckelmann as essentially different from earlier writers on antiquity. The whole of Greek civilization made possible the artistic masterpieces of the fifth century B.C., Winckelmann argued, not merely the artist at work in his studio. As a writer in the Age of Reason, Winckelmann does not see art as an isolated phenomenon, withdrawn or rebelling from society. He would not have approved of the Romantic concept, which was soon to develop, of the 'Bohemian' or artist in his garret, which was to lead to the later nineteenth-century 'art for art's sake'. For Winckelmann, when general conditions are good, art is good; when the one deteriorates, so does the other. Winckelmann helped to lay the foundation for the historical interpretation of the art of a period as the general index of the spirit of the time. This pervasive spirit, or *Zeitgeist*, was to be formulated into a proper philosophy of culture by Hegel, and elaborated in the context of art history by subsequent nineteenth-century writers.

Winckelmann's concept of art history and civilization belongs to the cyclic view of history. By the time Winckelmann was writing, the cyclic interpretation had gained dominance over the alternative, apocalyptic one, which saw history as a decline from an original golden age. The cyclic view analysed history as an evolution from primitivism to sophistication to decline and oblivion. The interpretation stemmed ultimately from Plato's *Laws*. By the mid-eighteenth century the cyclical view had reached the point, in the writings of some historians and philosophers, of omitting the phase of decline: history was seen as an evolution of continual progress. Winckelmann's Scottish contemporary, Adam Ferguson, was typical of his generation when he wrote in his *Essay on the History of Civil Society* (1767): 'Not only the individual advances from infancy to manhood, but the species itself from rudeness to civilization. Hence the supposed departure of mankind from the state of nature; hence our conjectures and different opinions of what man must have been in the first

age of his being. . . . Historical monuments, even of the earliest date, are to be considered as novelties.' Winckelmann did not adopt such an extreme view. Winckelmann saw the greatness of Greece declining under Rome, reviving only at the time of the Renaissance, and declining once again in the seventeenth and early eighteenth centuries, to revive once more—in the work of only a few artists—in his own day.

The importance of Winckelmann as an art historian can only be properly appreciated in the light of subsequent developments in art historical literature. He is one of the writers of the eighteenth and nineteenth centuries who has been called the 'father of art history', a title to which there are rival claimants, including Kugler and Burckhardt. Vasari in his famous *Lives* had been the father of the history of artists, not of the history of art. In the sense that modern art historians are concerned with succeeding styles of art, Winckelmann must be credited with establishing the term 'style' in its modern sense largely through his *History*. Writers in the sixteenth and seventeenth centuries had been moving towards the use of 'style', but it only really emerges with Winckelmann. Winckelmann defined characteristics of each civilization of ancient art and each period within that civilization, and used these stylistic variations to discuss different periods and evaluate their development. His characteristics of style were extracted not only from works of art, but from social conditions, religion, customs and climate. As E. H. Gombrich points out in his article on 'Style' in the *International Encyclopaedia of the Social Sciences* (1968), it was Winckelmann's treatment of Greek style as an expression of the Greek way of life which encouraged Herder and other writers to do the same for the medieval period, thus firmly establishing art history in terms of succeeding period styles.

This development of style, in the post-Winckelmann sense, is to be found in the writings of Franz Kugler, who was appointed to the Professorship of History of Art at the Berlin Academy of Art in 1833. His *Handbook of the History of Painting from Constantine to the Present Day* (1837) and his *Handbook of the History of Art* (1841–2) are still worth reading. The titles of some of his chapters reveal Kugler's new approach, such as 'The Monumental Taste of Italian Architecture', and 'Treatment of Form in the Early Renaissance'. Kugler's books have largely fallen into

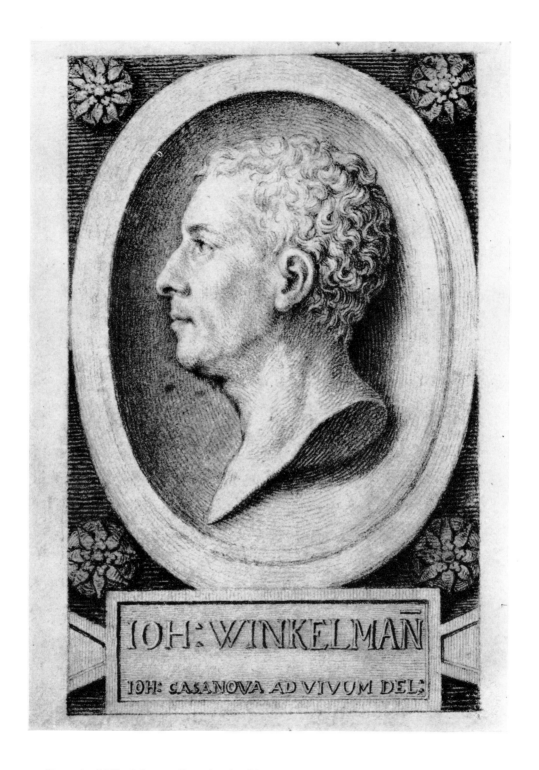

1. *Portrait of Winckelmann*. Drawing by Giovanni Battista Casanova, 1764. Leipzig, Museum der Bildenden Künste. The portrait is conceived as an antique gem.

2. *Imaginary tomb of Winckelmann*. Frontispiece from d'Hancarville, *Antiquities from the Cabinet of Sir William Hamilton*, vol. II, dated 1767, but actually published 1768, the year of Winckelmann's murder. The tomb is based on ancient Roman sarcophagi and architecture.

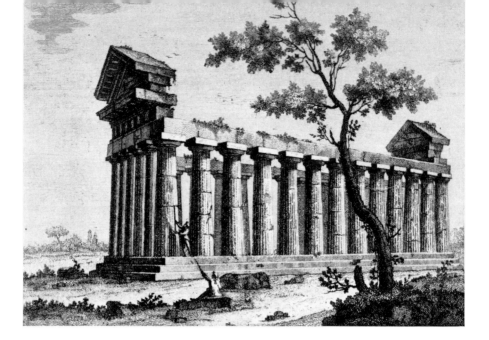

3. *Temple of Concord, Agrigento.* Engraving from the Italian edition of 1783–4 of Winckelmann, *Geschichte der Kunst des Alterthums* and other essays. One of the few works of classical architecture about which Winckelmann wrote.

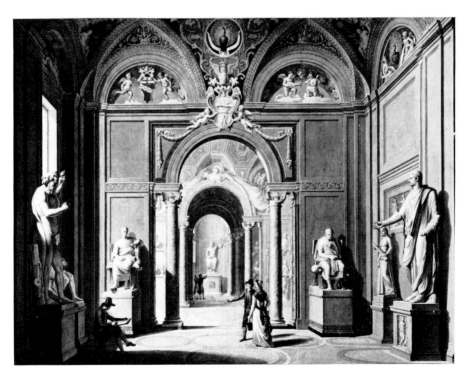

4. *Vatican Sculpture Galleries.* Drawing by Vincenzo Feoli. Vienna, Albertina. The galleries as they looked in Winckelmann's lifetime, before the building of the present galleries later in the eighteenth century.

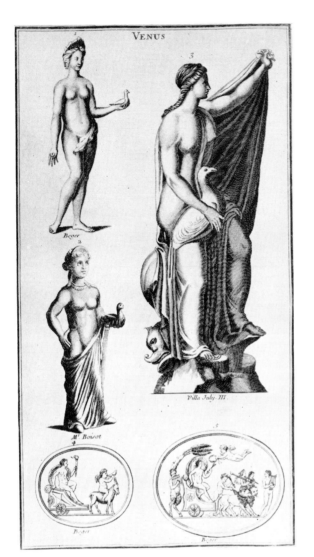

Plates 5–8 illustrate four different
aspects of ancient art chosen from books
and actual examples known to
Winckelmann.

5.
Venus: five versions. Plate from
Montfaucon, *L'Antiquité expliquée*, vol. I,
1719.

6.
*Sarcophagus relief: Birth of Aphrodite,
between Perseus and Athena, and Perseus
freeing Andromeda.* Anonymous drawing
after a relief still in Palazzo Mattei,
Rome, in the Dal Pozzo–Albani volumes.
Windsor Castle, Royal Collection.

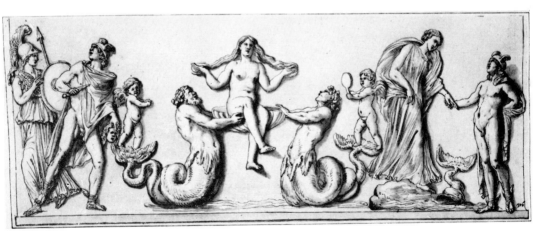

7.
Bacchante: fresco from
Herculaneum. Plate from
Le Pitture Antiche d'Ercolano,
vol. I, 1757.

8.
Relief from Arch of Constantine.
Plate from Bartoli and Bellori,
Admiranda Romanorum
Antiquitatum, 1685.

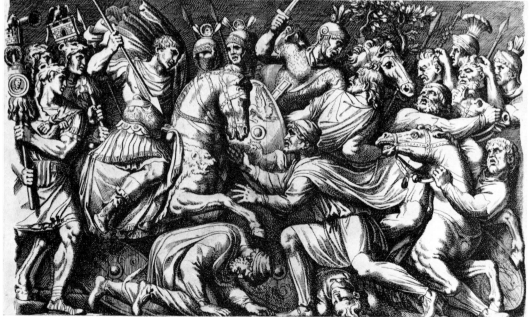

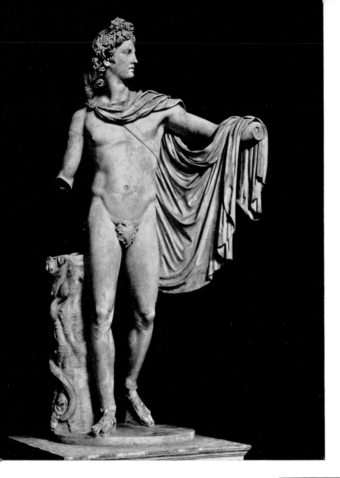

Plates 9–12 illustrate four key works of ancient sculpture in Winckelmann's writings.

9.
Apollo Belvedere, about 350–320 B.C. Roman copy. Vatican Museum.

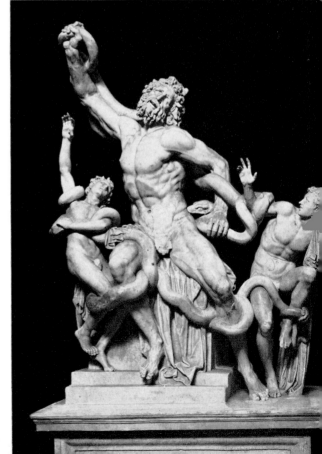

10.
Laocoon, second century B.C.(?). Vatican Museum.

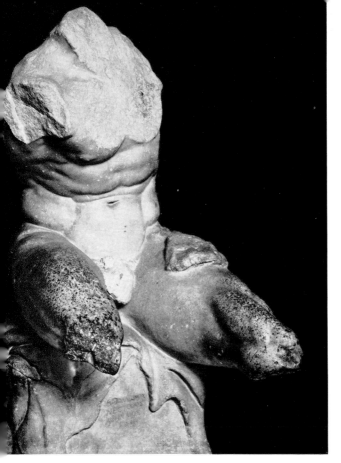

11.
Torso Belvedere, about 150 B.C.
Roman copy. Vatican Museum.

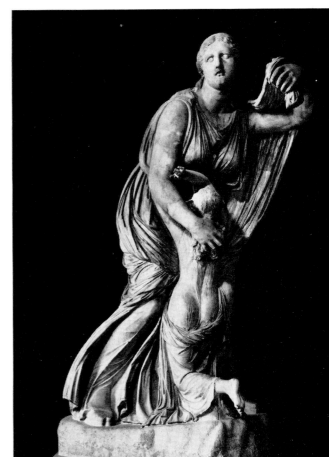

12.
Niobe and daughter, fourth century B.C.(?).
Roman copy. Florence, Uffizi. Part of a
group portraying Niobe and her children.

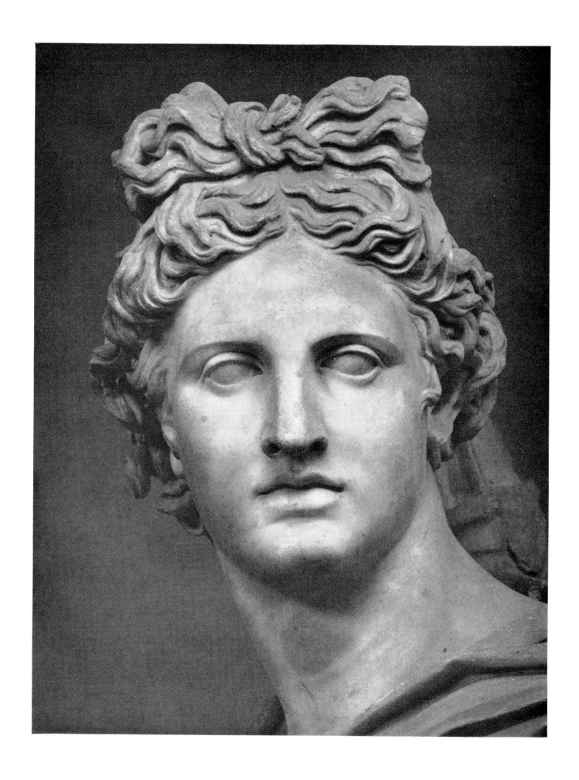

13. *Head of Apollo Belvedere* (compare Plate 9).

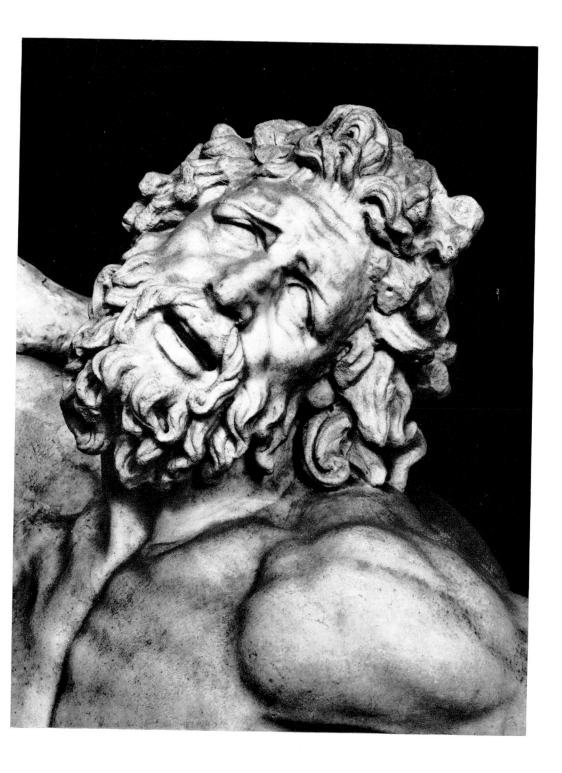

14. *Head of Laocoön* (compare Plate 10).

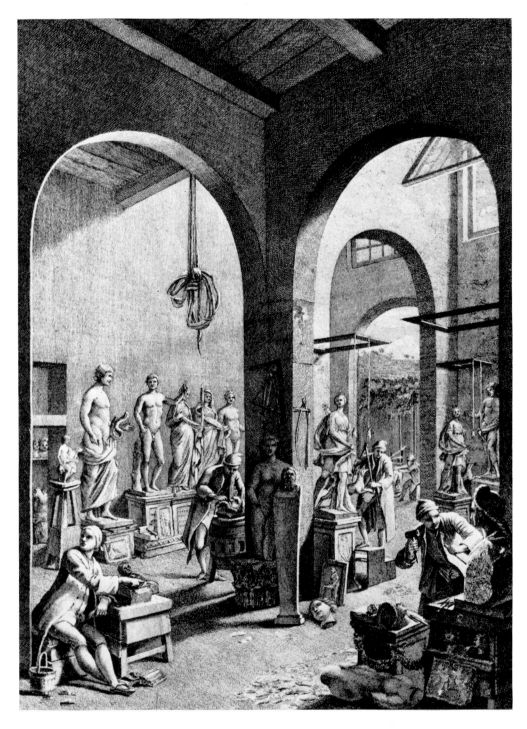

15. *Restoration of antique statues in the studio of Bartolomeo Cavaceppi in Rome.* Plate from Cavaceppi, *Raccolta d'antiche statue,* 1768. A good example of a contemporary restorer's studio, that of Winckelmann's friend.

Plates 16 and 17 show two works which reflect Winckelmann's influence at the time that he was working for Cardinal Albani.

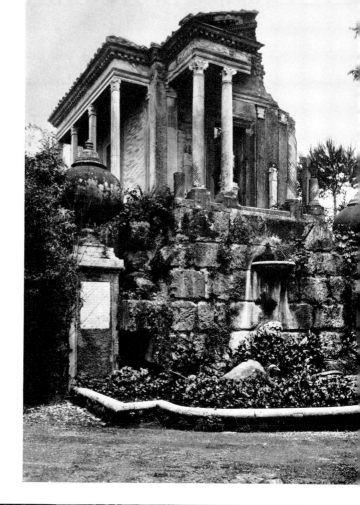

16.
Tempietto Diruto, by Carlo Marchionni, about 1760, an artificial ruin in the grounds of the Villa Albani (now the Villa Torlonia).

17.
Parnassus. Ceiling mural by Anton Raphael Mengs, 1761, in the Villa Albani (Torlonia).

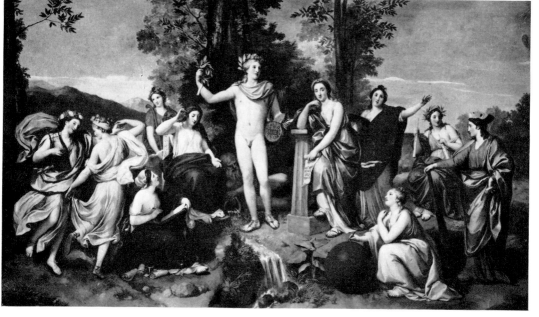

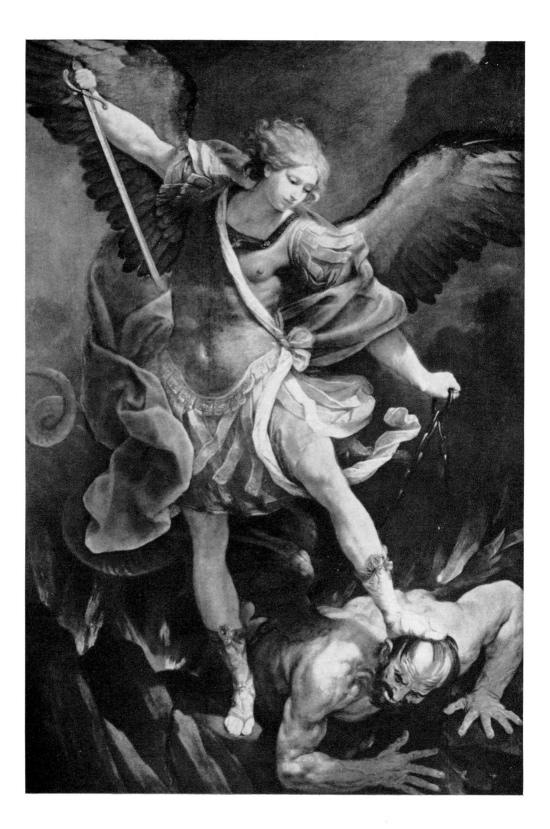

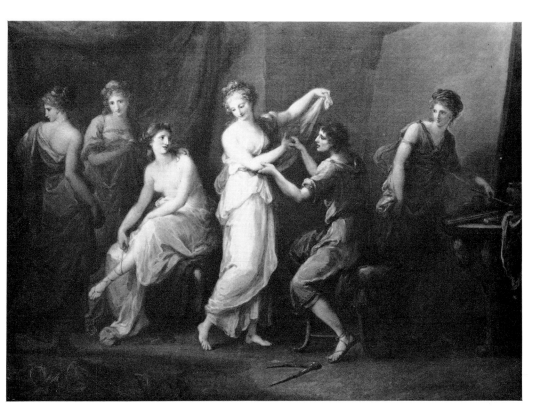

19. *Zeuxis selecting models for his painting of Helen of Troy.* Painting by Angelica Kauffmann. Providence, Rhode Island, Annmary Brown Memorial Museum. A fine representation of Neoclassical painting, and at the same time one of the best eighteenth-century illustrations of the concept of idealization derived from the ancient Roman story about the Greek painter Zeuxis.

18. *St. Michael casting out the Devil.* Painting by Guido Reni, about 1635. Rome, Sta. Maria della Concezione. One of the most famous works by the seventeenth-century artist much admired by Winckelmann.

Two rivals and their different views of the antique: the linear, simplified Winckelmann (*left*) and the deeply, modelled, complex Piranesi.

20.
Greek painted vase, with detail.
Plate from Winckelmann,
Monumenti Antichi Inediti, 1767.

21.
Antique Roman altar restored by Piranesi. Plate from his *Vasi, Candelabri*, 1778.

22.
Medici Venus, side view, measured. Drawing by
Joseph Nollekens, 1770. Walter Brandt
Collection. Representative of many meticulous
studies of antique sculpture made in the
eighteenth century.

23.
Andromache bewailing the death of Hector.
Engraving by Domenico Cunego, 1764, after a
painting, now lost, by Gavin Hamilton, 1761.
An early Neoclassical painting, its style but not
its colour approved by Winckelmann.

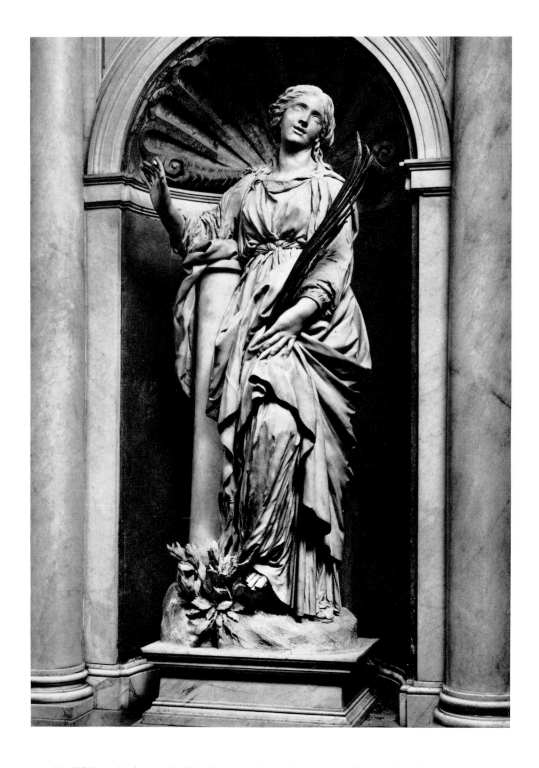

24. *St. Bibiana*. Sculpture by Gianlorenzo Bernini, 1624–61. Rome, Sta. Bibiana. Bernini's work epitomized for Winckelmann all that he disliked of the Baroque.

oblivion, but merit revival. He is not, however, of the stature of either Winckelmann or Burckhardt.

Winckelmann has been pushed more and more into the background as an art historian, overshadowed especially by the first great art historian of culture, Jacob Burckhardt. Burckhardt studied under the well-known historian Ranke, historian of the papacy. Whilst Professor of Art History at Basle University, he published his important *Civilization of the Renaissance in Italy* (1860), which was intended to be one of a series of cultural histories. But the series was never completed, only one other title appearing, on *The Age of Constantine* (1853), in which Burckhardt asks, at the beginning of his discussion on the decline of taste: 'If the developed Greek system of forms could maintain itself for six centuries under all vicissitudes of history and always spring new shoots, why should it lose its power and its creative energy precisely from the age of the Antonines [second century A.D.] downward? Why could it not have lasted into the fourth century? Perhaps an *a priori* answer may emerge from a general philosophic consideration of the period, but it is more prudent not to seek to determine the life span of a spiritual force of such magnitude. Collateral reasons for the phenomenon are clear enough: changes in the material and in the tasks and subjects of art, or indirectly, the changed viewpoint of the purchasers.' Burckhardt's most important study of style was to appear a few years later in 1867, his *History of the Renaissance in Italy*, which was published as the fourth volume of Kugler's *History of Architecture*. His concept of cultural history is even more clearly shown by his sub-headings than Kugler's. In the *Civilization* they include 'The State as a Work of Art', 'The Development of the Individual', 'The Revival of Antiquity', 'The Discovery of the World and of Man', and so on.

The great Heinrich Wölfflin, who succeeded Burckhardt at Basle, was to continue in his predecessor's path, but was to eventually reach the point of formulating a theory that style is independent of a work of art, thus paving the way for the 'significant form' of Clive Bell and Roger Fry. Wölfflin left a permanent mark on the interpretation of art history in his *Renaissance and Baroque* (1888), *Classic Art* (1899) and *Principles of Art History* (1915). In the earliest book he was able to write, in the spirit of the Winckelmann–Burckhardt tradition: 'To explain a style cannot

mean anything but to fit its expressive character into the general history of the period, to prove that its forms do not say anything in their language that is not also said by other organs of the age.'

Interpretations of art history have become increasingly complex since Winckelmann first wrote. The concept of 'will-to-form' coined by Alois Riegl in his *Stilfragen* (1893) finds no place in Winckelmann. Riegl wished to explain why ornamentation changed, not merely as the result of techniques, as was normally argued, but also because of an innate desire for change because each generation sees differently. The will-to-form concept has been quite influential: one can find it, for instance, in Kenneth Clark's *The Nude* (1956).

Another important interpretation of art history to develop since Winckelmann's day is the history of art as the history of ideas (*Kunstgeschichte als Geistesgeschichte*), which is entirely a twentieth-century development, and has given rise as a side issue to the social histories of art, whether Marxist or otherwise. Max Dvořák in Vienna was the key figure in establishing this new concept, notably with his writings on Bruegel and on El Greco. Philosopher-historians at the time were evolving along similar lines, including the famous Max Weber. Lecturing on El Greco in 1920, Dvořák was able to say: 'In the perennial struggle between matter and spirit the scales are now inclining to the side of the spirit. If we have recognized in El Greco a great artist and a prophetic soul we owe it to this momentous change.' Social historians include Arnold Hauser, with his controversial *Social History of Art* (1951), and Frederick Antal, with his penetrating studies of Henry Fuseli (1956) and Hogarth (1962). The whole of this important aspect of art history has emerged long after Winckelmann's death.

The other most significant development in art historical writings in the present century has been in the field of iconography. This is an aspect in which Winckelmann showed some interest. Although iconographic studies were in a very rudimentary state in the eighteenth century, Winckelmann's *Allegorie* is in the tradition of iconographic treatises stemming from Ripa. In his essays on art, and especially in his *History*, Winckelmann took considerable pains to sort out subject-matter on bas-reliefs and other sculptures. Subsequently he has sometimes been proved

wrong, or been insufficiently thorough, but this should not discredit his iconographic interests. As a systematic, scientific study, however, iconography has only emerged in the present century, as the result of the influence of Aby Warburg in Hamburg. Warburg (whose Institute, named after him, now forms part of London University) together with other eminent scholars have produced some very penetrating interpretations of art history. The majority of the important art historians of the older generation in recent years have been German, and often connected at some time in their lives with the Warburg Institute. It is symptomatic of this trend in art history that when E. H. Gombrich gave his inaugural lecture as Durning Lawrence Professor of the History of Art at University College, London, he called his lecture 'Art and Scholarship'. Winckelmann, as the first writer to use the phrase 'history of art' on a title page (of his *History*), would be proud of his descendants.

TEXTS

1 On the Imitation of the Painting and Sculpture of the Greeks [1755]¹

I NATURE

TO THE GREEK CLIMATE we owe the production of taste, and from thence it spread at length over all the politer world. Every invention, communicated by foreigners to that nation, was but the seed of what it became afterwards, changing both its nature and size in a country, chosen, as Plato says,² by Minerva, to be inhabited by the Greeks, as productive of every kind of genius.

But this taste was not only original among the Greeks, but seemed also quite peculiar to their country: it seldom went abroad without loss, and was long ere it imparted its kind influences to more distant climes. It was, doubtless, a stranger to the northern zones, when painting and sculpture, those offsprings of Greece, were despised there to such a degree, that the most valuable pieces of Correggio served only for blinds to the windows of the royal stables at Stockholm.

There is but one way for the moderns to become great, and perhaps unequalled; I mean, by imitating the ancients. And what we are told of Homer, that whoever understands him well, admires him, we find no less true in matters concerning the ancient, especially the Greek arts. But then we must be as familiar with them as with a friend, to find *Laocoon* as inimitable as Homer. By such intimacy our judgment will be that of Nicomachus: Take these eyes, replied he to some paltry critic, censuring the Helen of Zeuxis, Take my eyes, and she will appear a goddess.

With such eyes Michelangelo, Raphael, and Poussin, considered the performances of the ancients. They imbibed taste at its source; and Raphael particularly in its native country. We know, that he sent young artists to Greece, to copy there, for his use, the remains of antiquity.

An ancient Roman statue, compared to a Greek one, will generally appear like Virgil's Diana amidst her Oreads, in comparison of the Nausicaa of Homer, whom he imitated.

Laocoon was the standard of the Roman artists, as well as ours; and the rules of Polycletus became the rules of art.

I need not put the reader in mind of the negligences to be met with in the most celebrated ancient performances: the Dolphin at the feet of the Medici *Venus*, with the children, being commonly known. The reverse

61

of the best Egyptian and Syrian coins seldom equals the head, in point of workmanship. Great artists are wisely negligent, and even their errors instruct. Behold their works as Lucian bids you behold the Zeus of Phidias; Zeus himself, not his footstool.

It is not only nature which the votaries of the Greeks find in their works, but still more, something superior to nature; ideal beauties, brain-born images, as Proclus says.[3]

The most beautiful body of ours would perhaps be as much inferior to the most beautiful Greek one, as Iphicles was to his brother Hercules. The forms of the Greeks, prepared to beauty, by the influence of the mildest and purest sky, became perfectly elegant by their early exercises. Take a Spartan youth, sprung from heroes, undistorted by swaddling-cloths; whose bed, from his seventh year, was the earth, familiar with wrestling and swimming from his infancy; and compare him with one of our young Sybarites, and then decide which of the two would be deemed worthy, by an artist, to serve for the model of a Theseus, an Achilles, or even a Bacchus. The latter would produce a Theseus fed on roses, the former a Theseus fed on flesh, to borrow the expression of Euphranor.[4]

The grand games were always a very strong incentive for every Greek youth to exercise himself. Whoever aspired to the honours of these was obliged, by the laws, to submit to a trial of ten months at Elis, the general rendezvous; and there the first rewards were commonly won by youths as Pindar tells us.[5] To be like the God-like Diagoras, was the fondest wish of every youth.

Behold the swift Indian outstripping in pursuit the hart: how briskly his juices circulate! how flexible, how elastic his nerves and muscles! how easy his whole frame! Thus Homer draws his heroes, and his Achilles he eminently marks for being swift of foot.

By these exercises the bodies of the Greeks got the great and manly contour observed in their statues, without any bloated corpulency. The young Spartans were bound to appear every tenth day naked before the ephors,[6] who, when they perceived any inclinable to fatness, ordered them a scantier diet; nay, it was one of Pythagoras's precepts, to beware of growing too corpulent; and, perhaps for the same reason, youths

aspiring to wrestling-games were, in the remoter ages of Greece, during their trial, confined to a milk diet.

They were particularly cautious in avoiding every deforming custom; and Alcibiades, when a boy, refusing to learn to play on the flute, for fear of its discomposing his features, was followed by all the youth of Athens.

In their dress they were professed followers of nature. No modern stiffening habit, no squeezing stays hindered nature from forming easy beauty; the fair knew no anxiety about their attire.

We know what pains they took to have handsome children, but want to be acquainted with their methods: for certainly Quillet, in his *Callipaedia*,[7] falls short of their numerous expedients. They even attempted changing blue eyes to black ones, and games of beauty were exhibited at Elis, the rewards consisting of arms consecrated to the temple of Minerva. How could they miss of competent and learned judges, when, as Aristotle tells us,[8] the Greek youths were taught drawing expressly for that purpose? From their fine complexion, which, though mingled with a vast deal of foreign blood, is still preserved in most of the Greek islands, and from the still enticing beauty of the fair sex, especially at Chios; we may easily form an idea of the beauty of the former inhabitants, who boasted of being aborigines, nay, more ancient than the moon.

And are not there several modern nations, among whom beauty is too common to give any title to pre-eminence? Such are unanimously accounted the Georgians and the Kabardines in the Crimea.

Those diseases which are destructive of beauty, were moreover unknown to the Greeks. There is not the least hint of the small-pox, in the writings of their physicians; and Homer, whose portraits are always so truly drawn, mentions not one pitted face. Venereal plagues, and their daughter the English malady[9] had not yet names.

And must we not then, considering every advantage which nature bestows, or art teaches, for forming, preserving, and improving beauty, enjoyed and applied by the Greeks; must we not then confess, there is the strongest probability that the beauty of their persons excelled all we can have an idea of?

Art claims liberty: in vain would nature produce her noblest offsprings,

in a country where rigid laws would choke her progressive growth, as in Egypt, that pretended parent of sciences and arts: but in Greece, where, from their earliest youth, the happy inhabitants were devoted to mirth and pleasure, where narrow-spirited formality never restrained the liberty of manners, the artist enjoyed nature without a veil.

The gymnasia, where, sheltered by public modesty, the youths exercised themselves naked, were the schools of art. These the philosopher frequented, as well as the artist. Socrates for the instruction of a Charmides, Autolycus, Lysis; Phidias for the improvement of his art by their beauty. Here he studied the elasticity of the muscles, the ever varying motions of the frame, the outlines of fair forms, or the contour left by the young wrestler on the sand. Here beautiful nakedness appeared with such a liveliness of expression, such truth and variety of situations, such a noble air of the body, as it would be ridiculous to look for in any hired model of our academies.

Truth springs from the feelings of the heart. What shadow of it therefore can the modern artist hope for, by relying upon a vile model, whose soul is either too base to feel, or too stupid to express the passions, the sentiment his object claims? unhappy he! if experience and fancy fail him.

The beginning of many of Plato's dialogues, supposed to have been held in the gymnasia, cannot raise our admiration of the generous souls of the Athenian youth, without giving us, at the same time, a strong presumption of a suitable nobleness in their outward carriage and bodily exercises.

The fairest youths danced undressed on the theatre; and Sophocles, the great Sophocles, when young, was the first who dared to entertain his fellow-citizens in this manner. Phryne went to bathe at the Eleusinian games, exposed to the eyes of all Greece, and rising from the water became the model of Venus Anadyomene. During certain solemnities the young Spartan maidens danced naked before the young men: strange this may seem, but will appear more probable, when we consider that the christians of the primitive church, both men and women, were dipped together in the same font.

Then every solemnity, every festival, afforded the artist opportunity to familiarize himself with all the beauties of Nature.

In the most happy times of their freedom, the humanity of the Greeks abhorred bloody games, which even in the Ionic Asia had ceased long before, if, as some guess, they had once been usual there. Antiochus Epiphanes, by ordering shows of Roman gladiators, first presented them with such unhappy victims; and custom and time, weakening the pangs of sympathizing humanity, changed even these games into schools of art. There Ctesias studied his dying gladiator, in whom you might descry how much life was still left in him.[10]

These frequent occasions of observing nature, taught the Greeks to go on still farther. They began to form certain general ideas of beauty, with regard to the proportions of the inferior parts, as well as of the whole frame: these they raised above the reach of mortality, according to the superior model of some ideal nature.

Thus Raphael formed his *Galatea*, as we learn by his letter to Count Baldassare Castiglione, where he says, 'Beauty being so seldom found among the fair, I avail myself of a certain ideal image.'

According to those ideas, exalted above the pitch of material models, the Greeks formed their gods and heroes: the profile of the brow and nose of gods and goddesses is almost a straight line. The same they gave on their coins to queens, etc. but without indulging their fancy too much. Perhaps this profile was as peculiar to the ancient Greeks, as flat noses and little eyes to the Kalmyks and Chinese; a supposition which receives some strength from the large eyes of all the heads on Greek coins and gems.

From the same ideas the Romans formed their Empresses on their coins. Livia and Agrippina have the profile of Artemisia and Cleopatra.

We observe, nevertheless, that the Greek artists in general, submitted to the law prescribed by the Thebans: 'To do, under a penalty, their best in imitating nature.' For, where they could not possibly apply their easy profile, without endangering the resemblance, they followed nature, as we see instanced in the beauteous head of Julia, the daughter of Titus, done by Euodus.[11]

But to form a 'just resemblance, and, at the same time, a handsomer one', being always the chief rule they observed, and which Polygnotus constantly went by; they must, of necessity, be supposed to have had in view a more beauteous and more perfect nature. And when we are told,

that some artists imitated Praxiteles, who took his concubine Cratina for the model of his Cnidian *Venus*; it is to be understood that they did so, without neglecting these great laws of the art. Sensual beauty furnished the painter with all that nature could give; ideal beauty with the awful and sublime; from that he took the Human, from this the Divine.

Let any one, sagacious enough to pierce into the depths of art, compare the whole system of the Greek figures with that of the moderns, by which, as they say, nature alone is imitated; good heaven! what a number of neglected beauties will he not discover!

For instance, in most of the modern figures, if the skin happens to be any where pressed, you see there several little smart wrinkles: when, on the contrary, the same parts, pressed in the same manner on Greek statues, by their soft undulations, form at last but one noble pressure. These masterpieces never show us the skin forcibly stretched, but softly embracing the firm flesh, which fills it up without any tumid expansion, and harmoniously follows its direction. There the skin never, as on modern bodies, appears in plaits distinct from the flesh.

Modern works are likewise distinguished from the ancient by parts; a crowd of small touches and dimples too sensibly drawn. In ancient works you find these distributed with sparing sagacity, and, as relative to a completer and more perfect nature, offered but as hints, nay, often perceived only by the learned.

The probability still increases, that the bodies of the Greeks, as well as the works of their artists, were framed with more unity of system, a nobler harmony of parts, and a completeness of the whole, above our lean tensions and hollow wrinkles.

Probability, it is true, is all we can pretend to: but it deserves the attention of our artists and connoisseurs the rather, as the veneration professed for the ancient monuments is commonly imputed to prejudice, and not to their excellence; as if the numerous ages, during which they have mouldered, were the only motive for bestowing on them exalted praises, and setting them up for the standards of imitation.

Such as would fain deny to the Greeks the advantages both of a more perfect nature and of ideal beauties, boast of the famous Bernini, as their great champion. He was of opinion, besides, that nature was possessed of

every requisite beauty: the only skill being to discover that. He boasted of having got rid of a prejudice concerning the Medici *Venus,* whose charms he at first thought peculiar ones; but, after many careful researches, discovered them now and then in nature (Plate 22).[12]

He was taught then, by the *Venus,* to discover beauties in common nature, which he had formerly thought peculiar to that statue, and but for it, never would have searched for them. Follows it not from thence, that the beauties of the Greek statues being discovered with less difficulty than those of nature, are of course more affecting; not so diffused, but more harmoniously united? and if this be true, the pointing out of nature as chiefly imitable, is leading us into a more tedious and bewildered road to the knowledge of perfect beauty, than setting up the ancients for that purpose: consequently Bernini, by adhering too strictly to nature, acted against his own principles, as well as obstructed the progress of his disciples.

The imitation of beauty is either reduced to a single object, and is individual, or, gathering observations from single ones, composes of these one whole. The former we call copying, drawing a portrait; it is the straight way to Dutch forms and figures; whereas the other leads to general beauty, and its ideal images, and is the way the Greeks took. But there is still this difference between them and us: they enjoying daily occasions of seeing beauty (suppose even not superior to ours), acquired those ideal riches with less toil than we, confined as we are to a few and often fruitless opportunities, ever can hope for. It would be no easy matter, I fancy, for our nature, to produce a frame equal in beauty to that of *Antinous;*[13] and surely no idea can soar above the more than human proportions of a deity, in the *Apollo* of the Vatican, which is a compound of the united force of nature, genius, and art.

Their imitation discovering in the one every beauty diffused through nature, showing in the other the pitch to which the most perfect nature can elevate herself, when soaring above the senses, will quicken the genius of the artist, and shorten his discipleship: he will learn to think and draw with confidence, seeing here the fixed limits of human and divine beauty.

Building on this ground, his hand and senses directed by the Greek rule of beauty, the modern artist goes on the surest way to the imitation

of nature. The ideas of unity and perfection, which he acquired in meditating on antiquity, will help him to combine, and to ennoble the more scattered and weaker beauties of our nature. Thus he will improve every beauty he discovers in it, and by comparing the beauties of nature with the ideal, form rules for himself.

Then, and not sooner, he, particularly the painter, may be allowed to commit himself to nature, especially in cases where his art is beyond the instruction of the old marbles, to wit, in drapery; then, like Poussin, he may proceed with more liberty. Minds favoured by nature have here a plain way to become originals.

Thus the account de Piles[14] gives, ought to be understood, that Raphael, a short time before he was carried off by death, intended to forsake the marbles, in order to addict himself wholly to nature. True ancient taste would most certainly have guided him through every maze of common nature; and whatever observations, whatever new ideas he might have reaped from that, they would all, by a kind of chemical transmutation, have been changed to his own essence and soul.

He, perhaps, might have indulged more variety; enlarged his draperies; improved his colours, his light and shadow: but none of these improvements would have raised his pictures to that high esteem they deserve, for that noble contour, and that sublimity of thoughts, which he acquired from the ancients.

Nothing would more decisively prove the advantages to be got by imitating the ancients, preferably to nature, than an essay made with two youths of equal talents, by devoting the one to antiquity, the other to nature: this would draw nature as he finds her; if Italian, perhaps he might paint like Caravaggio; if Flemish, and lucky, like Jordaens; if French, like Stella:[15] the other would draw her as she directs, and paint like Raphael.

II CONTOUR

But even supposing that the imitation of nature could supply all the artist wants, she never could bestow the precision of contour, that characteristic distinction of the ancients.

The noblest contour unites or circumscribes every part of the most perfect nature, and the ideal beauties in the figures of the Greeks; or rather, contains them both. Euphranor, famous after the epoch of Zeuxis, is said to have first ennobled it.

Many of the moderns have attempted to imitate this contour, but very few with success. The great Rubens is far from having attained either its precision or elegance, especially in the performances which he finished before he went to Italy, and studied the antiques.

The line by which nature divides completeness from superfluity is but a small one, and, insensible as it often is, has been crossed even by the best moderns; while these, in shunning a meagre contour, became corpulent, those, in shunning that, grew lean.

Among them all, only Michelangelo, perhaps, may be said to have attained the antique; but only in strong muscular figures, heroic frames; not in those of tender youth; nor in female bodies, which, under his bold hand, grew Amazons.

The Greek artist, on the contrary, adjusted his contour, in every figure, to the breadth of a single hair, even in the nicest and most tiresome performances, as gems. Consider the *Diomedes* and *Perseus* of Dioscorides,[16] *Hercules* and *Iole* by Teucer,[17] and admire the inimitable Greeks.

Parrhasius, they say, was master of the correctest contour.

This contour reigns in Greek figures, even when covered with drapery, as the chief aim of the artist; the beautiful frame pierces the marble like a transparent racoon skin.

The high-styled *Agrippina*, and the three *Vestals* in the royal cabinet at Dresden, deserve to be mentioned as eminent proofs of this. This *Agrippina* seems not the mother of Nero, but an elder one, the spouse of Germanicus. She much resembles another pretended Agrippina, in the parlour of the library of San Marco, at Venice.[18] Ours is a sitting figure, above the size of nature, her head inclined on her right hand; her fine face speaks a soul pining in thought, absorbed in pensive sorrow, and senseless to every outward impression. The artist, I suppose, intended to draw his heroine in the mournful moment she received the news of her banishment.

The three *Vestals* deserve our esteem from a double title: as being the

first important discoveries of Herculaneum, and models of the sublimest drapery.[19] All three, but particularly one above the natural size, would, with regard to that, be worthy companions of the Farnese *Flora*,[20] and all the other boasts of antiquity. The two others seem, by their resemblance to each other, productions of the same hand, only distinguished by their heads, which are not of equal goodness. On the best the curled hairs, running in furrows from the forehead, are tied on the neck: on the other the hair being smooth on the scalp, and curled on the front, is gathered behind, and tied with a riband: this head seems of a modern hand, but a good one.

There is no veil on these heads; but that makes not against their being vestals: for the priestesses of Vesta (I speak on proof) were not always veiled; or rather, as the drapery seems to betray, the veil, which was of of one piece with the garments, being thrown backwards, mingles with the clothes on the neck.

It is to these three inimitable pieces that the world owes the first hints of the ensuing discovery of the subterranean treasures of Herculaneum.

Their discovery happened when the same ruins that overwhelmed the town had nearly extinguished the unhappy remembrance of it: when the tremendous fate that spoke its doom was only known by the account which Pliny gives of his uncle's death.

These great masterpieces of the Greek art were transplanted, and worshipped in Germany, long before Naples could boast of one single Herculanean monument.

They were discovered in the year 1706 at Portici near Naples, in a ruinous vault, on occasion of digging the foundations of a villa, for the Prince d'Elbeuf, and immediately, with other new discovered marble and metal statues, came into the possession of Prince Eugene, and were transported to Vienna.

Eugene, who well knew their value, provided a Sala Terrena to be built expressly for them, and a few others: and so highly were they esteemed, that even on the first rumour of their sale, the academy and the artists were in an uproar, and every body, when they were transported to Dresden, followed them with heavy eyes.

The famous Mattielli, to whom

His rule Polyclet, his chisel Phidias gave [Algarotti] [21]

copied them in clay before their removal, and following them some years after, filled Dresden with everlasting monuments of his art: but even there he studied the drapery of his priestesses, (drapery his chief skill!) till he laid down his chisel, and thus gave the most striking proof of their excellence.

III DRAPERY

By drapery is to be understood all that the art teaches of covering the nudities, and folding the garments; and this is the third prerogative of the ancients.

The drapery of the vestals above, is grand and elegant. The smaller foldings spring gradually from the larger ones, and in them are lost again, with a noble freedom, and gentle harmony of the whole, without hiding the correct contour. How few of the moderns would stand the test here!

Justice, however, shall not be refused to some great modern artists, who, without impairing nature or truth, have left, in certain cases, the road which the ancients generally pursued. The Greek drapery, in order to help the contour, was, for the most part, taken from thin and wet garments, which of course clasped the body, and discovered the shape. The robe of the Greek ladies was extremely thin.

Nevertheless the reliefs, the pictures, and particularly the busts of the ancients, are instances that they did not always keep to this undulating drapery.

In modern times the artists were forced to heap garments, and sometimes heavy ones, on each other, which of course could not fall into the flowing folds of the ancients. Hence the large-folded drapery, by which the painter and sculptor may display as much skill as by the ancient manner, Carlo Maratta and Francesco Solimena may be called the chief masters of it: [22] but the garments of the new Venetian school, by passing the bounds of nature and propriety, became stiff as brass.

71

IV EXPRESSION

The last and most eminent characteristic of the Greek works is a noble simplicity and sedate grandeur in gesture and expression. As the bottom of the sea lies peaceful beneath a foaming surface, a great soul lies sedate beneath the strife of passions in Greek figures.

It is in the face of Laocoon [that] this soul shines with full lustre, not confined however to the face, amidst the most violent sufferings (Plates 10, 14). Pangs piercing every muscle, every labouring nerve; pangs which we almost feel ourselves, while we consider—not the face, nor the most expressive parts—only the belly contracted by excruciating pains: these however, I say, exert not themselves with violence, either in the face or gesture. He pierces not heaven, like the Laocoon of Virgil; his mouth is rather opened to discharge an anxious overloaded groan, as Sadoleto says;[23] the struggling body and the supporting mind exert themselves with equal strength, nay balance all the frame.

Laocoon suffers, but suffers like the Philoctetes of Sophocles: we weeping feel his pains, but wish for the hero's strength to support his misery.

The expression of so great a soul is beyond the force of mere nature. It was in his own mind the artist was to search for the strength of spirit with which he marked his marble. Greece enjoyed artists and philosophers in the same persons; and the wisdom of more than one Metrodorus[24] directed art, and inspired its figures with more than common souls.

Had *Laocoon* been covered with a garb becoming an ancient sacrificer, his sufferings would have lost one half of their expression. Bernini pretended to perceive the first effects of the operating venom in the numbness of one of the thighs.

Every action or gesture in Greek figures, not stamped with this character of sage dignity, but too violent, too passionate, was called 'Parenthyrsos.'[25]

For, the more tranquillity reigns in a body, the fitter it is to draw the true character of the soul; which, in every excessive gesture, seems to rush from her proper centre, and being hurried away be extremes becomes unnatural. Wound up to the highest pitch of passion, she may force herself upon the duller eye; but the true sphere of her action is simplicity

and calmness. In *Laocoon* sufferings alone had been 'parenthyrsos'; the artists therefore, in order to reconcile the significative and ennobling qualities of his soul, put him into a posture, allowing for the sufferings that were necessary, the next to a state of tranquillity: a tranquillity however that is characteristical: the soul will be herself—this individual—not the soul of mankind: sedate, but active; calm, but not indifferent or drowsy.

What a contrast! how diametrically opposite to this is the taste of our modern artists, especially the young ones! on nothing do they bestow their approbation, but contorsions and strange postures, inspired with boldness; this they pretend is done with spirit, with *franchezza*. Contrast is the darling of their ideas; in it they fancy every perfection. They fill their performances with comet-like eccentric souls, despising every thing but an Ajax or a Capaneus.

Arts have their infancy as well as men; they begin, as well as the artist, with froth and bombast: in such buskins the muse of Aeschylus stalks, and part of the diction in his Agamemnon is more loaded with hyberboles than all Heraclitus's nonsense. Perhaps the primitive Greek painters drew in the same manner that their first good tragedian thought in.

In all human actions flutter and rashness precede, sedateness and solidity follow: but time only can discover, and the judicious will admire these only: they are the characteristics of great masters; violent passions run away with their disciples.

The sages in the art know the difficulties hid under that air of easiness:

<div align="right">ut sibi quivis</div>

Speret idem, sudet multum, frustraque laboret
Ausus idem. [Horace][26]

Lafage, though an eminent designer, was not able to attain the purity of ancient taste.[27] Every thing is animated in his works; they demand, and at the same time dissipate, your attention, like a company striving to talk all at once.

This noble simplicity and sedate grandeur is also the true characteristical mark of the best and maturest Greek writings, of the epoch and school

of Socrates. Possessed of these qualities Raphael became eminently great, and he owed them to the ancients.

That great soul of his, lodged in a beauteous body, was requisite for the first discovery of the true character of the ancients: he first felt all their beauties, and (what he was peculiarly happy in!) at an age when vulgar, unfeeling, and half-moulded souls overlook every higher beauty.

Ye that approach his works, teach your eyes to be sensible of those beauties, refine your taste by the true antique, and then that solemn tranquillity of the chief figures in his Attila, deemed insipid by the vulgar, will appear to you equally significant and sublime. The Roman bishop, in order to divert the Hun from his design of assailing Rome, appears not with the air of a *rhetor*,[28] but as a venerable man, whose very presence softens uproar into peace; like him drawn by Virgil:

> Tum pietate gravem ac meritis, si forte virum quem
> Conspexere, silent, adrectisque auribus adstant:[29]

full of confidence in God, he faces down the barbarian: the two Apostles descend not with the air of slaughtering angels, but (if sacred may be compared with profane) like Jove, whose very nod shakes Olympus.

Algardi, in his celebrated representation of the same story, done in bas-relief on an altar in St. Peter's at Rome,[30] was either too negligent, or too weak, to give this active tranquillity of his great predecessor to the figures of his Apostles. There they appear like messengers of the Lord of Hosts: here like human warriors with mortal arms.

How few of those we call connoisseurs have ever been able to understand, and sincerely to admire, the grandeur of expression in the *St. Michael* of Guido Reni, in the church of the Capuchins at Rome (Plate 18)! they prefer commonly the *Archangel* of Conca,[31] whose face glows with indignation and revenge; whereas Guido's Angel, after having overthrown the fiend of God and man, hovers over him unruffled and undismayed.

Thus, to heighten the hero of The Campaign, victorious Marlborough, the British poet paints the avenging Angel hovering over Britannia with the like serenity and awful calmness.

The royal gallery at Dresden contains now, among its treasures, one of Raphael's best pictures, witness Vasari, etc. a Madonna with the Infant;

St. Sixtus and St. Barbara kneeling, one on each side, and two Angels in the fore-part.[32]

It was the chief altar-piece in the cloister of St. Sixtus at Piacenza, which was crowded by connoisseurs, who came to see this Raphael, in the same manner as Thespiae was in the days of old, for the sake of the beautiful *Cupid* of Praxiteles.

Behold the Madonna, her face brightens with innocence; a form above the female size, and the calmness of her mien, make her appear as already beatified: she has that silent awfulness which the ancients spread over their deities. How grand, how noble is her contour!

The child in her arms is elevated above vulgar children, by a face darting the beams of divinity through every smiling feature of harmless childhood.

St. Barbara kneels, with adoring stillness, at her side: but being far beneath the majesty of the chief figure, the great artist compensated her humbler graces with soft enticing charms.

The Saint opposite to her is venerable with age. His features seem to bear witness of his sacred youth.

The veneration which St. Barbara declares for the Madonna, expressed in the most sensible and pathetic manner, by her fine hands clasped on her breast, helps to support the motion of one of St. Sixtus's hands, by which he utters his ecstasy, better becoming (as the artist judiciously thought and chose for variety's sake) manly strength, than female modesty.

Time, it is true, has withered the primitive splendour of this picture, and partly blown off its lively colours; but still the soul, with which the painter inspired his godlike work, breathes life through all its parts.

Let those that approach this, and the rest of Raphael's work, in hopes of finding there the trifling Dutch and Flemish beauties, the laboured nicety of Netscher, or Dou, flesh 'ivorified' by Van der Werff,[33] or even the 'licked' manner of some of Raphael's living countrymen; let those, I say, be told, that Raphael was not a great master for them.

V WORKMANSHIP IN SCULPTURE

After these remarks on the nature, the contour, the drapery, the simplicity and grandeur of expression in the performances of the Greek artists, we shall proceed to some inquiries into their method of working.

Their models were generally made of wax; instead of which the moderns used clay, or such like unctuous stuff, as seeming fitter for expressing flesh, than the more gluey and tenacious wax.

A method however not new, though more frequent in our times: for we know even the name of that ancient who first attempted modelling in wet clay; it was Dibutades of Sicyon; and Arcesilaus, the friend of Lucullus, grew more famous by his models of clay than his other performances.[34] He made for Lucullus a figure of clay representing Happiness, and received 60,000 sesterces: and Octavius, a Roman Knight, paid him a talent for the model only of a large dish, in plaster, which he designed to have finished in gold.

Of all materials, clay might be allowed to be the fittest for shaping figures, could it preserve its moistness; but losing that by time or fire, its solider parts, contracting by degrees, lessen the bulk of the mass; and that which is formed, being of different diameters, grows sooner dry in some parts than in others, and the dry ones being shrunk to a smaller size, there will be no proportion kept in the whole.

From this inconvenience wax is always free: it loses nothing of its bulk; and there are also means to give it the smoothness of flesh, which is refused to modelling; viz. you make your model of clay, mould it with plaster, and cast the wax over it.

But for transferring their models to the marble, the Greeks seem to have possessed some peculiar advantages, which are now lost: for you discover, every where in their works, the traces of a confident hand; and even in those of inferior rank, it would be no easy matter to prove a wrong cut. Surely hands so steady, so secure, must of necessity have been guided by rules more determinate and less arbitrary than we can boast of.

The usual method of our sculptors is, to quarter the well-prepared model with horizontals and perpendiculars, and, as is common in copying a picture, to draw a relative number of squares on the marble.

Thus, regular gradations of a scale being supposed, every small square of the model has its corresponding one on the marble. But the contents of the relative masses not being determinable by a measured surface, the artist, though he gives to his stone the resemblance of the model, yet, as he only depends on the precarious aid of his eye, he shall never cease wavering, as to his doing right or wrong, cutting too flat or too deep.

Nor can he find lines to determine precisely the outlines, or the contour of the inward parts, and the centre of his model, in so fixed and unchangeable a manner, as to enable him, exactly, to transfer the same contours upon his stone.

To all this add, that, if his work happens to be too voluminous for one single hand, he must trust to those of his journeymen and disciples, who, too often, are neither skilful nor cautious enough to follow their master's design; and if once the smallest trifle be cut wrong, for it is impossible to fix, by this method, the limits of the cuts, all is lost. It is to be remarked in general, that every sculptor, who carries on his chisellings their whole length, on first fashioning his marble, and does not prepare them by gradual cuts for the last final strokes; it is to be remarked, I say, that he never can keep his work free from faults.

Another chief defect in that method is this: the artist cannot help cutting off, every moment, the lines on his block; and though he restore them, cannot possibly be sure of avoiding mistakes.

On account of this unavoidable uncertainty, the artists found themselves obliged to contrive another method, and that which the French Academy at Rome first made use of for copying antiques, was applied by many even to modelled performances.

Over the statue which you want to copy, you fix a well-proportioned square, dividing it into equally distant degrees, by plummets: by these the outlines of the figure are more distinctly marked than they could possibly be by means of the former method: they moreover afford the artist an exact measure of the more prominent or lower parts, by the degrees in which these parts are near them, and in short, allow him to go on with more confidence.

But the undulations of a curve being not determinable by a single perpendicular, the contours of the figure are but indifferently indicated

77

to the artist; and among their many declinations from a straight surface, his tenour is every moment lost.

The difficulty of discovering the real proportions of the figures, may also be easily imagined: they seek them by horizontals placed across the plummets. But the rays reflected from the figure through the squares, will strike the eye in enlarged angles, and consequently appear bigger, in proportion as they are high or low to the point of view.

Nevertheless, as the ancient monuments must be most cautiously dealt with, plummets are still of use in copying them, as no surer or easier method has been discovered: but for performances to be done from models they are unfit for want of precision.

Michelangelo went alone a way unknown before him, and (strange to tell!) untrod since the time of that genius of modern sculpture.

This Phidias of latter times, and next to the Greeks, hath, in all probability, hit the very mark of his great masters. We know at least no method so eminently proper for expressing on the block every, even the minutest, beauty of the model.

Vasari seems to give but a defective description of this method, namely that Michelangelo took a vessel filled with water, in which he placed his model of wax, or some such indissoluble matter: then, by degrees, raised it to the surface of the water. In this manner the prominent parts were unwet, the lower covered, until the whole at length appeared. Thus says Vasari, he cut his marble, proceeding from the more prominent parts to the lower ones.

Vasari, it seems, either mistook something in the management of his friend, or by the negligence of his account gives us room to imagine it somewhat different from what he relates.

The form of the vessel is not determined; to raise the figure from below would prove too troublesome, and presupposes much more than this historian had a mind to inform us of.

Michelangelo, no doubt, thoroughly examined his invention, its conveniences and inconveniences, and in all probability observed the following method.

He took a vessel proportioned to his model; for instance, an oblong square: he marked the surface of its sides with certain dimensions, and

these he transferred afterwards, with regular gradations, on the marble. The inside of the vessel he marked to the bottom with degrees. Then he laid, or, if of wax, fastened his model in it; he drew, perhaps, a bar over the vessel suitable to its dimensions, according to whose number he drew, first, lines on his marble, and immediately after, the figure; he poured water on the model till it reached its outmost points, and after having fixed upon a prominent part, he drew off as much water as hindered him from seeing it, and then went to work with his chisel, the degrees showing him how to go on; if, at the same time, some other part of the model appeared, it was copied too, as far as seen.

Water was again carried off, in order to let the lower parts appear; by the degrees he saw to what pitch it was reduced, and by its smoothness he discovered the exact surfaces of the lower parts; nor could he go wrong, having the same number of degrees to guide him, upon his marble.

The water not only pointed him out the heights or depths, but also the contour of his model; and the space left free on the insides to the surface of the water, whose largeness was determined by the degrees of the two other sides, was the exact measure of what might safely be cut down from the block.

His work had now got the first form, and a correct one: the levelness of the water had drawn a line, of which every prominence of the mass was a point; according to the diminution of the water the line sunk in a horizontal direction, and was followed by the artist until he discovered the declinations of the prominences, and their mingling with the lower parts. Proceeding thus with every degree, as it appeared, he finished the contour, and took his model out of the water.

His figure wanted beauty: he again poured water to a proper height over his model, and then numbering the degrees to the line described by the water, he described the exact height of the protuberant parts; on these he levelled his rule, and took the measure of the distance, from its verge to the bottom; and then comparing all he had done with his marble, and finding the same number of degrees, he was geometrically sure of success.

Repeating his task, he attempted to express the motion and re-action of nerves and muscles, the soft undulations of the smaller parts, and every

imitable beauty of his model. The water insinuating itself, even into the most inaccessible parts, traced their contour with the correctest sharpness and precision.

This method admits of every possible posture. In profile especially, it discovers every inadvertency; shows the contour of the prominent and lower parts, and the whole diameter.

All this, and the hope of success, presupposes a model formed by skilful hands, in the true taste of antiquity.

This is the way by which Michelangelo arrived at immortality. Fame and rewards conspired to procure him what leisure he wanted, for performances which required so much care.

But the artist of our days, however endowed by nature and industry with talents to raise himself, and even though he perceive precision and truth in this method, is forced to exert his abilities for getting bread rather than honour: he of course rests in his usual sphere, and continues to trust in an eye directed by years and practice.

Now this eye, by the observations of which he is chiefly ruled, being at last, though by a great deal of uncertain practice, become almost decisive: how refined, how exact might it not have been, if, from early youth, acquainted with never-changing rules!

And were young artists, at their first beginning to shape the clay or form the wax, so happy as to be instructed in this sure method of Michelangelo, which was the fruit of long researches, they might with reason hope to come as near the Greeks as he did.

VI PAINTING

Greek painting perhaps would share all the praises bestowed on their sculpture, had time and the barbarity of mankind allowed us to be decisive on that point.

All the Greek painters are allowed is contour and expression. Perspective, composition, and colouring, are denied them; a judgment founded on some bas-reliefs, and the newly discovered ancient (for we dare not say Greek) pictures, at and near Rome, in the subterranean vaults of the

palaces of Maecenas, Titus, Trajan, and the Antonines; of which but about thirty are preserved entire, some being only in mosaic.

Turnbull, to his treatise on ancient painting,[35] has subjoined a collection of the most known ancient pictures, drawn by Camillo Paderni, and engraved by Mynde; and these alone give some value to the magnificent and abused paper of his work. Two of them are copied from originals in the cabinet of the late Dr. Mead.[36]

That Poussin much studied the pretended *Aldobrandini Wedding*; that drawings are found done by Annibale Carracci, from the presumed *Marcius Coriolanus*; and that there is a most striking resemblance between the heads of Guido Reni, and those on the mosaic representing *Jupiter carrying off Europa*, are remarks long since made.

Indeed, if ancient painting were to be judged by these, and such like remains of fresco, contour and expression might be wrested from it in the same manner. For the pictures, with figures as big as life, pulled off with the walls of the Herculanean theatre, afford but a very poor idea of the contour and expression of the ancient painters. Theseus, the conqueror of the Minotaur, worshipped by the Athenian youths; Flora with Hercules and a Faunus; the pretended judgment of the *decemvir* Appius Claudius, are on the testimony of an artist who saw them, of a contour as mean as faulty; and the heads want not only expression, but those in the Claudius even character.

But even this is an evident instance of the meanness of the artists: for the science of beautiful proportions, of contour, and expression, could not be the exclusive privilege of Greek sculptors alone.

However, though I am for doing justice to the ancients, I have no intention to lessen the merit of the moderns.

In perspective there is no comparison between them and the ancients, whom no learned defence can entitle to any superiority in that science. The laws of composition and ordinance seem to have been but imperfectly known by the ancients: the reliefs of the times when the Greek arts were flourishing at Rome, are instances of this. The accounts of the ancient writers, and the remains of painting are likewise, in point of colouring, decisive in favour of the moderns.

There are several other objects of painting which, in modern times,

81

have attained greater perfection: such are landscapes and cattle pieces. The ancients seem not to have been acquainted with the handsomer varieties of different animals in different climes, if we may conclude from the horse of *Marcus Aurelius*; the two horses on Monte Cavallo; the pretended Lysippean horses above the portal of San Marco in Venice; the *Farnese Bull*, and other animals of that group.[37]

I observe, by the bye, that the ancients were careless of giving to their horses the diametrical motion of their legs; as we see in the horses at Venice, and the ancient coins: and in that they have been followed, nay even defended, by some ignorant moderns.

It is chiefly to oil-painting that our landscapes, and especially those of the Dutch, owe their beauties: by that their colours acquired more strength and liveliness; and even nature herself seems to have given them a thicker, moister atmosphere, as an advantage to this branch of the art.

These, and some other advantages over the ancients, deserve to be set forth with more solid arguments than we have hitherto had.

VII ALLEGORY

There is one other important step left towards the achievement of the art: but the artist, who, boldly forsaking the common path, dares to attempt it, finds himself at once on the brink of a precipice, and starts back dismayed.

The stories of martyrs and saints, fables and metamorphoses, are almost the only objects of modern painters—repeated a thousand times, and varied almost beyond the limits of possibility, every tolerable judge grows sick at them.

The judicious artist falls asleep over a Daphne and Apollo, a Proserpine carried off by Pluto, a Europa, etc. he wishes for occasions to show himself a poet, to produce significant images, to paint allegory.

Painting goes beyond the senses: *there* is its most elevated pitch, to which the Greeks strove to raise themselves, as their writings evince. Parrhasius, like Aristides, a painter of the soul, was able to express the character even of a whole people: he painted the Athenians as mild as

cruel, as fickle as steady, as brave as timid. Such a representation owes its possibility only to the allegorical method, whose images convey general ideas.

But here the artist is lost in a desert. Tongues the most savage, which are entirely destitute of abstracted ideas, containing no word whose sense could express memory, space, duration, etc. these tongues, I say, are not more destitute of general signs, than painting in our days. The painter who thinks beyond his palette longs for some learned apparatus, by whose stores he might be enabled to invest abstracted ideas with sensible and meaning images. Nothing has yet been published of this kind, to satisfy a rational being; the essays hitherto made are not considerable, and far beneath this great design. The artist himself knows best in what degree he is satisfied with Ripa's *Iconology*, and the emblems of ancient nations, by Van Hooge.[38]

Hence the greatest artists have chosen but vulgar objects. Annibale Carracci, instead of representing in general symbols and sensible images the history of the Farnese family, as an allegorical poet, wasted all his skill in fables known to the whole world.

Go, visit the galleries of monarchs, and the public repositories of art, and see what difference there is between the number of allegorical, poetical, or even historical performances, and that of fables, saints, or madonnas.

Among great artists, Rubens is the most eminent, who first, like a sublime poet, dared to attempt this untrodden path. His most voluminous composition, the gallery of the Palais du Luxembourg, Paris, has been communicated to the world by the hands of the best engravers.[39]

After him the sublimest performance undertaken and finished, in that kind, is, no doubt, the cupola of the imperial library at Vienna, painted by Daniel Gran, and engraved by Sedelmayer.[40] The Apotheosis of Hercules at Versailles, done by Lemoyne,[41] and alluding to the Cardinal Hercules de Fleury, though deemed in France the most august of compositions, is, in comparison of the learned and ingenious performance of the German artist, but a very mean and short-sighted allegory, resembling a panegyric, the most striking beauties of which are relative to the almanac. The artist had it in his power to indulge grandeur, and his slipping the occasion is astonishing: but even allowing, that the apotheosis of a

minister was all that he ought to have decked the chief ceiling of a royal palace with, we nevertheless see through his fig-leaf.

The artist would require a work, containing every image with which any abstracted idea might be poetically invested: a work collected from all mythology, the best poets of all ages, the mysterious philosophy of different nations, the monuments of the ancients on gems, coins, utensils, etc. This magazine should be distributed into several classes, and, with proper applications to peculiar possible cases, adapted to the instruction of the artist. This would, at the same time, open a vast field for imitating the ancients, and participating of their sublimer taste.

The taste in our decorations, which, since the complaints of Vitruvius,[42] hath changed for the worse, partly by the grotesques brought in vogue by Morto da Feltro,[43] partly by our trifling house-painting, might also, from more intimacy with the ancients, reap the advantages of reality and common sense.

The caricatura-carvings, and favourite shells, those chief supports of our ornaments, are full as unnatural as the candlesticks of Vitruvius, with their little castles and palaces: how easy would it be, by the help of allegory, to give some learned convenience to the smallest ornament!

Reddere personae scit convenientia cuique. [Horace][44]

Paintings of ceilings, doors, and chimney-pieces, are commonly but the expletives of these places, because they cannot be gilt all over. Not only have they not the least relation to the rank and circumstances of the proprietor, but often throw some ridicule or reflection upon him.

It is an abhorrence of barrenness that fills walls and rooms; and pictures void of thought must supply the vacuum.

Hence the artist, abandoned to the dictates of his own fancy, paints, for want of allegory, perhaps a satire on him to whom he owes his industry; or, to shun this Charybdis,[45] finds himself reduced to paint figures void of any meaning.

Nay, he may often find it difficult to meet even with those, until at last

—velut aegri somnia, vanae
Fingentur species. [Horace][46]

Thus painting is degraded from its most eminent prerogative, the representation of invisible, past and future things.

If pictures be sometimes met with, which might be significant in some particular place, they often lose that property by stupid and wrong applications.

Perhaps the master of some new building

Dives agris, dives positis in fenore nummis [Horace][47]

may, without the least compunction for offending the rules of perspective, place figures of the smallest size above the vast doors of his apartments and salons. I speak here of those ornaments which make part of the furniture; not of figures which are often, and for good reasons, set up promiscuously in collections.

The decorations of architecture are often as ill-chosen. Arms and trophies deck a hunting-house as nonsensically as Ganymede and the eagle, Jupiter and Leda, figure among the reliefs of the bronze doors of St. Peter's at Rome.[48]

Arts have a double aim: to delight and to instruct. Hence the greatest landscape-painters think, they have fulfilled but half their task in drawing their pieces without figures.

Let the artist's pencil, like the pen of Aristotle, be impregnated with reason; that, after having satiated the eye, he may nourish the mind: and this he may obtain by allegory; investing, not hiding his ideas. Then, whether he choose some poetical object himself, or follow the dictates of others, he shall be inspired by his art, shall be fired with the flame brought down from heaven by Prometheus, shall entertain the votary of art, and instruct the mere lover of it.

2 Remarks on the Architecture of the Ancients [1762] [1]

CHAPTER II: CONCERNING ORNAMENTATION IN ARCHITECTURE

AFTER THE BASIC ESSENTIALS of architecture comes its embellishment, which is the subject of this chapter. Firstly I shall discuss it in general, then in particular.

A building without decoration is like health in a state of poverty, which nobody regards as being fortunate; and sameness or monotony can be a defect in architecture as in writing and other works of art. Decoration depends on variety; in writing and in buildings it provides a change for the intellect and the eye, and when decoration in architecture is combined with simplicity, the result is beauty: for a thing is good and beautiful if it is what it ought to be. So the ornamentation of a building should be in keeping with the general purpose as well as the particular; in accordance with the former it should look like an addition, and in accordance with the latter, it should not alter the nature of the place and its function. It is to be regarded as clothing which serves to cover nakedness, and the larger the groundwork of the building, the less decoration is required; just as a precious stone would only be set in a gold thread, to show its full brilliance.

Ornamentation was as rare in the oldest buildings as in the oldest statues, and in the former one sees neither ogee-mouldings nor roundels, as little as on the oldest altars. Under the Consulate of Dolabella, not long before the time of Augustus, an arch was built in the Claudian aqueduct, over which the protruding cornice of travertine runs diagonally, but in a straight line, something which would not have been so easy to do in later times.

But later, architectural variety became the aim, which was achieved by curved elevations or concave and arched lines; the straight members and parts were broken up and as a result were diversified. But this variety, which adapted itself to every architectural order in a different way, was actually not regarded as decoration, which indeed was so little sought after by the ancients that the word which had this meaning for the ancient Romans was only applied to ornamentation in clothing; it was only in later times that the Roman word for decoration was first also applied to

works of the intellect. For since true good taste went into a decline and appearance was put before substance, decorations were no longer regarded as mere additions, and whole squares which had until then remained empty, were filled with them. The result of this was insignificant architecture: for if each part is small, the whole will be small as well, as Aristotle says.[2] Architecture suffered the same fate as the old languages, which became richer when they lost their beauty; this can be proved by the Greek as well as the Roman language, and as architects could neither equal nor surpass their predecessors in beauty, they tried to show that they were richer.

Over-lavish decoration probably began under Nero: for at the time of Titus good taste prevailed, as one can see from his arches, and this increased more and more under the subsequent emperors. The palaces and temples at Palmyra show the type of architecture under Marcus Aurelius: for what is left there was presumably built shortly before or during his time, as all the buildings are in the same style. It has not been decided whether the colossal fragment of a marble architrave from a sun temple in the garden of the Palazzo Colonna was built under the afore-mentioned emperor.

A comparison ought to be made between the decorative forms of the ancients and modern architects, if one could explain it clearly by means of copperplates. In the designs of decorations made by the ancients, simplicity always prevailed; with modern architects who do not follow the ancients, the reverse is the case: the ancients are united in their decorations which are like branches on a trunk; the modern architects ramble about and sometimes one can find neither beginning nor end. Finally even newly invented scrolls, with which French and Augsburg copperplates were framed and decorated some time ago, have been put on the façades of buildings. The most abominable monument to the deterioration of good taste is in Italy itself, at Portici, near Naples. There Duke Caravita has erected in stone the most preposterous scrolls by those copperplate engravers, and these caricatures stand, each separated from the other, yards high along the garden paths.[3]

Michelangelo, whose fertile imagination could not be contained by economy and imitation of the ancients, began to branch out in ornamentation,

and Borromini, who exaggerated these ornaments, brought about a deterioration in architecture which spread through Italy and other countries and will survive, because our times are going even further away from the severity of the ancients, and people are very like the kings of Peru, who had gold plants and flowers in their gardens, and whose greatness was shown by their decadent taste.

3 Essay on the Beautiful in Art [1763] [1]

I SHALL EXPLAIN the delay of this essay which I promised you about the capacity to perceive beauty in art in the same way as Pindar, when he made Agesidamus—a noble youth of Lokri 'who was beauteous in form and suffused with grace'—wait so long for an ode which was intended for him: 'A debt repaid with interest (he said) cancels out any reproach.' [2] Your kindness can apply this to the present essay, which has turned out to be more complex than was thought at the beginning.

The capacity of perceiving beauty in art is a concept which combines both the person and the object, the containing and the contained, but I shall put them together, so that I shall concentrate here particularly on the first, and for the moment remark that 'the beautiful' is more comprehensive than 'beauty': the latter concerns education and is the highest aim of art, the former involves everything that is thought, designed and executed.

This capacity is regarded in the same way as ordinary, healthy sense; everyone believes he has it (although it is rarer than wit): because one has eyes like anybody else, one thinks one can see as well as anyone else. Just as a girl is reluctant to regard herself as ugly, everyone wants to know beauty. There is nothing more delicate than trying to deny someone's good taste, which in another word means just this capacity; one is far readier to declare oneself wanting in all sorts of knowledge than to hear the accusation of being incapable of knowing beauty. If need be, one will admit to *inexperience* in this knowledge, but will insist on the *capacity* of feeling it. It is like the poetic spirit, a gift of heaven; but it develops just as little spontaneously as that does, and would remain empty and dead without any rules or instruction. Consequently this essay has two parts: the natural capacity itself and instruction in it.

Heaven has given all intelligent creatures the capacity of perceiving beauty, but in very varying degrees. The majority are like those insubstantial particles which are attracted indiscriminately by a body electrically charged by friction and then soon fall off again; so their feeling is brief, like the tone of a taut string. Beauty and mediocrity are as welcome to these people as men of merit and the common rabble are to a person of unlimited civility. Some people have such a minute degree of this capacity that they could appear to have been overlooked by nature in the dispensation of the same; and of this type was a certain young Briton of the highest

class who was in his carriage and did not even show a sign of life and of his presence when I gave him a talk on the beauty of Apollo and other statues of the highest quality. The sensitivity of Malvasia, author of the lives of the Bolognese painters, must have been of a similar type; this tattler calls the great Raphael a 'jug-seller from Urbino',[3] in accordance with the common legend that this god of artists painted pots, which shows ignorance to be a rarity on that side of the Alps: he does not hesitate to claim that the Carracci ruined themselves by imitating Raphael. The true beauties of art have the same effect on such people as the Northern Lights, which shine but give no warmth; one could almost say that they were 'those sort of creatures, who', as Sanchuniathon says, 'have no feeling.'[4] Even if beauty in art were all face, in the same way as God is all eye according to the Egyptians, even if it were thus combined into one part, it would still leave many people cold.

One can also conclude that this feeling is rare by the lack of instructive literature on beauty: for from Plato onwards until our own time the writings of this sort about beauty in general are empty, uninstructive and of meagre content; a few more recent writers, who have never appreciated beauty, have attempted to discuss beauty in art. I could give you new proof of this, my friend, in a letter from the famous Baron von Stosch, the greatest scholar of antiquity of our times. Because he did not know me personally he tried in this letter at the beginning of our correspondence to inform me about the relative merit of the best statues, and the order in which I was to look at them. I was amazed when I saw that such a famous antiquarian put the *Apollo Belvedere* (Plate 9), the miracle of art, after the *Sleeping Faun* in the Palazzo Barberini, which is a natural creature of the forest, after the *Centaur* in the Villa Borghese, which is incapable of any ideal beauty, and after the two old *Satyrs* in the Campidoglio. *Niobe and her daughter* (Plate 12), models of the highest feminine beauty, have the last place in that order. I convinced him of his erroneous order of merit, and his excuse was that he saw the works of ancient art on the other side of the mountains in his youthful days, in the company of two artists who were still living, upon whose judgment he had hitherto based his own. We exchanged a few letters about a round work in the Villa Doria–Pamphili, Rome, with raised figures, which he held to be the

oldest monument of Greek art, and which I, on the other hand, held to be one of the latest under the Emperors. What basis did his opinion have? He had taken the *worst* to be the *oldest*; and Natter[5] uses the same system with his engraved stones. Just as false is his judgment of the presumed great antiquity of the stones on the eighth to the twelfth plates: here he follows history in believing that a very old subject such as the *Death of Othryades*, must also presuppose a very old artist. It is due to such connoisseurs that any attention has been paid to the alleged *Seneca in his bath* in the Villa Borghese. It is a web of stringy veins and in my eyes can hardly be considered worthy of the art of antiquity. This judgment will appear heretical to the majority, and a few years ago I would not have dared to make it publicly.

This capacity is aroused and matured by good education and appears earlier than is the case with a neglected education, which, however, cannot stifle it, as I for my part know here. But it develops better in large towns than in small ones, and in social life rather than through erudition: for great knowledge, the Greeks say, does not lead to a healthy intellect, and those who have made a close study of antiquities through mere scholarship have not become any more knowledgeable about them. This feeling remains a meaningless part of the education of native Romans, in whom it could appear earlier and be more mature, and it does not develop, because people are like the hen who goes past the corn lying in front of her in order to get corn from further away: things which we daily have in front of us do not usually arouse our desire. There is even a famous painter still living, Niccolo Ricciolini,[6] a native Roman and a man of great talent and knowledge, even beyond his own art, who only a few years ago saw the statues in the Villa Borghese for the first time, when he was in his seventieth year. The same man studied architecture thoroughly, and yet he has not seen one of the most beautiful monuments, namely the tomb of Cecilia Metella, the wife of Crassus, although he has wandered far and wide outside Rome, being a keen hunter. And so for these reasons few famous artists have been native Romans, except Giulio Romano; the majority of those who found fame in Rome, painters as well as sculptors and architects, were not natives, and even now there is no Roman prominent in art.

In early youth, this capacity, like any other tendency, is cloaked in dark and confused emotions and appears like a passing itch in the skin which one cannot actually locate when one tries to scratch it. It is more to be found in youths of pleasing appearance than in others, since our thinking is usually determined by our constitution, though less as regards our physical form than our nature and disposition: a soft heart and responsive senses are signs of such a capacity. It can be seen more clearly when, on reading an author, feeling is aroused more delicately, where an impetuous mind rushes on, as would happen more than once in the speech of Glaucus to Diomedes, which is the moving analogy of human life with leaves blown down by the wind, to be renewed again in the spring.[7] Where this capacity does not exist, one is preaching knowledge of beauty to the blind, just as if one were teaching music to an unmusical ear. A better sign is a natural instinct to draw in youths who are brought up away from art and are not expressly destined for it; it is innate, like the attraction to poetry and music.

Furthermore, since human beauty has to be expressed in a general concept, I have observed that those who are only aware of beauty in the female sex and are hardly or not at all affected by beauty in *our* sex, have little innate feeling for beauty in art in a general and vital sense. The same people have an inadequate response to the art of the Greeks, since their greatest beauties are more of our sex than the other. But more feeling is required for beauty in art than in nature, since the former is without any life, as tears in the theatre are without pain, and must be aroused and restored by the imagination. But since the imagination is far more ardent in youth than in maturity, the capacity of which we are speaking should be put into practice in good time and directed towards beauty before we reach the age where we are horrified to admit that we cannot feel it.

However, we should not always conclude that a person does not possess the capacity for this feeling if he admires what is bad. For in the same way as children who are allowed to hold everything they look at close to their eyes learn to squint, so the feeling can be spoiled and go wrong, if the painted subjects which a person looks at in early years are mediocre or bad. I recall how people of talent in towns where art cannot take its

rightful place, talked a lot about the prominent veins on the small sculptures in our cathedral churches, in order to show their good taste: they had never seen anything better, like the Milanese, who prefer their cathedral to St. Peter's in Rome.

The true feeling for beauty is like a liquid plaster cast which is poured over the head of Apollo, touching every single part and enclosing it. The subject which evokes this feeling is not what instinct, friendship and courtesy praise, but what the inner, more refined sense feels, which is purified of all other purposes for the sake of beauty. Here you will say that I am starting on platonic concepts, which could deny this feeling to many people; but you know that one must seek the highest tone in teaching, as in laws, since the chord stops by itself: I am stating *what ought to be*, not *what is usual*, and my concept is like the test for accuracy in calculation.

The tool of this feeling is the *outer* sense and the seat of it is the *inner* sense: the former must be accurate and the latter must be sensitive and refined. But accuracy of eye is a gift which many lack, like a delicate ear and an acute sense of smell. One of the most famous contemporary singers in Italy has all the qualities of his art except a truly musical ear; he lacks something which was superfluous to the blind Saunderson, Newton's successor.[8] Many doctors would be more skilful if they had acquired great sensitivity. Our eye is frequently misled by optics and not seldom by itself.

The accuracy of the eye consists in observing the *true form* and *greatness* of the subjects of paintings and *form* applies to colour as much as to shape. Artists do not necessarily perceive colours in the same way, because they imitate them in different ways. To prove this I shall not cite the altogether bad colour of a few artists, such as Poussin, because that is partly due to neglect, to bad training and to lack of skill; however, I shall conclude from what I myself have seen executed that such artists do not realize how bad their colour is. One of the best British painters[9] would not have valued his life-size *Death of Hector* quite so highly, the colour of it being vastly inferior to the drawing: this work will shortly appear in Rome as an engraving (Plate 23). My proposition is founded mainly on those artists who are counted amongst the good colourists and have certain defects:

and here I cite the famous Federico Baroccio,[10] whose skin has a greenish tinge. He had a special way of doing the first rough sketch of a nude in green, as one can clearly see from a few unfinished works in the Albani collection. The colour, which in Guido's work is soft and gay and in Guercino's work appears strong, dull and very gloomy, can even be read in the faces of these two artists.

Artists are equally dissimilar in their idea of the true nature of form, which one must conclude from the incomplete sketches of this in their imagination. Baroccio is recognizable from the very sunken profiles of his faces, Pietro da Cortona from the small chin on his heads, and Parmigianino from the long oval and the long fingers. But I will not maintain that all artists lacked visual accuracy at a time when all figures were equally consumptive, as before Raphael, and when they all looked as if they suffered from dropsy, because of Bernini: for here the blame lies in a false system, which was chosen and followed blindly. This is the case in the matter of size. We see that artists even go wrong in portraits, in the proportion of the parts which they can see at peace and at will; in some the head is smaller or larger, in others it is the hands; sometimes the neck is too long or too short, and so on. If the eye has not achieved this proportion in a few years of constant practice, then it is futile to hope for it.

If the *outer* sense is accurate, then it is to be desired that the *inner* sense is correspondingly perfect: for it is a second mirror, in which we see the essential quality of our own likeness, through the profile. The inner sense is the presentation and formation of the impressions of the outer sense, and, with *one* word, what we call *perception*. But the inner sense is not always in proportion to the outer, that is it is not sensitive with the same accuracy as the outer sense, because it operates mechanically, where in the case of the outer sense there is an intellectual effect. Thus we can have genuine drawers who have no feeling, and I know a man who is like this; but they are at most only skilled in copying beauty, not in finding and drawing it themselves. Nature denied Bernini this perception in sculpture; but Lorenzetti was endowed with the gift to a greater degree, it seems, than other sculptors of modern times. He was Raphael's pupil and his *Jonah* in the Chigi Chapel is well known; but a perfect work of his

in the Pantheon, a standing *Madonna* twice as large as life, which he made after his master's death, is noticed by no one.[11]

The inner sense must be ready and swift, since first impressions are the strongest and come before reflection: what we feel after reflection is weaker. This is the general emotion which attracts us to beauty and can be dark and unfathomable, as is usual with all first, rapid impressions, until examination of the works admits reflection, accepts it and demands it. Anyone now wishing to proceed from the parts to the whole would show a grammatical brain and would scarcely arouse in himself a perception of the whole and delight in it.

This sense must be delicate rather than violent, since beauty consists in the harmony of the parts, the perfection of which lies in a gentle rise and fall, which consequently affects our perception uniformly and guides it gently rather than sweeping it away suddenly. All violent emotions go beyond the indirect to the direct, since feeling should be aroused in the same way as a beautiful day comes into being, through the heralding of a lovely morning flush. Violent feeling is also harmful to the contemplation and enjoyment of beauty, because it is too short: for it leads straight to its goal instead of feeling step by step. Antiquity seems to have clothed its thoughts in images with regard to this contemplation too, and concealed its meaning, in order to give the intellect the pleasure of reaching it indirectly. Very fiery, impulsive heads are therefore not the most capable of perceiving beauty, and just as enjoyment of ourselves and true pleasure are to be achieved with peace of mind and body, the perception and enjoyment of beauty must be delicate and gentle, coming like a mild dew, rather than a sudden downpour of rain. And since true beauty of human form is generally embodied in an innocent, quiet nature, it needs to be felt and recognized by a similar mind. Here we do not need a Pegasus to travel through the air, but Pallas to guide us.

The third characteristic of the inner feeling consists of a vivid formation of the contemplated beauty, and is a consequence of the two first characteristics, not something independent; but its strength grows, like memory, through practice, which has nothing to contribute to the other characteristics. The greatest sensibility can have less of this quality than an experienced artist lacking in sensibility, to such an extent that the

95

conceived image is vivid and clear in general, but fades if we try to imagine it detail by detail in a precise way. This is what usually happens with the mental image of a distant loved one, and we experience it in most things: we lose the whole if we attempt to go into too much detail.

My suggestion for the instruction of a boy who shows signs of the desired capacity is as follows: firstly, his heart and feelings should be aroused by explanations of the finest passages of ancient and modern authors, especially poets, and should be prepared for personal contemplation of beauty of all kinds, for this path leads to perfection. At the same time his eye should be trained to contemplate beauty in art, which can be done in any country if absolutely necessary.

First of all show him the old relief sculptures, together with the old paintings which Pietro Santi Bartoli engraved, showing the beauty of these works with truth and good taste.[12] In addition, the so-called Bible of Raphael can be sought out, that is the history of the Old Testament which this great artist painted on the ceiling of the Loggie in the Vatican; part of it was done by himself and part by others in accordance with his drawings. This work has also been engraved by the aforementioned Bartoli. These two works will be to the unspoiled eye what a proper writing-model is to the hand; and since unpractised feeling is like ivy, clinging as easily to a tree as an old wall, by which I mean that it looks at bad and good with equal pleasure, one should occupy it with *beautiful* pictures. Here we see the validity of what Diogenes said—that we ought to ask the gods to give us pleasant visions.[13] In a boy charmed by Raphael's pictures one will notice with time what is felt by someone who, after seeing the *Apollo Belvedere* and *Laocoon* on the spot, looks at a few statues of sanctified monks in St. Peter's directly afterwards. For just as truth convinces even without proof, beauty, if seen from early youth, will give great pleasure even without further instruction.

If the boy who is being educated for beauty is in a large town where he can be given oral instruction, I would recommend him nothing but that at first. But if his teachers have the rare ability to distinguish between the work of ancient and modern artists, to the copies of *ancient* engraved stones a collection of prints of *new* engraved stones could be added, in order to show, through a comparison of both, the concept of true beauty

in the ancient works and the erroneous concept of beauty in most modern works. Much can be shown and made comprehensible, even without instruction in drawing: for it is clear from the contrast, just as the mediocrity of a singer becomes apparent beside a harmonious instrument, although he seemed different when singing without it. But drawing, which can be taught at the same time as writing, provides a more complete and thorough knowledge if a high degree of skill has been attained.

Meantime, this private instruction from plates in books and prints is like land-surveying on paper; the small-scale copy is only the shadow, not the truth and there is no greater difference between Homer and his best translators than between the works of the ancients and Raphael and their copies: the latter are dead pictures, the former speak. And so the true and full knowledge of beauty in art can be achieved in no other way but by contemplation of the original paintings themselves, and especially in Rome; and a journey to Italy is advisable for those who are gifted by nature with the capacity to recognize beauty, and who have received sufficient instruction in it. Outside Rome, one must, like many of those in love, be content with a glance and a sigh, that is, esteem the meagre and the mediocre.

In architecture, beauty is more general, since it consists principally in the *proportion*: for a building can become and be beautiful through that alone, without decoration. Sculpture does not have two difficult parts, namely colour and light and shade, through which painting achieves its greatest beauty, and so it is easier to acquire and understand the one art in stages than the other. For this reason Bernini, who had no feeling for human beauty, could have been a great architect, which praise he does not deserve in sculpture. This is so sensuous that I wonder how there are people who doubt which is the more difficult, painting or sculpture: for the fact that there have been less good sculptors than artists in modern times cannot cast doubt on this. Consequently, since beauty in sculpture is more concentrated on *one* thing than in the two other arts, the perception of it in these two must be so much more rare, because it is rare in sculpture, which is apparent even in the newest buildings in Rome itself, of which few are executed according to the rules of true beauty, as are those by Vignola without exception.[14] In Florence beautiful architecture

is rare, so that only a single small house can be called beautiful, which even the people of Florence point out as a curiosity: one can say the same of Naples. But Venice surpasses both these cities with various palaces on the Grand Canal which were put up by Palladio. One can draw conclusions about other countries apart from Italy by oneself. But in Rome there are more beautiful palaces and houses than in the rest of Italy put together; the most beautiful building of our times is the Villa of Cardinal Alessandro Albani, and its gallery can be called the most beautiful and most magnificent in the world.

The epitome of beauty in architecture is to be found in the most beautiful building in the world, and that is St. Peter's. The flaws which Campbell finds in it in his *Vitruvius Britannicus*,[15] and others beside him, are only by hearsay and have not the least foundation. They criticize the front on the grounds that the openings and members are not in proportion to the size of the building, but they have not considered that these apparent flaws necessarily arise due to the balcony, on which the Pope gives the blessing here, as in San Giovanni in Laterano and Santa Maria Maggiore. The attic order on this side is not higher than that of the whole building. But the apparent main fault is that Carlo Maderno, the architect of the front side, made it protrude too far and gave this temple the form of the Latin cross instead of the Greek cross, where the cupola would have been in the middle. But this was done by order, to include the whole area of the old church in the new building. This extension was even designed by Raphael, as architect of St. Peter's before Michelangelo, as one can see from his plans in Serlio,[16] and Michelangelo indeed seems to have had this intention. Also, the form of the Greek cross would have been against the rules of the old architects, who teach that the width of a temple should comprise a third of the length.

Beauty in painting is as much in the drawing and in the composition as in the colour and in the light and shade. In the drawing, beauty itself is the touchstone, also with regard to what should arouse fear: for something which departs from beautiful form can be said to be drawn in a scholarly fashion, but not beautifully. A few figures in the *Feast of the Gods* by Raphael are not consistent with this principle;[17] but that work was done by his pupil, Giulio Romano, his favourite, who did not possess

feeling for true beauty. When the school of Raphael, which only arose like the flush of dawn, ceased to exist, the artists left antiquity and followed their own imagination as had been the case before. The decline began through the two Zuccari, and Giuseppe d'Arpino deluded himself and others.[18] Nearly fifty years after Raphael the school of the Carracci began to flourish; Lodovico, the founder and elder of the two, only saw Rome for fourteen days and consequently was greatly inferior to his grandsons, especially Annibale, in drawing. They were eclectics and sought to combine the purity of the ancients and of Raphael, the knowledge of Michelangelo, the richness and the exuberance of the Venetian school, especially of Paolo Veronese, and the gaiety of the Lombard brush in Correggio. Domenichino, Guido Reni, Guercino and Francesco Albani trained in the school of Agostino and Annibale, and achieved the fame of their masters, but they must be regarded as imitators.

Domenichino studied the ancients more than any other follower of the Carracci and did not set to work before he had drawn even the smallest details, as one can see from, amongst other things, eight volumes of his drawings in the collection of Cardinal Alessandro Albani, which is now in the Royal Collection in England. But he did not achieve the purity of Raphael in drawing the nude. Guido Reni is not consistent, either in drawing or in execution: he recognized beauty, but did not always achieve it. His Apollo in the famous *Aurora*[19] is nothing less than a beautiful figure and like a servant to his master compared with the Apollo of Mengs amongst the Muses in the Villa Albani. The head of his *Archangel* is beautiful, but not ideal (Plate 18). He abandoned his original strong colour and adopted a light, insipid and weak manner. Guercino was not at his best with nudes and did not retain the stringency of the drawing of Raphael and the ancients whose garments and customs he had observed and imitated in a few works. His paintings are noble, but designed according to his own ideas, so that he, more than the aforementioned, can be called an original. Francesco Albani is the painter of grace, but not of the highest order, to which the ancients paid homage, but of the lowest; his heads are charming, rather than beautiful. After these indications, one can try to judge for oneself the beauty of individual figures in the work of other painters who may deserve it.

The beauty of composition consists in wisdom, that is, it should resemble a collection of civilized and wise people, not of wild and angry spirits, like those of Lafage. The second characteristic is thoroughness, that is, nothing in it should be unused and empty, nothing set, as with verses for the sake of the rhyme, so that the subordinate figures do not look like grafted twigs but like branches from the main trunk. The third quality is the avoidance of repetition in actions and positions, which show a poverty of ideas and carelessness. One does not admire great compositions as such: the 'machinists', or those who can quickly fill huge spaces with figures, like Lanfranco.

Quantity and quality are seldom to be found together; and the man who wrote to his friend: 'I have had no time to explain myself more briefly', knew that it is not *length* which is difficult, but brevity. Tiepolo did more in a day than Mengs in a week, but the former is seen and forgotten; the latter remains for ever. But if the great works are thoroughly studied in all their details, such as the *Last Judgment* of Michelangelo, of which there are many first, original sketches of a few figures and a pile of others, amongst the former Albani and now English royal drawings, and such as the *Battle of Constantine* by Raphael:[20] then, I say, we have a whole system of art in front of our eyes. An illustration of the above is the *Battle of Alexander against Porus* by Pietro da Cortona, in the Campidoglio, which is a medley of rapidly sketched and executed small figures, generally shown and seen as a miraculous work.

Colour receives its beauty from a flowing execution: for the many variations of the colours and their middle tints are not quickly found and applied. Not all great painters worked rapidly, and the school of Raphael, indeed all great colourists, made their works for examination at close range too. The latest foreign painters, of whom Carlo Maratta is the most distinguished, have painted rapidly and contented themselves with a general effect of their works, which lose a lot if one wants to examine them at length and at close range. These painters must have inspired the German proverb: 'Beautiful from a distance, like Italian paintings.' Here I make a distinction between frescoes and other paintings, since frescoes are not delicately executed because they have to be effective from a distance; likewise diligently finished and 'licked' paintings, which are painfully and

fearfully worked and recommend themselves more through diligence than true skill. But frescoes show the certainty and confidence, and the free brush loses nothing at close range and is far more effective from a distance than that of paintings. Of this latter type is the crown of all paintings in small scale in the world, namely the famous *Transfiguration* by Raphael (in the Palazzo Albani), which many regard as the work of the master himself, though some attribute it to his pupils.[21] Of the other sort is a *Descent from the Cross* by Van der Werff,[22] one of his best works, in that very place which the artist made for the Prince of the Palatinate as a present to Pope Clement XI. Correggio and Titian are the supreme masters in the colour of the nude: for their flesh is truth and life; Rubens, who is not ideal in drawing, is not ideal in this respect either; his flesh is like the redness of fingers held against the sun, and, compared with theirs, his colour is like a transparent glass composition compared with pure porcelain.

Few works of Caravaggio and Ribera can be beautiful with regard to light and shade: for they go against the nature of light. The basis for their dark shadows is the principle: contrasting objects are more effective if placed together, as is the case with white skin next to a dark dress. But nature does not work according to this principle; it proceeds gradually in light, shadow and darkness, and before the day comes the flush of dawn, before the night comes the dusk. Pedants in painting tend to esteem this black art, as pedants in scholarship do a few fusty writers. But a lover of art, who notices in himself a feeling for the beautiful, and who does not possess enough knowledge, will go astray if he hears paintings praised by apparent connoisseurs, where his sense tells him the opposite. If he has looked at the works of the masters, so that he has achieved absolutely necessary experience, he can allow his eye and his feeling to guide him more than an opinion which does not convince him. For there are people who only praise what does not please others, in order to put themselves above common opinion; just as the famous Maffei,[23] who was very shaky in Greek, considered the gloomy and forced Nicander to be equal to Homer, in order to say something different and to make people believe that he had read and understood his hero. The lover of art can be assured that if it were not necessary to know the style of certain masters, the

101

paintings of Luca Giordano, Preti, Solimena and altogether all Neapolitan painters, are hardly worth the time to examine them: this can be said of the modern Venetian painters, especially of Piazzetta.

I shall add the following reminders to this study of beauty in art: one should above all be mindful of special and original thoughts in the works of art which sometimes stand like costly pearls in a rope of inferior ones and can be lost among them. Our consideration should commence with the effects of the intellect as the most worthy part of beauty, and from there proceed to the execution. This is especially to be borne in mind with Poussin's works, where the eye is not stimulated by the colour and thus could overlook its great distinction. This artist has represented the words of the apostle, 'I have fought a good fight', in the painting of the *Extreme Unction* by a sign about the bed of the dying man, on which the name of Christ appears as on the old Christian lamps; beneath this hangs a quiver, which could signify the arrows of the devil.[24] *The Plague of Ashdod* is expressed in two persons, who give the sick man their hands and hold their noses.[25] A noble thought is the panting hart at the water in the famous *Io* by Correggio,[26] taken from the words of the Psalmist, 'As the hart panteth etc.', as a pure image of the ardour of Jupiter: for in Hebrew 'the cry of the hart' means at the same time 'to demand something passionately and ardently'. The *Fall of the First Man* by Domenichino in the Colonna Gallery[27] is beautifully conceived: the Almighty, borne by a choir of angels, reproaches Adam with his crime; the latter puts the blame on Eve, and Eve puts it on the snake, which creeps under her; and these figures are represented in stages, as is the action, and in a chain of connected action, one on top of the other.

The second reminder will be the observation of nature. Art, as an imitator of nature, should at all times aim at what is natural in the creation of beauty, and should as far as possible avoid what is violent, since even the beauty in life can be displeasing if the gestures are forced. Just as applied knowledge has to give way to clear and intelligible instruction in a book, art should do likewise to nature there, and art should be weighed up against Nature. Great artists have acted against this principle, the main figure in this case being Michelangelo, who, in order to show his knowledge, even overlooked the indecency of the figures on the graves

of the grand dukes.[28] For this reason one should not look for beauty in extreme foreshortening; for this is like the contrived brevity of Cartesius' geometry and it conceals what should be visible; it could be proof of skill in drawing, but not of knowledge of beauty.

The third reminder refers to execution. Since this cannot be the first and greatest aim, one should overlook the artificialities in it as one would beauty-spots, for here the artists from the Tyrol, who have carved the whole Lord's Prayer in relief on a cherry-stone, could contend with any-one for pride of place. But where minor details have been just as diligently executed as the main subject, as is the case with the plants in the fore-ground of the *Transfiguration of Christ*, it is an indication of the artist's uniformity in thought and execution, which, like the Creator, try to appear great and beautiful even on the smallest scale. Maffei, who claims, although erroneously, that the old engravers of stone knew how to make the background of their hollowed-out figures more smooth than the modern engravers are able to, must have been more attentive to the inessentials of art than the essential. The smoothness of the marble is therefore not a quality of a statue, like the smoothness of a garment, but at the most like the smooth surface of the sea: for there are statues, and indeed, some of the most beautiful, which have not been polished.

This can be considered to be sufficient for the intention of this outline, which is meant to be general. The greatest clarity cannot be given to things which rely on feeling, and here not everything can be taught in writing, as, amongst others, is proved by the criteria which Argenville presumes to give in his lives of artists[29] about their drawings. Here it is stated: Go hither and look.

4 History of Ancient Art [1764][1]

PREFACE

THE HISTORY OF ANCIENT ART which I have undertaken to write is not a mere chronicle of epochs, and of the changes which occurred within them. I use the term history in the more extended signification which it has in the Greek language; and it is my intention to attempt to present a system. In the first part, the treatise on the art of ancient nations, I have sought to execute this design in regard to the art of each nation individually, but specially in reference to that of the Greek. The second part contains the history of art in a more limited sense, that is to say, as far as external circumstances were concerned, but only in reference to the Greeks and Romans. In both parts, however, the principal object is the essential of art, on which the history of the individual artists has little bearing.

The History of Art is intended to show the origin, progress, change, and downfall of art, together with the different styles of nations, periods, and artists, and to prove the whole, as far as it is possible, from the ancient monuments now in existence.

A few works have been published under the title of a *History of Art*. Art, however, had but a small share in them, for their authors were not sufficiently familiar with it, and therefore could communicate nothing more than what they had learned from books or hearsay. There is scarcely one who guides us to the essential of art, and into its interior; and those who treat of antiquities either touch only on those points in which they can exhibit their learning, or, if they speak of art, they do so either in general terms of commendation, or their opinion is based on strange and false grounds.

In the large and valuable works descriptive of ancient statues which have hitherto been published, we seek in vain for research and knowledge in regard to art. The description of a statue ought to show the cause of its beauty, and the peculiarity in its style. It is necessary, therefore, to touch upon particulars in art before it is possible to arrive at a judgment on works of art. But where are we taught the points in which the beauty of a statue consists? What writer has looked at beauty with an artist's eyes?

104

Descriptions of extant antiquities, of the galleries and villas at Rome, afford quite as little instruction: they rather mislead than instruct.

Richardson has described the palaces and villas in Rome, and the statues in them,[2] like one who had seen them only in a dream. Many palaces he did not see at all, on account of his brief stay in the city, and some, according to his own statement, he visited but once; and yet his work, in despite of its many deficiencies and errors, is the best we have.

Montfaucon, having compiled his work at a distance from the treasuries of ancient art, saw with the eyes of others, and formed his opinions from engravings and drawings, by which he has been led into great errors. *Hercules and Antaeus*, in the Palazzo Pitti, Florence,—a statue of inferior rank, and of which more than one half is of modern restoration,—is, according to him and Maffei, nothing less than a work of Polycleitus. The statue of *Sleep*, of black marble, by Algardi, in the Villa Borghese,[3] he pronounces an antique.

The mistakes of learned men in regard to things of antiquity proceed mostly from inattention to restoration, as many of them have been unable to distinguish the repairs by which mutilated and lost portions have been replaced.

Hence it is difficult, indeed almost impossible, to write in a thorough manner of ancient art, and of unknown antiquities, anywhere but in Rome. Even a residence there of two years is insufficient for the purpose, as I learn by the laborious preparation required in my own case.

From youth upward, a love for art has been my strongest passion; and though education and circumstances led me in quite another direction, still my natural inclination was constantly manifesting itself. All the pictures and statues, as well as engraved gems and coins, which I have adduced as proofs, I have myself seen, and seen frequently, and been able to study; but for the purpose of aiding the reader's conception, I have cited, besides these, both gems and coins from books, whenever the engravings of them were tolerably good.

As Greek art is the principal point which this *History* has in view, I have, consequently, been obliged in the chapter upon it to enter more into detail; yet I should have been able to say more if I had written for the Greeks, and not in a modern tongue, which imposes on me certain

restrictions. For this reason, I have, although reluctantly, left out a *Dialogue upon Beauty*, after the manner of the *Phaedrus of Plato*, which would have served to elucidate my remarks when speaking of it theoretically.

The *History of Art* I dedicate to Art and the Age, and especially to my friend, Anton Raphael Mengs.

BOOK I: THE ORIGIN OF ART, AND THE CAUSES OF ITS DIFFERENCE AMONG DIFFERENT NATIONS

Chapter I: The Shapes with which Art Commenced

The arts which are dependent on drawing have, like all inventions, commenced with the necessary; the next object of research was beauty; and, finally, the superfluous followed: these are the three principal stages in art.

In the infancy of art, its productions are, like the handsomest of human beings at birth, misshapen, and similar one to another, like the seeds of plants of entirely different kinds; but in its bloom and decay, they resemble those mighty streams, which, at the point where they should be the broadest, either dwindle into small rivulets, or totally disappear.

The art of drawing among the Egyptians is to be compared to a tree which, though well cultivated, has been checked and arrested in its growth by a worm, or other casualties; for it remained unchanged, precisely the same, yet without attaining its perfection, until the period when Greek kings held sway over them; and the case appears to have been the same with Persian art. Etruscan art, when in its bloom, may be compared to a raging stream, rushing furiously along between crags and over rocks; for the characteristics of its drawing are hardness and exaggeration. But, among the Greeks, the art of drawing resembles a river

106

whose clear waters flow in numerous windings through a fertile vale, and fill its channel, yet do not overflow.

As art has been devoted principally to the representation of man, we might say of him more correctly than Protagoras did, that 'he is the measure and rule of all things'. The most ancient records also teach us, that the earliest essays, especially in the drawing of figures, have represented, not the manner in which a man appears to us, but what he is; not a view of his body, but the outline of his shadow. From this simplicity of shape the artist next proceeded to examine proportions; this inquiry taught exactness; the exactness hereby acquired gave confidence, and afterwards success, to his endeavours after grandeur, and at last gradually raised art among the Greeks to the highest beauty. After all the parts constituting grandeur and beauty were united, the artist, in seeking to embellish them, fell into the error of profuseness; art consequently lost its grandeur; and the loss was finally followed by its utter downfall.

In the course of time, increasing knowledge taught the Etruscan and Greek artists how to forsake the stiff and motionless conformations of their earliest essays, to which the Egyptians adhered,—compulsorily adhered,—and enabled them to express different actions in their figures. But, in art, knowledge precedes beauty; being based on exact, severe rules, its teachings at the beginning have necessarily a precise and vigorous definiteness. Consequently, the style of drawing was regular, but angular; expressive, but hard, and frequently exaggerated,—as the Etruscan works show. This is just the way in which sculpture has been improved in modern days by the celebrated Michelangelo. Works in this style have been preserved on reliefs in marble, and on engraved gems.

[Chapter II: *Materials Used in Statuary* omitted]

Chapter III: Influence of Climate on Conformation

That noble beauty which consists not merely in a soft skin, a brilliant complexion, wanton or languishing eyes, but in the shape and form, is

found more frequently in countries which enjoy a uniform mildness of climate. Beauty, however, was not a general quality, even among the Greeks.

In Athens, where, after the expulsion of the tyrants, a democratic form of government was adopted, in which the entire people had a share, the spirit of each citizen became loftier than that of the other Greeks, and the city itself surpassed all other cities. As good taste was now generally diffused, and wealthy burghers sought to gain the respect and love of their fellow-citizens by erecting splendid public buildings and by works of art, and thus prepare the way to distinction, everything flowed into this city, in consequence of its power and greatness, even as rivers flow towards the sea. Here the arts and sciences established themselves; here they formed their principal residence; and hence they went abroad into other lands. We may find proof that the causes just mentioned [temperate climate and mild rule] will account for the progress of the arts in Athens, in a similar state of things at Florence, where, after a long interval of darkness, the arts and sciences began, in modern times, to be relumined.

BOOK II: ART AMONG THE EGYPTIANS, PHOENICIANS, AND PERSIANS

Chapter I: Causes of the Peculiar Character of Egyptian Art

The abhorrence felt by the Egyptians for Greek customs—especially before they fell under the sovereignty of the Greeks—strengthened them in their religious use of the form which they had anciently adopted for the images of their worship; and this feeling, necessarily, would make their artists very indifferent to the art of other nations; and, consequently, would check the progress of knowledge as well as of art. As their physicians durst prescribe no other remedies than those recorded in the sacred

books, so their artists were not permitted to deviate from the ancient style; for their laws allowed no further scope to the mind than mere imitation of their forefathers, and prohibited all innovations.

[Further account of Egyptian art omitted, and also chapter on Phoenician and Persian art]

BOOK III: ART OF THE ETRUSCANS AND THEIR NEIGHBOURS

Chapter I: Preliminary Remarks

Etruria, tranquil and industrious, won and maintained for herself a degree of respect greater than was paid to any other nation of Italy; and she attracted the entire trade, not only of the Etruscan Sea, but also of the Ionian. In this flourishing condition of the ancient nation of the Etruscans, united with the Tyrrhenians, the arts were blooming at a time when the first essays in them in Greece had come to naught; and numerous specimens of their productions plainly show that they were executed before the Greeks themselves were able to produce any work of shapely appearance.

This brief sketch of the earliest history of the Etruscans reaches, however, to the period when the arts flourished among them; and, owing to the favourable external circumstances of which mention has been made, they ought to have attained the highest state of perfection. But as this point was not reached, and as an excessive degree of hardness continued to characterize the drawing of their artists, the cause of the failure apparently lay in the character and temperament of the Etruscans.

The disposition of the Etruscans appears to have been more tinged with melancholy than was the case with the Greek race,—as we may infer from their religious services and their customs. Such a temperament is

fitted to profound investigation, but it gives rise to emotions of too violent a nature, and the senses are not affected with that gentle agitation which renders the soul perfectly susceptible to beauty. This conjecture is grounded, in the first place, on the practice of soothsaying, which was invented, in the West, by this people; hence Etruria is called the mother and producer of superstition; and the books in which the art of divination was written filled with fear and terror those who had recourse to them for advice,—so terrible were the figures and words in which they were composed.

But the prosperity of the Etruscans did not last long enough to enable them to overcome nature, and her influence upon art. Soon after the establishment of the Republic at Rome, they were engaged in bloody and unsuccessful wars with the Romans.

Chapter II: Conformation of Gods and Heroes, Peculiar to the Etruscans

To us the representation of several of the Etruscan divinities appears strange; but there were strange and extraordinary shapes among the Greeks also. As the heated and undisciplined imagination of the earliest poets sought for strange figures, and those which would make more impression upon the rude men of the times than pictures of beauty and tenderness,—partly to excite attention and wonder, and partly to arouse the passions,—so too, and for the same reasons, art also in her infancy shaped forms of a similar kind. The conception of a Jupiter, enveloped in the dung of horses and other animals,—as he is represented by the poet Pampho, who lived before Homer,—is not more strange than is, in the art of the Greeks, the image of Apomyos or Muscarius, whose figure is borrowed from a fly, so that the wings form the beard; the belly forms the face; and on the head, in the place of hair, is the head of the fly.

[Winckelmann mentions several sculptures, including the famous bronze *Chimera* in the Archaeological Museum, Florence]

Chapter III: Style of Etruscan Artists

The attributes of the elder and first style of the Etruscan artists are, in the first place, the straight lines of their drawing, together with the stiff attitudes and constrained action of their figures, and, in the second place, their imperfect idea of beauty of the face. The first attribute consists in this, that the outline of the figures sinks and swells but little; the consequence is, the figures look thin and spindle-like,—because the muscles are slightly marked. This style is, consequently, deficient in variety. The cause of the stiffness in the attitudes is to be found partly in the mode of drawing, but principally in the ignorance of the earliest ages.

This first style is found in many small bronze figures, in addition to the coins mentioned; and some of them perfectly resemble the Egyptian in the arms and feet, the former hanging down close to the sides, and the latter being placed parallel to each other.

Notwithstanding all this want of skill in the drawing of figures, the earliest Etruscan artists attained, in their vases, to the knowledge of elegance of forms; that is, they had learnt that which is simply ideal and scientific, and had, on the contrary, continued deficient in the excellence acquired by imitation. This fact is shown by many vases, the drawing of the pictures on which indicates the very earliest style.

We pass, therefore, from the first and more ancient Etruscan style to the second and subsequent. Its attributes and marks are, in part, a perceptible signification of the joints and muscles, and the arrangement of the hair in rows, and partly a constrained attitude and action, which in some figures is violent and exaggerated.

It may be established as a rule, generally, that the Greeks studied more the expression and marking of the muscles; but the Etruscans, of the bones.

This second style, compared with the Greek style of a good period, might be looked upon as a young man who has not enjoyed the advantages of a careful education, and whose desires and exuberant spirits, which impel him to acts of excess, have been left unchecked.

These characteristics of the ancient Etruscan artists still show forth, in modern days, in the works of their descendants, and to the eyes of

impartial connoisseurs manifest themselves in the drawings of Michelangelo, the greatest among them. Hence some one says, not without reason, that whoever has seen one figure by this artist, has seen them all. This mannerism also is, unquestionably, one of the imperfections of Daniel da Volterra, Pietro da Cortona, and others.

Chapter IV: Art of the Nations Bordering on the Etruscans

The drawing on most of the vases is of such a quality, that the figures might deservedly have a place in a drawing by Raphael; and it is remarkable, that no two are found with pictures of precisely the same kind. Whoever studies and is able to comprehend the masterly and elegant drawing on them, and knows the mode of proceeding in laying the colours on baked works of a similar kind, will find in this sort of painting the strongest proof of the great correctness, and dexterity too, of the artists in drawing. For these vases are painted not otherwise than our pottery, or the common porcelain. Painting of this kind requires to be executed dexterously and rapidly; for all burnt clay instantly absorbs the moisture from the colours and the pencil, even as a parched and thirsty soil absorbs the dew, so that, if the outlines are not drawn rapidly with a single stroke, nothing remains in the pencil but an earthy matter. Consequently, as breaks, or lines joined and again commenced, are not generally found, every line of the contour of the figure must be drawn with an unbroken sweep; this must seem almost miraculous, when we consider the quality of the figures. We must also reflect, that, in this sort of workmanship, no change or amendment is possible; as the outlines are drawn, so they must remain. As the smallest, meanest insects are wonders in nature, so these vases are a wonder in the art and manner of the ancients; and as, in Raphael's first sketches of his ideas, the outline of a head, and even entire figures, drawn with a single unbroken sweep of the pen, show the master to the connoisseur not less than his finished drawings, so the great facility and confidence of the ancient artists are more apparent

in the vases than in other works. A collection of them is a treasure of drawings.

[Winckelmann concludes the chapter with a brief discussion of Sardinian bronzes]

BOOK IV: ART AMONG THE GREEKS

Chapter I: Grounds and Causes of the Progress and Superiority of Greek Art Beyond That of Other Nations

The superiority which art acquired among the Greeks is to be ascribed partly to the influence of climate, partly to their constitution and government, and the habits of thinking which originated therefrom, and, in an equal degree also, to respect for the artist, and the use and application of art.

The influence of climate must vivify the seed from which art is to be produced; and for this seed Greece was the chosen soil. The talent for philosophy was believed by Epicurus to be exclusively Greek; but this pre-eminence might be claimed more correctly for art. The Greeks acknowledged and prized the happy clime under which they lived, though it did not extend to them the enjoyment of a perennial spring; for, on the night when the revolt against the Spartan government broke out in Thebes, it snowed so violently as to confine every one to the house. Moderateness of temperature constituted its superiority, and is to be regarded as one of the more remote causes of that excellence which art attained among the Greeks. The climate gave birth to a joyousness of disposition; this, in its turn, invented games and festivals; and both together fostered art, which had already reached its highest pinnacle at

a period when that which we call learning was utterly unknown to the Greeks.

Much that might seem ideal to us was natural among them. Nature, after having passed step by step through cold and heat, established herself in Greece. Here, where a temperature prevails which is balanced between winter and summer, she chose her central point; and the nigher she approaches it, the more genial and joyous does she become and the more general is her influence in producing conformations full of spirit and wit, and features strongly marked and rich in promise.

Since, therefore, beauty was thus desired and prized by the Greeks, nothing was concealed which could enhance it. Every beautiful person sought to become known to the whole nation by this endowment, and especially to please the artists, because they decreed the prize of beauty; and, for this very reason, they had an opportunity of seeing beauty daily. Beauty was an excellence which led to fame.

To the same influence, in an equal degree, which the atmosphere and climate exercised upon the physical conformation are to be ascribed their kindly natures, their gentle hearts, and joyous dispositions,—qualities that contributed fully as much to the beautiful and lovely images which they designed, as nature did to the production of the form. History convinces us that this was their character. The humanity of the Athenians is as well known as their reputation in the arts.

This is more easily understood by contrasting the Greeks with the Romans. The inhuman, sanguinary games, and the agonizing and dying gladiators, in the amphitheatres of the latter, even during the period of their greatest refinement, were the most gratifying sources of amusement to the whole people. The former, on the contrary, abhorred such cruelty; and, when similar fearful games were about to be introduced at Corinth, some one observed, that they must throw down the altar of Mercy and Pity, before they could resolve to look upon such horrors. The Romans, however, finally succeeded in introducing them even at Athens.

The humanity of the Greeks and the fierceness of the Romans, are, moreover, manifest from the mode in which they respectively conducted their wars.

The independence of Greece is to be regarded as the most prominent

of the causes, originating in its constitution and government, of its superiority in art. Liberty had always held her seat in this country, even near the throne of kings,—whose rule was paternal,—before the increasing light of reason had shown to its inhabitants the blessings of entire freedom. Thus, Homer calls Agamemnon a shepherd of his people, to signify his love for them, and his solicitude for their welfare.

Art was, indeed, employed very early, to preserve the remembrance of individuals; and such a mode of commemoration was free to every Greek. It was even allowable to set up in the temples the statues of one's children.

Next to these causes, the reverence for statues may be regarded as among the most prominent. For it was maintained that the oldest images of the deities—the artists of which were unknown—had fallen from heaven.

Besides this superstitious belief, the gaiety of the Greeks had also an influence upon the general progress of art. The artist, even in the earliest ages, was occupied in executing statues of the victors in the numerous games then celebrated, which he was required to make in the likeness of the individuals, and not above the size of life.

The thoughts of the whole people rose higher with freedom, just as a noble branch rises from a sound stock. As the mind of a man accustomed to reflection is usually more elevated in the broad fields, on the public highway, and on the summit of an edifice, than in an ordinary chamber, or in a confined space, so, also, the manner of thinking among the free Greeks must have been very different from that of nations living under more arbitrary forms of government.

The freedom which gave birth to great events, political changes, and jealousy among the Greeks, planted, as it were in the very production of these effects, the germ of noble and elevated sentiments. As the sight of the boundless surface of the sea, and the dashing of its proud waves upon the rocky shore, expands our views and carries the soul away from, and above, inferior objects, so it was impossible to think ignobly in the presence of deeds so great and men so distinguished. The Greeks, in their palmy days, were a thinking people. At an age when we do not generally begin to judge for ourselves, they had already exerted their reasoning

115

faculties for twenty years or more; they employed their intellectual powers at the period when they are brightest and strongest and are sustained by the vigour and sprightliness of the body, which, among us, is ignobly nourished until it decays.

The reputation and success of artists were not dependent upon the caprice of ignorance and arrogance, nor were their works fashioned to suit the wretched taste or the incompetent eye of a judge set up by flattery and fawning; but the wisest of the whole nation, in the assembly of united Greece, passed judgment upon, and rewarded, them and their works; and at Delphos, as well as at Corinth, contests in painting, for which judges were specially appointed, were instituted in the time of Phidias.

Hence, the artist wrought for immortality; and the value set upon his works placed him in a position to elevate his art above all mere mercenary considerations. Thus, it is known that Polygnotus gratuitously embellished with paintings the Portico at Athens, and also, as it appears, a public edifice at Delphos, in which he represented the taking of Troy.

In general, excellence in art and handiwork of every kind was particularly prized; the best workman in the most humble craft might succeed in rendering his name immortal; and we are told that the Greeks were accustomed to pray the gods that their memories might never die. Plato himself has immortalized in his works Thearion, a baker, on account of his skill in his handicraft, as well as Sarambus, a clever vintner.[4]

The uses to which art was applied sustained its greatness. Being consecrated to the gods, and devoted only to the holiest and best purposes in the land, at the same time that economy and simplicity characterized the abodes of the citizens, the artist was not cramped in the grandeur of his subject or of his conceptions to suit the size of the dwelling or gratify the fancy of its proprietor, but his work was made to conform to the lofty ideas of the whole nation. We know that Miltiades, Themistocles, Aristides, and Cimon, the leaders and deliverers of Greece, resided in no better houses than their neighbours.

The arts of sculpture and painting attained among the Greeks a certain excellence earlier than architecture, because the latter has in it more of the ideal than the two former; it cannot be an imitation of anything actual, and must therefore, of necessity, be based on the general principles

and rules of proportion. The two former, which originated in mere imitation, found all the requisite rules determined in man; whereas, architecture was obliged to discover its own rules by repeated trials, and establish them by general approval.

Sculpture, however, outstripped painting, and, like an elder sister, served as a guide to the younger. Pliny, indeed, is of opinion that painting had no existence at the date of the Trojan war. The Jupiter of Phidias and the Juno of Polycleitus, the most perfect statues of antiquity, were in being before light and shadow had been introduced into painting.

Chapter II: The Essential of Art

But how has it happened, that, whilst well-grounded elementary treatises on all other departments of knowledge exist, the principles of art and of beauty have been so little investigated? The fault, reader, lies in our innate indolent unwillingness to think for ourselves, and in scholastic philosophy. On the one hand, the ancient works of art have been regarded as beauties which one can never hope fully to enjoy, and which on this account easily warm some imaginations, but do not touch the heart; and antiquities have given occasion for the display of reading only, but have ministered little nutriment, or absolutely none at all, to the understanding. On the other hand, philosophy has been practised and taught principally by those who, from reading the works of their gloomy predecessors, have but little room left for the feelings, over which they have, as it were, drawn an insensible cuticle, and we have consequently been led through a labyrinth of metaphysical subtlety and wordiness, which have principally served the purpose of producing big books, and disgusting the understanding.

Beauty is one of the great mysteries of nature, whose influence we all see and feel; but a general, distinct idea of its essential must be classed among the truths yet undiscovered. If this idea were geometrically clear, men would not differ in their opinions upon the beautiful, and it would be easy to prove what true beauty is.

[In some nations] the climate has not allowed the gentle feeling of pure beauty to mature; it has either been confirmed in them by art,—that is, by constantly and studiously employing their scientific knowledge in the representation of youthful beauties,—as in Michelangelo, or become in time utterly corrupted, as was the case with Bernini, by a vulgar flattery of the course and uncultivated, in attempting to render everything more intelligible to them. The former busied himself in the contemplation of lofty beauty; Michelangelo, compared with Raphael, is what Thucydides is to Xenophon. The very course which led Michelangelo to impassable places and steep cliffs plunged Bernini, on the contrary, into bogs and pools; for he sought to dignify, as it were, by exaggeration.

Colour assists beauty; generally, it heightens beauty and its forms, but it does not constitute it; just as the taste of wine is more agreeable, from its colour, when drunk from a transparent glass, than from the most costly golden cup. Colour, however, should have but little share in our consideration of beauty, because the essence of beauty consists, not in colour, but in shape, and on this point enlightened minds will at once agree. As white is the colour which reflects the greatest number of rays of light, and consequently is the most easily perceived, a beautiful body will, accordingly, be the more beautiful the whiter it is, just as we see that all figures in gypsum, when freshly formed, strike us as larger than the statues from which they are made.

The highest beauty is in God; and our idea of human beauty advances towards perfection in proportion as it can be imagined in conformity and harmony with that highest Existence which, in our conception of unity and indivisibility, we distinguish from matter. This idea of beauty is like an essence extracted from matter by fire; it seeks to beget unto itself a creature formed after the likeness of the first rational being designed in the mind of the Divinity. The forms of such a figure are simple and flowing, and various in their unity; and for this reason they are harmonious, just as a sweet and pleasing tone can be extracted from bodies the parts of which are uniform. All beauty is heightened by unity and simplicity, as is everything which we do and say; for whatever is great in itself is elevated, when executed and uttered with simplicity. It is not more strictly circumscribed, nor does it lose any of its greatness, because the

mind can survey and measure it with a glance, and comprehend and embrace it in a single idea; but the very readiness with which it may be embraced places it before us in its true greatness, and the mind is enlarged, and likewise elevated, by the comprehension of it. Everything which we must consider in separate pieces, or which we cannot survey at once, from the number of its constituent parts, loses thereby some portion of its greatness, just as a long road is shortened by many objects presenting themselves on it, or by many inns at which a stop can be made. The harmony which ravishes the soul does not consist in arpeggios, and tied and slurred notes, but in simple, long-drawn tones. This is the reason why a large palace appears small, when it is over-loaded with ornament, and a house large, when elegant and simple in its style.

From unity proceeds another attribute of lofty beauty, the absence of individuality; that is, the forms of it are described neither by points nor lines other than those which shape beauty merely, and consequently produce a figure which is neither peculiar to any particular individual, nor yet expresses any one state of the mind or affection of the passions, because these blend with it strange lines, and mar the unity. According to this idea, beauty should be like the best kind of water, drawn from the spring itself; the less taste it has, the more healthful it is considered, because free from all foreign admixture. As the state of happiness—that is, the absence of sorrow, and the enjoyment of content—is the very easiest state in nature, and the road to it is the most direct, and can be followed without trouble and without expense, so the idea of beauty appears to be the simplest and easiest, requiring no philosophical knowledge of man, no investigation and no expression of the passions of his soul.

Since, however, there is no middle state in human nature between pain and pleasure, even according to Epicurus, and the passions are the winds which impel our bark over the sea of life, with which the poet sails, and on which the artist soars, pure beauty alone cannot be the sole object of our consideration; we must place it also in a state of action and of passion, which we comprehend in art under the term *expression*. We shall, therefore, in the first place, treat of the shape of beauty, and in the second place, of expression.

The shape of beauty is either *individual*,—that is, confined to an imitation of one individual,—or it is a selection of beautiful parts from many individuals, and their union into one, which we call *ideal*, yet with the remark that a thing may be ideal without being beautiful. The form of the Egyptian figures, in which neither muscles, tendons, nor veins are indicated, is ideal, but still it shapes forth no beauty in them; neither can the drapery of Egyptian female figures—which can only be imagined, and consequently is ideal—be termed beautiful.

The conformation of beauty commenced with individual beauty, with an imitation of a beautiful male form, even in the representation of the gods; and, in the blooming days of sculpture, the statues of goddesses were actually made after the likeness of beautiful women.

To each age, even as to the goddesses of the seasons, there belongs its peculiar beauty, but differing in degree. It is associated especially with youth, which it is the great effort of art to represent. Here, more than in manhood, the artist found the cause of beauty, in unity, variety, and harmony. The forms of beautiful youth resemble the unity of the surface of the sea, which at some distance appears smooth and still, like a mirror, although constantly in movement with its heaving swell. The soul, though a simple existence, brings forth at once, and in an instant, many different ideas; so it is with the beautiful youthful outline, which appears simple, and yet at the same time has infinitely different variations, and that soft tapering which is difficult of attainment in a column is still more so in the diverse forms of a youthful body.

But nature and the structure of the most beautiful bodies are rarely without fault. They have forms which can either be found more perfect in other bodies, or which may be imagined more perfect. In conformity to this teaching of experience, those wise artists, the ancients, acted as a skilful gardener does, who ingrafts different shoots of excellent sorts upon the same stock; and, as a bee gathers from many flowers, so were their ideas of beauty not limited to the beautiful in a single individual,[5]—as at times are the ideas of both ancient and modern poets, and of the majority of artists of the present day,—but they sought to unite the beautiful parts of many beautiful bodies; this we learn also from the dialogue between Socrates and the celebrated painter Parrhasius. They purified their images

from all personal feelings, by which the mind is diverted from the truly beautiful.

This selection of the most beautiful parts and their harmonious union in one figure produced ideal beauty,—which is therefore no metaphysical abstraction; so that the ideal is not found in every part of the human figure taken separately, but can be ascribed to it only as a whole; for beauties as great as any of those which art has ever produced can be found singly in nature, but, in the entire figure, nature must yield the palm to art.

By the ideal is to be understood merely the highest possible beauty of the whole figure, which can hardly exist in nature in the same high degree in which it appears in some statues; and it is an error to apply the term to single parts, in speaking of beautiful youth. Even Raphael and Guido Reni seem to have fallen into the mistake alluded to. The former when about to paint the *Galatea*, in the Farnesina, writes to his friend, the distinguished Count Balthazar Castiglione: 'in order to select a beautiful woman, one must see those who are more beautiful; but, as beautiful women are rare, I make use of a certain image supplied by my imagination.' But the conception of the head of his *Galatea* is common; women of greater beauty are to be found everywhere. Moreover, the figure is so disposed, that the breast, the most beautiful part of the naked female form, is completely covered by one arm, and the knee which is in view is much too cartilaginous for a person of youthful age, to say nothing of a divine nymph. When Guido was preparing to paint his *Archangel Michael* (Plate 18), he wrote to a Roman prelate,—'I should like to give to the figure I am about to paint beauty such as that which dwells in Paradise, irradiated by the glories of heaven; but I have not yet been able to rise so high, and I have sought it, in vain on earth.' Nevertheless, his *Archangel* is less beautiful than some young men I have known, and still know.

In this respect the ancient artists have risen to the ideal, not only in the conformation of the face, but also in the youthful figures of certain gods, as Apollo and Bacchus. This ideal consists in the incorporation of the forms of prolonged youth in the female sex with the masculine forms of a beautiful young man, which they consequently made plumper, rounder, and softer, in admirable conformity with their ideas of their deities. For

to some of these the ancients gave both sexes, blended with a mystic significance in one.

BOOK V: ART AMONG THE GREEKS (continued)

Chapter I: The Conformation and Beauty of the Male Deities and Heroes

Ideal beauty, however, exists not only in the spring-time of life, and in youthful or female figures, but also in manhood, to which the ancient artists, in the statues of their deities, imparted the joyousness and freshness of youth. In Jupiter, Neptune, and an Indian Bacchus, the beard and venerable head-hair are the sole marks of age; it is not denoted either by wrinkles, projecting cheek-bones, or hollow temples. The cheeks are less full than in youthful divinities, and the forehead is usually more rounded. This conformation is in keeping with their admirable conception of the divine nature, which neither suffers change from time, nor passes through gradations of age, and in regard to which we must think of existence without succession. Such elevated ideas of the godhead ought to be peculiar to our artists, rather than to the ancients; and yet, in most of the figures of the Eternal Father we see an aged man, with a bad head. Even Jupiter himself is represented by the school of Raphael, in the *Feast of the Gods*, in the Farnesina, with the hair of the head, as well as of the beard, snow-white.

The artist shaped the forms of heroes heroically, and gave to certain parts a preternatural development; placed in the muscles quickness of action and of motion; and in energetic efforts brought into operation all the motive powers of nature. The object which he sought to attain was variety in its utmost extent; and in this respect, Myron exceeded all his

predecessors. It is visible even in the *Gladiator*, in the Villa Borghese. The serrated muscles on the sides, as well as others, are more prominent, active, and contractile than is natural. The same thing is yet more clearly seen, in the same muscles, in the *Laocoon*, if this portion of the body be compared with the corresponding portion in deified or godlike figures, as the *Hercules* and *Apollo* of the Belvedere (Plates 9, 10). The action of these muscles, in the *Laocoon*, is carried beyond truth to the limits of possibility; they lie like hills which are drawing themselves together,— for the purpose of expressing the extremest exertion in anguish and resistance.

Chapter II: The Conformation and Beauty of the Female Deities and Heroines

Among the goddesses, Venus stands fairly pre-eminent, not only as the goddess of beauty, but because she alone, with the Graces, and the Seasons or Hours, is undraped, and also because she is found represented more frequently than any other goddess, and in different ages.[6] The Medici *Venus*, at Florence (Plate 22), resembles a rose which, after a lovely dawn, unfolds its leaves to the rising sun; resembles one who is passing from an age which is hard and somewhat harsh—like fruits before their perfect ripeness—into another, in which all the vessels of the animal system are beginning to dilate, and the breasts to enlarge, as her bosom indicates,— which, in fact, is more developed than is usual in tender maidens.

Chapter III: The Expression of Beauty in Features and Action

In art, the term *expression* signifies imitation of the active and passive states of the mind and body, and of the passions as well as of the actions. In its widest sense it comprehends action; but in its more limited meaning, it is restricted to those emotions which are denoted by looks and the

features of the face. Action relates rather to the movements of the limbs and the whole body; it sustains the expression.

Repose and equanimity, in their highest degree, are incompatible with action. The most elevated idea of beauty, therefore, can neither be aimed at, nor preserved, even in figures of the deities, who must of necessity be represented under a human shape. But the expression was made commensurate, as it were, with the beauty, and regulated by it.

Repose and stillness are likewise to be regarded as a consequence of the propriety which the Greeks always endeavoured to observe both in feature and action, insomuch that even a quick walk was regarded as, in a certain measure, opposed to their ideas of decorum. It seemed to involve a kind of boldness.

The highest conception of these principles, especially of repose and stillness, is embodied in the figures of the divinities, which, from the father of the gods down to the inferior deities, show no trace of emotion. Thus, Homer pictures to us his Jupiter as shaking Olympus solely by the bending of his eyebrows and the waving of his hair. Most of the images of the gods are equally tranquil and passionless.

The *Apollo Belvedere* was intended to represent this deity in a state of anger over the serpent, Python, slain by his arrows, and at the same time with a feeling of contempt for his victory, which to a god was an easy achievement (Plates 9, 13). As the skilful artist wished to personify the most beautiful of the gods, he expressed only the anger in the nose, and the contempt on the lips. The latter emotion is manifested by the elevation of the lower lip, by which the chin is raised at the same time; the former is visible in the dilated nostrils.

In representing heroes, the artist is allowed less licence than the poet. The latter can depict them according to their times, when the passions were as yet unrestrained by social laws or the artificial proprieties of life, because the qualities ascribed to a man have a necessary relation to his age and standing, but none necessarily to his figure. The former, however, being obliged to select the most beautiful parts of the most beautiful conformations, is limited, in the expression of the passions, to a degree which will not conflict with the physical beauty of the figure which he models.

The truth of this remark is apparent in two of the most beautiful works of antiquity. One of them is a representation of the fear of death; the other, of extreme suffering and pain (Plates 12, 10). The daughters of Niobe, at whom Diana has aimed her fatal shafts, are represented in that state of indescribable anguish, their senses horror-struck and benumbed, in which all the mental powers are completely overwhelmed and paralysed by the near approach of inevitable death. The transformation of Niobe into a rock, in the fable, is an image of this state of deathlike anguish; and for this reason Aeschylus introduced her as a silent personage in his tragedy on this subject. A state such as this, in which sensation and reflection cease, and which resembles apathy, does not disturb a limb or a feature, and thus enabled the great artist to represent in this instance the highest beauty just as he has represented it; for Niobe and her daughters are beautiful according to the highest conceptions of beauty.

Laocoon is an image of the most intense suffering. It manifests itself in his muscles, sinews, and veins. The poison introduced into the blood, by the deadly bite of the serpents, has caused the utmost excitement in the circulation; every part of the body seems as if straining with agony. By this means the artist brought into action all the natural motive powers, and at the same time displayed the wonders of his science and skill. But in the representation of this intense suffering is seen the determined spirit of a great man who struggles with necessity and strives to suppress all audible manifestations of pain.

An exaggerated style of expression is even inculcated by Charles Le Brun, in his treatise on the passions,[7]—a work in the hands of most young students of art. In his illustrative drawings, the passions are not only represented, in the face, in an extreme degree, but in several instances the expression of them amounts even to frenzy.

Moreover, we do not find in those figures of the ancients which are in a still position any of that meretricious, artificial grace so common among the moderns; to mention one instance of it, the hinder foot is frequently made to rest upon the toes alone.

He who desires to institute a comparison between ancient and modern sculptors must reflect upon what I have said of beauty generally, and of action in particular. If a certain learned member of the French Academy

had had any knowledge of the works of the ancients, he would not have ventured to say that modern, meaning thereby French, sculptors had finally succeeded, not only in equalling, but even in surpassing the finest productions of Rome and Athens.[8] To convince one who expresses such opinions of their incorrectness is always a difficulty; but, in the following instance, it seemed to me an impossibility;—a Russian nobleman, whilst preparing for his third journey to Italy, said to me, in the presence of other persons, that he regarded all statues, the *Apollo*, the *Laocoon*, the Farnese *Hercules*, as nothing, when compared with the *Mercury* of Pigalle, in the Sans Souci, near Potsdam.

Others, who appear more modest in their opinions, and believe that a Michelangelo, a Puget, a Fiammingo, need not shrink from comparison with an Apollonius or an Agasias, may take beauty as the touchstone of their comparative merit. Let us commence by offering to their view the best heads by the heroes of modern art; let us place before them the finest figure of *Christ*, by Michelangelo, the celebrated head of *Prudence* on the monument of Paul III, in St. Peter's, Rome, by Guglielmo della Porta, the follower of Michelangelo, then the much-admired head of *St. Susanna* by Fiammingo, and that of *St. Bibiana* by Bernini:[9] I name the last statue, because it is always selected by those who wish to extol the artist (Plate 24).

It is found, on comparing modern with ancient painting, that the result of the comparison is less unfavourable to it than to modern sculpture. The reason probably is, that painting, since its restoration, has been more practised, and consequently has furnished greater facilities than sculpture for the formation of eminent masters. Leonardo da Vinci and Andrea del Sarto, who saw but few works of the ancients, thought and toiled as we cannot but imagine the Greek artists did. It may be said, generally, that the spirit of grace manifested itself more fully to those painters who flourished in the golden age of the art, at the commencement of the sixteenth century, than to their successors. After a long interval, it reappeared in Annibale Carracci.

Chapter IV: Proportion—Composition

The principal rules of the ancient artists on composition were, first, fewness of figures; second, repose in action. It was a rule of the drama, first introduced by Sophocles, not to allow more than three persons to be present on the stage at one time. It appears from a very large number of ancient works, that the same principle was adopted and observed also in art. We find, indeed, that the ancient artists strove to express much, an entire action, in fact, in a single figure. As they all drew their subjects from the same source, namely, Homer, they were in fact limited to a certain number of figures, because in a great many of the scenes in that poet only two or three persons are engaged: such, for example, is the celebrated interchange of arms by Glaucus and Diomedes, so frequently represented in ancient times; also the enterprise of Ulysses and Diomedes against the Trojan camp.

As regards repose in composition, the works of ancient artists never present, like those of modern times, an assemblage of persons, all seeking to be heard at the same time, or resembling a crowd hastily gathered together, in which each one is straining to look over his neighbour's shoulder. No; their images resemble an assemblage of persons who inspire and demand respect. They understood very well what we call *grouping*; but we must not expect to find composition of this kind on that class of reliefs with which one most frequently meets, because these are all taken from sepulchral urns (sarcophagi), the narrowness of whose shape would not always admit of it. The composition of some of them, however, is rich, crowded with figures. But, whenever the space was ample enough to allow the figures to be arranged in a variety of positions, then even these urns may serve as models in composition.

[Chapter V: *Beauty of Individual Parts of the Body* omitted]

[Chapter VI: *Beauty of the Extremities, Breast and Abdomen—Drawing of the Figures of Animals by Greek Masters* omitted]

BOOK VI: DRAPERY

[Chapters I and II omitted]

Chapter III: Dress of Male Figures

There are few modern artists whose drapery is free from errors, and in the previous century all, with the single exception of Poussin, were faulty. Even the cloak of *Saint Bibiana*, by Bernini, is confined over the tunics by a broad girdle (Plate 24). Now this is not only in opposition to all ancient dress, but also to the nature of a cloak, for it ceases, as it were, to be a cloak the moment it is girt. The artist who executed the drawings of the beautifully engraved plates to Chambray's *Parallel of Ancient and Modern Architecture*[10] has actually dressed Callimachus, the inventor of the Corinthian capital, in a woman's garments.

BOOK VII: MECHANICAL PART OF GREEK ART

Chapter I: Materials Used in Art

The *Laocoon* is the finest of all the statues which have received their last finish from the chisel, and here, in particular, an observant eye can discover with what masterly address and skilful boldness the chisel has been managed, in order not to impair, by polishing, the effect of those traits which most evince the knowledge of the artist (Plates 10, 14). Though the outer skin of this statue when compared with a smooth and polished surface appears somewhat rough, rough as a soft velvet contrasted with a lustrous satin, yet it is, as it were, like the skin of the ancient Greeks,

which had neither been relaxed by the constant use of warm baths,—as was the case with the Romans after the introduction among them of effeminate habits,—nor rubbed smooth by a scraper, but on which lay a healthy moisture, resembling the first appearance of down upon the chin.

Chapter III: Paintings of the Ancients

The four largest Herculaneum paintings were found on the walls of niches in a round and moderately large temple, sacred probably to Hercules. The subjects are *Theseus after killing the Minotaur*, the *Birth of Telephus*, *Chiron and Achilles*, and *Pan and Olympus*. The Theseus does not give us any idea of the beauty of the young hero, who, on his arrival at Athens, a stranger, was looked upon as a young maiden. I should like to see him with long flowing locks, such as he as well as Jason wore when the latter arrived for the first time at Athens. Theseus ought to resemble the Jason described by Pindar, whose beauty excited universal astonishment, and a belief among the people that Apollo, Bacchus, or Mars had appeared to them. In the *Birth of Telephus* Hercules does not resemble any Greek Alcides, and the other heads have a common conformation. Achilles is quiet and composed, but his countenance gives occasion for much reflection. The features show very promising indications of the future hero, and we read in his eyes, which are fixed with great attention upon Chiron, an impatient desire of instruction, in order that he may more speedily complete his course of youthful study, and render memorable by glorious deeds the briefly limited period of his life. On the forehead sit a noble shame and rebuke of his own incapacity when his teacher takes the plectrum from his hand for the purpose of correcting his mistakes. He is beautiful in the sense of Aristotle; the sweetness and charm of youth are blended with pride and sensitiveness. In the engraving of this picture there is a lack of thoughtfulness in the face of Achilles, and his eyes are looking away into the distance when they ought to be fixed upon Chiron.

Among the most beautiful of these paintings may be enumerated the *Dancing-women*, the *Bacchantes* (Plate 7), but especially the *Centaurs*,—not

quite a span high, and painted on a black ground,—in which we recognize the correctness and firmness of a skilled artist. Still, there was felt a wish to have pieces of more finish, for these are dashed off with great facility, as if with one stroke of the pencil, and at the close of the year 1761 this wish was gratified. [Winckelmann then describes paintings found at Stabiae.]

In respect to the time in which the paintings discovered in and about Rome, and in Herculaneum, were executed, it can be proved that most of them belong to the days of the Caesars.

Pliny, lamenting the downfall of painting, assigns as one of the causes, 'that the art, even before and during this time, had not been followed by respectable persons'. It had not, however, become an occupation of freedmen from the low estimation in which it was held; for it appears that Amulius, who painted the Golden House of Nero, and Cornelius Pinus and Accius Priscus, who displayed their art in the Temple of Virtue and Honour on its restoration by Vespasian, were Roman citizens. As we know, however, that the art of drawing, and of painting especially, was practised among the Greeks by persons of free birth only, and that among the Romans they had fallen into the hands of liberated slaves, this abasement of the dignity of painting may be considered as one cause of its decay even as early as the Caesars, so that Petronius complains that there were not to be found in the art the least trace of its former mastery. The decline of painting was also much accelerated by the new style—introduced under August by a certain Ludius—of ornamenting rooms with landscapes, views of harbours, forests, and other insignificant things; Vitruvius lamenting over the change, remarks that the subjects of the paintings on the walls were of an instructive character prior to this time, and had been drawn from the history of the gods and heroes, consequently it might be called an heroic style of painting.

[Chapter IV: *Execution of Pictures* omitted]

BOOK VIII: THE RISE AND FALL OF GREEK ART, IN WHICH FOUR PERIODS AND AS MANY STYLES CAN BE DETERMINED

Chapter I: The More Ancient Style of Art

The more ancient style lasted until Phidias; through him and the artists of his time art attained its greatness. This style may be called the grand and lofty. From the time of Praxiteles to that of Lysippus and Apelles, art acquired more grace and pleasingness; this style should be named the beautiful. Some little time subsequent to these artists and their school, art began to decline among their imitators; and we might now add a third style, that of the imitators, until art gradually bowed itself to its fall.

Chapter II: The Grand Style

Finally, at the time when Greece attained its highest degree of refinement and freedom, art also became more unfettered and lofty; for the older style was constructed upon a system composed of rules which, though originally derived from nature, had afterwards departed from it and become ideal. The artist wrought more in conformity to these rules than to nature, the object of imitation, for art had created for itself a nature of its own. The improvers of art elevated themselves above this adopted system, and drew nearer to the truth of nature, by which they were taught to throw aside, for flowing outlines, the hardness of the older style, with its prominent and abruptly ending parts of the figure, to make the violent positions and actions more refined and becoming, and to display in their works less science, and more beauty, loftiness, and grandeur. Through this improvement in art, Phidias, Polycleitus, Scopas, Alcamenes, Myron, and other masters, made themselves celebrated; and their style may be called the Grand Style, because their chief object, besides beauty, appears to have been grandeur.

The most admirable, and one may say the sole works in Rome belonging to the period of the grand style, as far as I can see, are the oft-quoted *Pallas*, nine palms high (6 ft. 9 in.), in the Villa Albani, and the *Niobe and her Daughters*, in the Villa Medici (Plate 12).[11] The *Niobe and her Daughters* are to be regarded as indisputable works of the grand style; [showing] a lofty simplicity as well in the conformation of the heads as in the whole drawing, in the drapery, and in the execution. This beauty is like an idea conceived without the aid of the senses, which might be generated in a lofty understanding and in a happy imagination, if it could rise in contemplation near to divine beauty; so great is the unity of form and outline, that it appears to have been produced not with labour, but awakened like a thought, and blown out with a breath; just as the skilful hand of the great Raphael—which, like a ready tool, obeyed his will— would, with a single stroke of the pen, design a most beautiful outline of a Madonna's head, and, without making any improvements, go on correctly and confidently with the execution of it.

The beautiful style of art begins with Praxiteles; it attained its highest splendour through Lysippus and Apelles,—the proofs of which will be adduced hereafter.

The principal attribute by which the beautiful style is distinguished from the grand is grace; and in this respect the artists last named hold the same relation towards their predecessors that Guido Reni, among the moderns, would hold to Raphael.

In regard to the drawing generally, it was a principle to avoid everything angular, even what had hitherto remained in the statues of great artists, like Polycleitus. The merit of this improvement in art is, in sculpture, especially attributed to Lysippus, who imitated nature more than did his predecessors; he therefore gave an undulating form to certain parts of his figures, which were still rendered angularly.

Grace is formed and dwells in the gestures, and is manifested in the actions and movements of the body; it even shows itself in the cast of the drapery, and in the entire dress. The artists who followed Phidias, Polycleitus, and their contemporaries, sought for it more than they, and were more successful in attaining it. The reason must lie in the loftiness of the ideas which the latter artists embodied, and in the severity of their drawing.

132

The great masters of the grand style whom we have just mentioned had sought for beauty only in perfect harmony of all the parts, and in elevation of expression, striving more for the truly beautiful than for the lovely. But as only a single idea of beauty in the highest degree and always equal to itself can be imagined, and as this idea was always present to those artists, their beautiful women must consequently always have approximated to their ideal, and been similar to each other, and uniform. This is the reason for the similarity in the heads of *Niobe and her Daughters*, which varies imperceptibly, and only with the age and degree of beauty in them.

Now, if the fundamental principle of the grand style was, as it appears, to represent the countenance and attitude of the gods and heroes as free from emotion, and not agitated by inward perturbation, in an equilibrium of feeling, and with a peaceful, always even, state of mind, we see why a certain grace was wanting; no attempt even was made to introduce it. But it demands a lofty understanding to express this significant and speaking stillness of the soul; for 'the imitation of the violent', as Plato says, 'can be made in different ways; but a calm, wise demeanour can neither be easily imitated, nor, when imitated, easily comprehended.'[12]

With grace the artist of the *Niobe* ventured into the kingdom of incorporeal forms, and mastered the secret of uniting the anguish of death with the highest beauty; he became a creator of pure spirits and heavenly souls, which, exciting no desires of the senses, produced a contemplative consideration of beauty of every kind; for they seem to have been formed, not for the expression of the passions, but simply for the lodgement of them.

[Chapter III: *The Style of the Imitators—Commencement of the Decline and Fall of Art* omitted]

Chapter IV: Of Art Among the Romans

If I were to conform to the common opinion, I should continue the treatise on Greek art by an examination of the style of the Roman artists, and here

especially of Roman sculptors. For I hear, even daily, our antiquarians and sculptors speak of a Latin art of sculpture, and of a style of workmanship peculiar to Roman artists, when they wish to denote anything of moderate excellence; but I give no more heed to this manner of speaking than to other expressions which error has brought into general use. We know, as well from writings as from remaining works, that there were Roman sculptors and painters, and it is not unlikely that some may have attained great excellence in art, and may have been worthy of comparison with many Greek artists; but from such notices and works it is impossible to deduce any system of Roman art, as distinguished from the Greek. Among the Greek artists, on the other hand, even as among Greek authors, there were probably some of middling excellence. Who will hold Nicander to be a great poet, but him who finds beauty only in that which is obscure? Art has surely had its Nicander and its Aratus.

Those who hold the common opinion in regard to Roman art are like those who do not distinguish primeval works of art from those of a later age; thus there have been and still are learned men who maintain that the most ancient Etruscan work was constructed in later Roman times.

The preconceived opinion that the Roman artists had a style of their own, and different from that of the Greeks, has arisen from two causes. One of them is the incorrect explanation of the figures represented; expositors desire to find Roman history in scenes that are drawn from Greek fable.

The second cause lies in an unseasonable reverence towards the works of Greek artists. As many works of only moderate excellence are found to exist, an unwillingness is felt to attribute them to the Greeks, and it seems more just to attribute to the Romans rather than to the Greeks the want of merit in such works. Hence everything which appears bad is comprehended under the name of Roman workmanship, yet without assigning the slightest characteristic of it.

BOOK IX: HISTORY OF ANCIENT ART IN ITS RELATION TO THE EXTERNAL CIRCUMSTANCES OF THE TIMES AMONG THE GREEKS

[Chapter I: *Art from the Earliest Ages to the Time of Phidias* and Chapter II: *Art from the Time of Phidias to the Time of Alexander the Great* omitted]

BOOK X: HISTORY OF ANCIENT ART IN ITS RELATION TO THE EXTERNAL CIRCUMSTANCES OF THE TIMES AMONG THE GREEKS (continued)

Chapter I: Art in the Reign of Alexander the Great

Laocoon is a statue representing a man in extreme suffering who is striving to collect the conscious strength of his soul to bear it (Plates 10, 14). While the muscles are swelling and the nerves are straining with torture, the determined spirit is visible in the turgid forehead, the chest is distended by the obstructed breath and the suppressed outburst of feeling, in order that he may retain and keep within himself the pain which tortures him. The indrawn anxious sigh and the inhaled breath exhaust the belly, and make the sides hollow to such a degree that we are almost able to see the movements of the entrails. But his own suffering seems to distress him less than that of his children, who turn their faces to their father and shriek for aid; the father's feelings are visible in the sorrowful eyes, and his pity seems to float on them in a dim vapour. The expression of the face is complaining, but not screaming; the eyes are turned for help to a higher

power. The mouth is full of sorrow, and the sunken under lip is heavy with the same feeling; but in the upper lip, which is drawn upwards, this expression is mingled with one of pain, which, with an emotion of indignation at unmerited, unworthy suffering, rises to the nose, swells it, and manifests itself in the dilated and upward-drawn nostrils. The struggle between the pain and the suppression of the feelings is rendered with great knowledge as concentrated in one point below the forehead; for whilst the pain elevates the eyebrows, resistance to it presses the fleshy parts above the eyes downward and towards the upper eyelid, so that it is almost entirely covered by the overhanging skin. As the artist could not make nature more beautiful, he has sought to exhibit it more developed, more strained, more powerful; in the parts where the greatest pain is placed he shows us the greatest beauty. The left side, into which the serpent with furious bite discharges its poison, appears to suffer the most violently from its greater sensibility in consequence of its vicinity to the heart; and this part of the body may be termed a miracle of art. It seems as though he wishes to raise his legs, that he may flee from his distress; no part is in repose; even the touches of the chisel are so managed as to suggest a benumbed skin.

Chapters II (omitted) and III: Art under the Immediate Successors of Alexander the Great

Abused and mutilated to the utmost, and without head, arms, or legs, as the *Torso Belvedere* is, it shows itself even now to those who have the power to look deeply into the secrets of art with all the splendour of its former beauty (Plate 11). The artist has presented in this Hercules[13] a lofty ideal of a body elevated above nature, and a shape at the full development of manhood, such as it might be if exalted to the degree of divine sufficiency. He appears here purified from the dross of humanity, and after having attained immortality and a seat among the gods; for he is represented without need of human nourishment, or further use of his powers. No veins are visible, and the belly is made only to enjoy, not to receive,

and to be full without being filled. The right arm was placed over the head, as we are able to determine from the position of the fragment which remains, for the purpose of representing him in repose after all his toils,— this attitude indicating respose. In this position, with the head turned upwards, his face probably had a pleased expression as he meditated with satisfaction on the great deeds which he had achieved; this feeling even the back seems to indicate, which is bent, as if the hero was absorbed in lofty reflections. In that powerfully developed chest we behold in imagination the breast against which the giant Geryon was squeezed, and in the length and strength of the thighs we recognize the unwearied hero who pursued and overtook the brazen-footed stag, and travelled through countless lands even to the very confines of the world.

The artist may admire in the outlines of this body the perpetual flowing of one form into another, and the undulating lines which rise and fall like waves, and become swallowed up in one another. He will find that no copyist can be sure of correctness, since the undulating movement which he thinks he is following turns imperceptibly away, and leads both the hand and eye astray by taking another direction. The bones appear covered with a fatty skin, the muscles are full without superfluity, and no other statue can be found which shows so well balanced a plumpness.

The *Torso* appears to be one of the last perfect works which art produced in Greece before the loss of its freedom. For, from the time Greece was converted into a Roman province until the time of the Roman triumvirate, we find no mention of any celebrated Greek artist.

BOOK XI: GREEK ART UNDER THE ROMANS

[Chapter I: *Under the Republic* omitted]

Chapter II: Under the Roman Caesars

Augustus, who is styled by Livy the builder and restorer of all temples, was even in this way a promoter of the arts. He purchased beautiful statues of the deities, with which he ornamented the squares and even the streets of Rome, and he placed the statues of all the distinguished Romans who had aggrandized their native land—represented as triumphing—in the portico of his forum, and those which were already there were again repaired; even the statue of Aeneas was included among them.

The almost colossal head of *Marcus Agrippa*, son-in-law of Augustus, also belongs to works of this period, for it is beautiful, and gives the clearest idea of the greatest man of his day; it stands in the Capitoline museum.

Already, in the reign of Augustus, there had begun to be a decline of good taste in the style of literature. It appears to have crept in especially from a desire to please Maecenas, who preferred the ornamental, playful, and tender style of composition. At this date a bad taste already prevailed in ornamental painting, as Vitruvius laments that in opposition to the aim of painting, which is truth or verisimilitude, things contradictory to nature and sound sense were represented, and palaces were built on the stems of reeds and lamp-stands, with the idea of imitating, in the long, disproportionate, and spindle-shaped columns, the antique shaft or lamp-stand. Among the Herculaneum pictures are some pieces of ideal edifices which were probably executed about this time or not long afterwards, and which show this corruption of taste. The columns in them have double the proper length, and already we see a beginning made of twisting columns, contrary to the principle of a supporting shaft, and the ornaments are absurd and barbarous.

Chapter III: Under the Roman Caesars (continued)

Nero, the successor of Claudius, exhibited an extravagant longing in regard to everything which belongs to the fine arts. But it was a craving like avarice, which seeks to accumulate rather than to produce. We can form an idea of his vitiated taste from the fact that he caused a bronze figure of Alexander the Great, executed by Lysippus, to be gilded; but, as it was the common remark that the statue had lost much by the process, the gilding was removed. Other proofs of his taste are also to be found in the rhyme of the caesura and at the end of the verse, after which he laboured, and in the inflated metaphors which he freely introduced; both these traits have been turned into ridicule by Persius. Probably Seneca, who excludes painting as well as sculpture from the liberal arts, had a great influence on his taste.

It is credible that the statue of the *Apollo* in the Belvedere, and the wrongly named *Gladiator* by Agasias of Ephesus, in the Villa Borghese, were among the statues brought from Greece.

Among all the works of antiquity which have escaped destruction the statue of *Apollo* is the highest ideal of art (Plates 9, 13). The artist has constructed this work entirely on the ideal, and has employed in its structure just so much only of the material as was necessary to carry out his design and render it visible. This *Apollo* exceeds all other figures of him as much as the Apollo of Homer excels him whom later poets paint. His stature is loftier than that of man, and his attitude speaks of the greatness with which he is filled. An eternal spring, as in the happy fields of Elysium, clothes with the charms of youth the graceful manliness of ripened years, and plays with softness and tenderness about the proud shape of his limbs. Let thy spirit penetrate into the kingdom of incorporeal beauties, and strive to become a creator of a heavenly nature, in order that thy mind may be filled with beauties that are elevated above nature; for there is nothing mortal here, nothing which human necessities require. Neither blood-vessels nor sinews heat and stir this body, but a heavenly essence, diffusing itself like a gentle stream, seems to fill the whole contour of the figure. He has pursued the python, against which he uses his bow for the first time; with vigorous step he has overtaken the

monster and slain it. His lofty look, filled with a consciousness of power, seems to rise far above his victory, and to gaze into infinity. Scorn sits upon his lips, and his nostrils are swelling with suppressed anger, which mounts even to the proud forehead; but the peace which floats upon it in blissful calm remains undisturbed, and his eye is full of sweetness as when the Muses gathered around him seeking to embrace him. The father of the gods in all the images of him which we have remaining, and which art venerates, does not approach so nearly the grandeur in which he manifested himself to the understanding of the divine poet, as he does here in the countenance of his son, and the individual beauties of the other deities are here as in the person of Pandora assembled together, a forehead of Jupiter, pregnant with the Goddess of Wisdom, and eyebrows the contractions of which express their will, the grandly arched eyes of the queen of the gods, and a mouth shaped like that whose touch stirred with delight the loved Branchus. The soft hair plays about the divine head as if agitated by a gentle breeze, like the slender waving tendrils of the noble vine; it seems to be anointed with the oil of the gods, and tied by the Graces with pleasing display on the crown of his head. In the presence of this miracle of art I forget all else, and I myself take a lofty position for the purpose of looking upon it in a worthy manner. My breast seems to enlarge and swell with reverence, like the breasts of those who were filled with the spirit of prophecy, and I feel myself transported to Delos and into the Lycaean groves,—places which Apollo honoured by his presence,—for my image seems to receive life and motion, like the beautiful creation of Pygmalion. How is it possible to paint and describe it!

The greatest work of the age of Trajan is his column, which stands in the middle of the Forum constructed at his order by Apollodorus of Athens. If any one has an opportunity to study the figures on the column from a plaster cast, he will be amazed at the infinite variety in the many thousand heads which it exhibits.

BOOK XII: GREEK ART UNDER THE ROMANS

Chapter I: Under the Roman Caesars

Trajan was succeeded by Hadrian, the greatest friend, patron, and connoisseur of art, who is said even to have executed statues with his own hand; so that this emperor, as a shameless flatterer says, may stand as a statuary and artist by the side of the celebrated sculptors Polycleitus and Euphranor. If from his prepossession in favour of the earlier mode of writing the Roman language, we could draw an inference in regard to art, we should say that he sought to renew the ancient style in the latter also.

In the person of Hadrian art was elevated to the throne, and the Greeks, so to say, with it; for Greece had never experienced a more favourable time nor had a more powerful friend since the loss of its freedom.

The delight of this emperor in building and giving encouragement to art was not however confined merely to Greece, but the cities of Italy were able to boast of similar munificence.

In Rome itself Hadrian built the splendid tomb which is now known by the name of Castel Sant'Angelo. Besides the colonnades by which it was surrounded, the whole building was overlaid with white marble, and ornamented by a row of statues. Afterwards it was used as a fortress, and when the Romans were besieged in it by the Goths they defended themselves by throwing the statues down upon their enemies. Among them was the celebrated *Sleeping Satyr* now in the Palazzo Barberini;[14] it is larger than life, and was found by the workmen employed in clearing out the ditch of the castle.

Of the many works executed by Hadrian in the four years that intervened between his return to Rome and his death, the greatest was probably his villa near Tivoli, the ruins of which embrace a circuit of ten miles. They include in addition to many temples and other buildings two theatres, one of which gives a very distinct idea of the arrangement of all the ancient theatres in the world, because the entire scena is preserved. He even caused to be made here a representation of the most celebrated regions and edifices in Greece, including the places which were known

under the name of the Elysian Fields. All the museums of entire Europe have been enriched with statues that have been dug out from this place in great numbers within the last two and a half centuries. Excavations are still going on and statues are found at the present day, and there will still remain discoveries to be made by future generations.

In addition to the most exquisite works in marble which have come from this same villa of Hadrian, and of which I shall speak hereafter, I mention in the first place the celebrated picture in mosaic representing a cup full of water, on the edge of which sit four doves, one of which is about to drink.[15]

The *Antinous* of the Belvedere, as it is called without reason, is commonly pronounced the most beautiful monument of art of the reign of Hadrian,—on the erroneous supposition that this statue represents his favourite; there is more probability that it represents Meleager, or some other young hero. It is placed among statues of the first class, as it deserves, more on account of the beauty of individual parts than of the perfection of the whole; for the legs and feet together with the belly are far inferior in form and workmanship to the rest of the figure. The head is indisputably one of the most beautiful youthful heads of antiquity. In the look of the *Apollo* majesty and pride predominate; but here is an image of the grace of sweet youth, and of the beauty of the flower of life, stamped with pleasing innocence and soft attractions without an indication of a single passion which could possibly disturb the concord of the parts and the youthful stillness of the soul. This state of repose, and, as it were, of enjoyment of itself, in which the senses are concentrated and withdrawn from all outward objects, is impressed upon the whole bearing of this noble figure. The eye which, as in the Goddess of Love, is moderately rounded, but without desire, speaks with captivating innocence; the small mouth with its full lips breathes emotions which are apparently unfelt; the cheeks of lovely fulness, and the softly prominent chin, roundly arched, complete the description of the admirable outline of this noble youth. But in the forehead we see more indeed than the youth; in its height and prominence like the forehead of Hercules, it proclaims the hero. The breast is strongly arched, and the shoulders, sides, and hips are wonderfully beautiful. But the legs are wanting in that beauty of shape required

by such a body; the feet are coarsely executed, and the navel is scarcely indicated; and in general the style is different from that of the time of Hadrian.

Chapter II: Under the Roman Caesars (continued)

The reign of the Antonines is in art like the apparent improvement shortly before death of persons dangerously ill, when life is reduced to a thin thread of breath; it resembles the flame of a lamp which, before it is entirely extinguished, gathers the remaining oil together, flares up into one bright blaze, and then instantly disappears.

Chapter III: Under the Roman Caesars (continued)

The reader will remember that when I speak of the fall of art in ancient times, my remarks are to be understood as applying especially to sculpture and painting; for when these declined, and approached their setting, architecture still flourished in a certain degree, and works were executed in Rome which for magnificence and splendour had never been equalled in Greece in her best days; and at a time when there were few artists able to draw a figure correctly, Caracalla erected the astonishing Baths of which even the ruins in the present day appear wonderful, and Diocletian constructed his Baths, in which he strove even to surpass those; and it must be acknowledged that that portion of them which has been preserved fills us with amazement. But the entablature of the columns is suffocated by the heaps of carved work, as were the spectators at the plays exhibited by him by the deluge of flowers which was showered upon them. Each side of his palace at Spalatro, Illyria, is seven hundred and five English feet in length according to the latest measurement by Mr. Robert Adam. The great palaces and temples at Palmyra were erected not long before, the magnificence of which exceeds all other buildings remaining in the

world; the carved work and ornaments on them fill the spectator with wonder.

I have already overstepped the boundaries of the history of art, and in meditating upon its downfall have felt almost like the historian who, in narrating the history of his native land, is compelled to allude to its destruction, of which he was a witness. Still I could not refrain from searching into the fate of works of art as far as my eye could reach; just as a maiden, standing on the shore of the ocean, follows with tearful eyes her departing lover with no hope of ever seeing him again, and fancies that in the distant sail she sees the image of her beloved. Like that loving maiden we too have, as it were, nothing but a shadowy outline left of the object of our wishes, but that very indistinctness awakens only a more earnest longing for what we have lost, and we study the copies of the originals more attentively than we should have done the originals themselves if we had been in full possession of them. In this particular we are very much like those who wish to have an interview with spirits, and who believe that they see them when there is nothing to be seen. In a similar manner the authority of antiquity predetermines our judgments; yet even this prepossession has been not without its advantages; for he who always proposes to himself to *find much* will by *seeking* for much perceive something.

5 Attempt at an Allegory [1766] [1]

CHAPTER I: ALLEGORY IN GENERAL

[The first part of this chapter has been omitted.]

The second part of this chapter is intended to give suggestions for new allegories, and after that to advise on the purpose behind these symbols and how to execute them. My advice is principally limited to allegories from antiquity which must give us new symbols, and I suggest three ways of obtaining these, of which the first is to give old symbols a new meaning and to use known allegories in a new and special sense, and with this meaning half of the symbol belongs to the one who uses it afresh. In this case it is very like the use of a verse by an old poet in a new and unexpected sense, where the second usage is much more beautiful than the thought of the poet himself.

The second way is to take allegories from the customs and manners and proverbs of antiquity, if they are not altogether unknown. In this way one could represent certain specific concepts visually; for example, a thing which can be taken by whoever finds it first: the Greeks used a proverb for this; they put the first fig which was broken off before an image of Mercury and anyone who wanted to could take it. According to the proverb 'purer than a steering rudder' (because it is constantly washed by the waves) a rudder could also be used to express purity of morals. Such scholarly symbols could be put up as abstract paintings in a painted room in such a place as Rome and afterwards engraved in copper and could easily become known and gain general currency.

The third way to get new allegories is the old heroic, as well as true, history.

Lastly in this second part, mention must be made of the purpose of new symbols and of their execution. The most noble qualities necessary to these images are *simplicity*, *clarity* and *grace*, and these three concepts are all to which I wish to draw attention.

Simplicity consists in the design of an image which, with as little drawing as possible, expresses the thing to be given significance, and this is the quality of allegories in the best times in antiquity. In later times

145

they began to combine many concepts through as many signs in a single figure, like the gods called Panthei, which have the attributes of all gods. Simplicity in allegories is like gold without any alloy, and is the proof of their purity, since they explain much through little; where the opposite happens, it is often a sign of unclear and immature concepts. The best and most perfect allegory of one or more concepts is contained and to be shown in one figure: for then it can be used in all possible cases. But this is difficult, indeed impossible in most paintings which are required. Longing for the fatherland is a noble symbol in the figure of Ulysses, who wishes he could see the smoke rising in Ithaca from afar; this hero can be made recognizable from old works, but this concept is not restricted to his figure alone.

Clarity arises from simplicity, but it depends on the circumstances, and one cannot expect a completely untutored person to understand a painting completely at first glance. But the allegorical symbol will be clear if it has a close connection with what is meant, as in the case of a few turnips which Guido Reni has put in his beautiful *Penitent Magdalene* in the Palazzo Barberini in order to show her austere life.[2]

The images should be graceful, in accordance with the aim of art, which is to delight and amuse. But grace consists in choosing images which have nothing indecent, ugly or horrible in them, and one should pay attention to what has been said in the history of art about the representation of the passions.

If one wishes to combine pleasure with instruction in art, what that Spartan[3] said is applicable here too,—that instruction is to make the good seem pleasant to youths: for just as the eye turns away from dazzling colours and refreshes itself with green, the same thing happens with the mind. But art with its symbols is different from poetry and cannot execute satisfactorily the extremely beautiful images which the latter paints. The fierce Necessity of Horace[4] would make us avert our faces if represented in a picture, as with the sight of a raging person, and the poetic discord of Petronius[5] can figure in painting as little as the Gorgons of Aeschylus[6] and Milton's devilry, of which one can convince oneself by imagining the effect on the stage of the British poet's images. This applies to Virgil's description of the rage of war:

—Furor impius intus
Saeva sedens super arma et centum vinctus aënis
Post tergum nodis, fremet horridus ore cruento.[7]

And if some interpreters of this believe that the poet had in mind the war painted by Apelles, whose work Augustus had put up in his forum, this is to be understood in his way. There are more images in later Roman poets which could not be very successfully executed in painting. Of this type is the description of anger in Prudentius.[8] This should be a rule for our painters and sculptors who try to use all their art in figures and statues of the saints in the representation of heresy at their feet, and their aim here is the utmost ugliness, so that the one who surpasses the others in the horrible and ugly figure appears to be the master. This sort of image has been put up more than once in St. Peter's, Rome. It would indicate the concept if the heresy were depicted in a beautiful female figure which either bends to the earth in shame or thinks of other means, full of bitterness. Artists should, like Democritus,[9] ask for visions of beautiful images. Even one fable instructs us with the aim of decency, and Marsyas, who thought it was indecent for Pallas to play the flute, because it puffed up her face, tells us that everything which can be disadvantageous to nature should be avoided in pictures. Contrary to this rule is a naked *Truth*,[10] life-size, in the Villa Mattei, executed by an artist in the last century, who has slit open the skin beneath her heart and is holding the gash open with one hand, in order to allow the heart to be seen through the opening at the same time. To a certain extent the same thing applies to an exaggerated expression as to the face of a sick man, which, according to Hippocrates,[11] gives a bad omen if it is very unlike itself, and here the truth of Bernini can serve as an example. This is not only advice about new symbols but also about the execution of old ones.

CHAPTER III: ALLEGORIES OF GENERAL IDEAS

Apotheosis

The apotheosis of empresses was represented on coins by a peacock, as a sign that they would reach the throne of Juno, and the apotheosis of the emperors and other heroes was shown by an eagle, on whose wings they, as half-gods, attained the enjoyment of Jupiter's company. The eagle alone on an altar had this meaning, just as, according to a Greek inscription, an eagle stood on an altar which was dedicated to Plato. It was also an old habit to represent the portraits of dead emperors being carried on eagles, and this image was taken from a real custom. For an eagle was released into the air from the wood-pyre on which the bodies of the emperors were burned, as soon as they were set on fire; this happened at the burning of Augustus and of Severus. Another image of the apotheosis of the sister and wife of Ptolemaeus, Arsinoe, who was borne into the air in bronze on an ostrich, could be interpreted as a satire: for the ostrich has short wings and cannot rise very far from the ground.

Calumny

Apelles painted calumny when he was falsely accused by Antiphilus, one of his fellow-artists, as an accomplice in treason to the fourth Ptolemaeus. On the right side of his painting sat a male figure with long ears like Midas, holding out his hand to Calumny; Ignorance and Suspicion stand around her. Calumny entered from the other side of the painting, a beautiful figure, but passionate and angry; in her right hand she held a burning torch, with the other hand she dragged a youth by the hair, who held his hands up to heaven and called on the gods to witness. A large man, who looked as if he were consumed by long illness, stepped in front of Calumny and gave a sharp look representing envy. The companions of Calumny were two women who were dressing her and encouraging her, Perfidy and Cunning. Another figure went behind them in black and torn clothing, full of Sadness, symbolizing Repentance; she looks around at Truth in shame and with tearful eyes.

Death

Death, and especially a premature one, was expressed by a rose, which one sees on gravestones. But even more significant and lovely is the Homeric picture of Aurora carrying a child away in her arms, just as Cephalus, according to the story, was abducted by her: this image is supposed to have been taken from the custom of burying young people before day-break. Dinocrates seems to have used this interpretation when he had Arsinoe abducted by the Zephyr West Wind and placed on the top of a temple he built. The death of boys in youthful years was attributed to Apollo and his arrows, just as the death of unmarried girls was blamed on Diana, and this is the basis for the story of Niobe. Homer says that the father of Queen Arete on the island of Scheria, was killed by the arrows of Apollo before he could beget a son. The death of Meleager is also to be explained by Apollo. But the arrows of Apollo and Diana are also a general symbol of death, as can be seen from Eumaeus's story to Ulysses on the Island of Syria, in which men reach the greatest age and eventually end their days through the gentle arrows of the aforementioned deities. The poet describes in the same way the death of Laodamia, Sarpedon's mother. I note here that skeletons appear on only two old monuments and marble urns, in Rome; one is in the Villa Mattei, the other in the museum of the Collegium Romanum; another with a skeleton is to be found in Spon's book[12] and is no longer to be found in Rome. There is a single stone engraving with this image in Gori's *Museum Florentinum*, and two in the Stosch catalogue. Death was possibly depicted in this way amongst the inhabitants of Gades, the modern Cadiz, who of all races were the ones to venerate death, since even amongst the Egyptians and Romans it was customary to remind oneself of death through a real or an imitation skeleton, to encourage one to enjoy the short life. The death of a person away from his native country was indicated on his grave by a piece of a ship. There was nothing but a spear on the gravestone of Eteocles and Polynices, which generally stood on the graves of those who fell in the war.

The Nile

The Nile and its flooding to the height of sixteen feet, which results in the greatest fertility, was symbolized in as many children on the figure of the river, as Pliny and Philostratus report, and as many children sat on the colossal *Nile* in the Belvedere, most of which have been preserved; the highest one is sitting on a shoulder, the rest sit in rows from the feet up over the thighs and further. In Philostratus' painting the highest child sat on the head of the river.

Prudence

Prudence is represented by Ulysses and other heroes and by Pallas, who accompanies them. Prudence and an acute mind seem to be indicated in the Muses by wings on their heads. It is more probable that they symbolize this on the coins of King Seleucus than Valour, which some people maintain. The Pegasus on the coins of King Hiero of Syracuse can perhaps have this meaning, especially as he carried out his plans rapidly. But the wings on the head can be interpreted differently, and Pindar crowns Asopichus, a victor in the stadium, with wings.

CHAPTER X: SOME GOOD AND USEFUL ALLEGORIES OF THE MODERNS

Allegory is indispensable in art and the designation of things and countries which were unknown to the ancients and new events and occurrences require new symbols. One of the countries unknown to the ancients is Canada, which produces more beavers than other countries and is consequently symbolized by this animal on a medal of Louis XIV. The same animal symbolizes it on a coin which was minted in England on the conquest of this province.

The allegories which I point out here are in the works of modern artists and either invented by them or given to them and regarded as their

own symbols. Some may have escaped my notice which are just as worthy of mention; but I think that there are very few good new allegories. For example, out of the many painted symbols by Zuccari in the Villa d'Este, Tivoli, there was not a single one which I considered exceptional.[13] Fortune riding on an ostrich is unusual, but I am unable to discover its meaning.

A *futile task* is represented on a Dutch coin of 1633 by the daughter of Danaus drawing water in a vessel full of holes.

Holzer, a worthy artist, has symbolized *fraternal love* on the house of two brothers in Augsburg[14] with the story of Castor and Pollux, in which the latter, as the Immortal, shares mortality with the former in order to bring him back to life.

The rearing of children was symbolized by a bear licking its cubs by Pietro da Cortona on the ceiling of the *salone* in the Palazzo Barberini, Rome.[15]

The *swift flight of Mercury* is represented by Giovanni Bologna in a well-known bronze figure by him in the Villa Medici, Rome,[16] as the head of a wind, on which the figure stands with one foot.

King Louis XIV at the age of 4, after the death of Louis XIII, was depicted on a medal sitting on a shield which was held up in the air by France and Providence, with the inscription: Ineunte regno. This refers to the custom of the old Franks, who put their new kings onto a shield which was held aloft and then showed him to the people, who acknowledged him as their lord by this solemn action.

A contagious *disease* and the unpleasant smell of the sick was symbolized by Raphael in one of his most beautiful drawings in the Albani collection, where the plague is depicted, through a figure holding out its one hand to other people and holding its nose with the other hand. This drawing was engraved by Marcantonio Raimondi and Poussin used the idea from this in his painting of *The Plague of Ashdod*.

Carlo Fontana attempted to use the image of a *stag* in an equally beautiful way: for when the great urn of porphyry, which had been used at the burial of Emperor Otto II, was supposed to be turned into a christening font for St. Peter's in 1693, according to the aforementioned architect's idea, this old work would have rested on four bronze stags, to

symbolize the cry of the stag for fresh water and also to represent the longing for baptism. But this idea was not carried out.

Chambray symbolized *painting* on the title-page of his comparison of ancient and modern architecture with a female figure in the act of painting, with her mouth bound, symbolizing that this is mute poetry, as the old poet Simonides said.[17]

Mnemosyne, the mother of the muses, is represented first by Mengs in his *Parnassus* on the ceiling of the splendid gallery in the Villa of Cardinal Albani (Plate 17). She is sitting on a seat, with her feet on a low stool and is fingering the lobes of her ears, as an allusion to her name, for if one touched a person by the ear in olden times it was a sign for reminiscence. Her head is slightly lowered, with downcast eyes, in order not to hinder the recollection of absent things to the memory by the subjects for artistic treatment which are around her. With the other hand, which lies idly in her lap, as with people deep in thought, she could have held a sceptre, which Homer gives her, or a dart, as it is actually called.

The futility and *instability of human activities* can be symbolized by soap-bubbles, as in the beautiful pastel painting of a Greek dancer in life-size on wood, which the aforementioned great artist painted for the Marquis Croismare in Paris, together with a Greek philosopher.[18]

The unknown sources of the *Nile* are ingeniously represented in the figure of this river on the fountain in the Piazza Navona in Rome by a garment with which he seems to be trying to conceal his head.[19] This symbol is still true today, for the true sources of the Nile have still not been discovered.

In addition to the *Sleeping Child* with poppy-heads, in black marble, Algardi has tried to give more significance to *Sleep* through a field-mouse, because this animal is supposed to sleep through the whole winter. This animal has been noticed as little by those who comment on this work as by Bellori in his life of Algardi.

Notes to the Texts

1. *On the Imitation of the Painting and Sculpture of the Greeks*

1. A complete reprint, with minor cuts and alterations, of Henry Fuseli's translation (Bibliography No. 1).
2. Plato, *Timaeus*, 23 D–24 A.
3. Proclus, Commentary on Plato's *Timaeus*, II, 122 B.
4. Euphranor, fourth century B.C. sculptor and painter, who called his own *Theseus* 'beef-fed' in contrast to the *Theseus* of Parrhasius, which he said was 'rose-fed'.
5. Pindar, *Olympic Odes*, VII.
6. Ephors were magistrates combining executive, judicial and disciplinary powers.
7. Claude Quillet, *Callipaedia* (Paris 1655), a treatise in Latin on how to have beautiful children.
8. Aristotle, *Politics*, Bk. V.
9. 'English malady' is an eighteenth-century term for nervous distempers, spleen.
10. Ctesias, first century A.D. sculptor. Note in original text refers to Pliny, *Natural History*, XXXIV, 85.
11. Note in original text refers to engraving in Stosch, *Gemmae Antiquae*, engraved by Picart (Amsterdam 1724), Plate XXXIII.
12. The story is recorded in Baldinucci's *Life* of Bernini, first published 1682.
13. The *Antinous*, more probably *Hermes*, after a lost original by Praxiteles, one of the most famous of the antique statues in the Vatican Belvedere.
14. Roger de Piles, well-known seventeenth-century French theorist, whose principal works were *Dialogue sur le Coloris* (1673) and *Conversations sur la Peinture* (1677).
15. Jacques Stella (1596–1657), follower of Poussin.
16. Note in original text refers to engravings in Stosch, op. cit., Plates XXIX and XXX.
17. Note in original text refers to engraving in Antonio Francesco Gori, *Museum Florentinum* (Florence 1731–42), vol. II, Plate V.
18. Note in original text refers to engraving in Antonio Maria Zanetti, *Antiche Statue nell'Antisala della Libreria di San Marco* (Venice 1740–3), vol. 1, Plate IX.
19. Marble statues of a so-called *Matron* and a *Maiden* led directly to the discovery of Herculaneum. They are still in Dresden, as are the other works to which Winckelman refers.
20. *Flora*, now in the Museo Nazionale, Naples, one of the most famous statues in the Farnese collection, which in Winckelmann's lifetime was in Rome.
21. Count Francesco Algarotti (1712–64) was the leading Italian critic in the mid-eighteenth century, with a prolific output of essays and letters. The quotation is from a series of his poems on the theme of the influence of ancient Greece and Rome. This poem is dedicated to Winckelmann's patron, Augustus III, in *Opere Varie* (Venice 1757), vol. II, p. 428. A free rendering of '. . . Matiello: A lui / Lo scalpello diè Fidia, onde di Paro / Vinca gli antichi onor Ligure marmo.' Lorenzo Mattielli, sculptor, born in Vicenza (date unknown) and died in Dresden 1748.

22. Maratta (1625–1713) and Solimena (1657–1747) were both Baroque artists with strong classicizing tendencies. Solimena had a considerable contemporary reputation both as painter and teacher.

23. This argument is taken up by Lessing in his *Laocoon* (1766). Virgil's Laocoon in *Aeneid*, II, lines 199–231, when struggling with the snakes 'lifts to the stars his horrifying shrieks' (line 222). Jacopo Sadoleto (1477–1547) wrote a poem on the *Laocoon*; see the translation in the excellent study by Margarete Bieber, *Laocoon: The Influence of the Group since its Rediscovery* (rev. edn, Detroit 1967), pp. 13–15.

24. Metrodorus of Lampsacus (about 330–277 B.C.) was the most important philosopher of Epicureanism, after Epicurus himself.

25. 'Parenthyrsos' means false sentiment or affectation of style. The word is used by Longinus in *On the Sublime* (3.5), who quotes Theorodus Epigrammaticus. Longinus was widely read in the eighteenth century, and in this passage, which Winckelmann knew, Longinus says of 'parenthyrsos': 'This is passion out of place and unmeaning, where there is no call for passion, or unrestrained where restraint is needed. Men are carried aside, as if under strong drink, into expressions of feeling which have nothing to do with the subject, but are personal to themselves and academic: then they play clumsy antics before an audience which has never been moved.'

26. *Ars Poetica*, lines 240–1, Latin extract from whole sentence which reads: 'My aim shall be poetry, so moulded from the familiar that anybody may hope for the same success, may sweat much and yet toil in vain when attempting the same.'

27. Raymond Lafage (1656–90), primarily an engraver of biblical and mythological subjects, including bacchanals. See also page 100.

28. At the school of the rhetor (fourth century A.D.) students were taught the art of rhetoric.

29. *Aeneid*, I, lines 151–2: 'Then should they chance to look upon a man by goodness and by service dignified, they hush, and stand around with ears attent.'

30. Alessandro Algardi's relief of *The Meeting of Leo and Attila* (1646–53), twenty-five feet high, is an important Baroque work, initiating the painterly relief.

31. Sebastiano Conca (1679–1764) was a pupil of Solimena, who emerged as a dominant late Baroque artist in Rome. His *St. Michael* is in Santa Maria in Campitelli, Rome.

32. Raphael's *Sistine Madonna* is still in Dresden, in the Gallery.

33. Winckelmann chooses three Dutch portrait and genre painters: Caspar Netscher (1639–84), Gerard Dou (1613–75), pupil of Rembrandt, and Adriaen Van der Werff (1659–1722).

34. Dibutades (or Butades) is mentioned in Pliny, *Natural History*, XXV, 151 ff. The sculptor Arcesilaus worked in Rome in the first century B.C.

35. George Turnbull, *Treatise on Ancient Painting* (London 1740).

36. Richard Mead (1673–1754), London physician and famous collector.

37. The two colossal famous horses on Monte Cavallo, generally known as the *Dioscuri*

(Castor and Pollux), dominate the Piazza del Quirinale, Rome. The *Farnese Bull* is in the Museo Nazionale, Naples; in Winckelmann's day in Rome.

38. Romein de Hooge, *Hieroglyphica of Merkbeelden der oude Volkeren* (Amsterdam 1735).
39. Rubens's paintings on the theme of the life of Marie de Médicis are now in the Louvre.
40. Imperial (now National) Library in Vienna, a Baroque building, was designed by Bernhard Fischer von Erlach and executed by his son between 1723 and 1726. The interior of the dome of the main hall was painted by Daniel Gran.
41. François Lemoyne (1688–1737), master of Boucher, continued into the eighteenth century the Grand Manner of the previous century in his Versailles decorations.
42. Vitruvius, *Ten Books of Architecture*, Book VII, chap. V, is devoted to mural decoration, with scathing comments on contemporary tastelessness. He disapproves, for instance, of decorations showing candelabra supporting improbable loads such as small buildings.
43. Morto da Feltro (*c.* 1467–1512), painter.
44. *Ars Poetica*, line 316, from the sentence: 'He who has learned what he owes his country and his friends . . . surely knows how to give each character his fitting part.'
45. Charybdis or whirlpool, in the Straits of Messina (where there is no such whirlpool), a peril from which Odysseus escaped (*Odyssey*, XII, lines 101 ff., 222 ff.). Subsequently Charybdis came to mean a serious danger.
46. *Ars Poetica*, 7–8: 'idle fancies shall be shaped like a sick man's dreams.'
47. *Ars Poetica*, 421: 'rich in lands, rich in moneys put out at interest.'
48. Of the five entrance doors to St. Peter's, Winckelmann refers to the famous Porta Mediana by Filarete (1439–45), which incorporates both Christian and pagan iconography.

2. *Remarks on the Architecture of the Ancients*

1. Bibliography No. 8. Extracts translated for this anthology by Susan Powell. The first chapter, which has been omitted, is devoted entirely to construction, discussing bricks, stones, cement, the art of building, and actual shapes of buildings. It is baldly factual and descriptive.
2. Aristotle, *Poetics*, VII. 8–10: 'In everything that is beautiful . . . parts must not only be well arranged but must also have a certain magnitude of their own; for beauty consists in magnitude and arrangement. From which it follows that neither would a very small creature be beautiful—for our view of it is almost instantaneous and therefore confused—nor a very large one, since being unable to view it all at once, we lose the effect of a single whole.'
3. Caravita's villa (now Villa Maltese) is next to the Palazzo Reale in Portici, with gardens running down to the sea. It was designed for him by Domenico Antonio Vaccaro about 1730. All contemporary descriptions concentrate on the gardens and

promenading in them, and regard the house itself (now much altered) as unimportant, as the descriptions say nothing about it.

3. *Essay on the Beautiful in Art*

1. Bibliography No. 10. Extracts translated for this anthology by Susan Powell. The essay is addressed to an unnamed friend.
2. Pindar, *Olympic Odes*, X.
3. Count Carlo Cesare Malvasia, *Felsina Pittrice: Vite dei Pittori Bolognesi* (Bologna 1678), p. 471, refers to Raphael as a jug-seller.
4. Sanchuniathon, a Phoenician who wrote a treatise on theogony, cosmogony, and the growth of civilization, quoted by Philon of Byblos (A.D. 64–141).
5. Laurent Natter, *Treatise on the Ancient Method of Engraving on Precious Stones* (London 1754). Also French language edition (London 1754). Winckelmann mentions plates 3 and 6.
6. Niccolo Ricciolini (1687–*c.* 1763), Roman painter and engraver.
7. *Iliad*, VI, 144 ff. Glaucus when he meets Diomedes on the battlefield: 'Men come and go as leaves year by year upon the trees. Those of autumn the wind sheds upon the ground, but when spring returns, the forest buds forth with fresh ones.'
8. Nicholas Saunderson (1682–1739), blind mathematician, who lectured at Cambridge on Newtonian principles.
9. See Introduction, page 46. Gavin Hamilton, *Andromache bewailing the death of Hector*, 1761, lost; engraved by Cunego 1764. Winckelmann first praised it in a letter, 1761 (*Briefe*, Rehm edn, II, p. 111). See D. Irwin, *English Neoclassical Art*, p. 36 and n. 2 for further references.
10. Federico Baroccio (1526–1612), a Mannerist, his style was influenced by Correggio.
11. Amongst the rich decorations of the Chigi Chapel, Santa Maria del Popolo, Rome, are sculpted prophets of the Resurrection: *Jonah* and *Elijah*, by the sixteenth-century sculptor Lorenzetti, and *Daniel* and *Habakkuk*, by Bernini. The *Madonna* by Lorenzetti is on the altar of Raphael's tomb in the Pantheon, Rome.
12. Bartoli's engravings of reliefs are chiefly in his *Admiranda Romanorum Antiquitatum* (1685) (see Plate 8); other publications include the columns of Marcus Aurelius (1672) and of Trajan (1673).
13. Diogenes, founder of the Cynic sect in the fourth century B.C.
14. Vignola (1507–73) was connected with the Palazzo Farnese (after Michelangelo broke with the Farnese family), supervised the construction of the Villa Giulia, and contributed to the design of St. Peter's.
15. Colen Campbell, *Vitruvius Britannicus, or the British Architect* (1717–25).
16. Sebastiano Serlio, *Tutte l'Opere d'Architettura*, first complete edition 1584.
17. *Feast of the Gods*, in the Palazzo della Farnesina, Rome.
18. Taddeo Zuccari (1529–66) and Federico Zuccari (*c.* 1540/3–1609), brothers, Man-

nerists in Rome, famous for many frescoes. Giuseppe d'Arpino (1568–1640) also a Mannerist; works include design of mosaics in St Peter's dome.

19. Guido Reni's *Aurora* (*c.* 1613–14), in Casino Rospigliosi, Rome.

20. In the Vatican Stanze. It is largely the work of Giulio Romano and assistants.

21. *Transfiguration*, now in the Vatican, commissioned 1517, unfinished on Raphael's death, completed partly by Giulio Romano.

22. Van der Werff's *Descent from the Cross* is in the Rijksmuseum, Amsterdam.

23. Francesco Scipione Maffei (1675–1755), scholar and tragic poet. His main publication is on the architecture and antiquities of Verona, *Verona Illustrata* (1731–2).

24. Weapons of war hang on the background wall of Poussin's second version of the *Extreme Unction* in the collection of the Duke of Sutherland (on loan to the National Gallery of Scotland, Edinburgh); in an engraving of the subject, however, they are clearer than in the original painting.

25. *The Plague of Ashdod* is in the Louvre. Winckelmann was very familiar with this particular Poussin, and includes it in his *Allegorie* (see page 151). *The Plague* was already famous in the seventeenth century as a study of expression.

26. Correggio's *Io* is in the Kunsthistorisches Museum, Vienna. The quotation is from Psalm 42, 1: 'As the hart panteth after the water brooks, so panteth my soul after thee, O God.'

27. Domenichino's *God the Father rebuking Adam and Eve* is now in a private collection in Rio de Janeiro.

28. The four *Times of Day* on the Medici tombs in San Lorenzo, Florence.

29. Antoine-Joseph Dezallier d'Argenville, *Abrégé de la vie des plus fameux peintres* (Paris 1745–52).

4. *History of Ancient Art*

1. Extracts from the complete translation by G. H. Lodge (Bibliography No. 11).

2. Jonathan Richardson, *An Account of some of the statues, bas-reliefs, drawings, and pictures, in Italy, &c. with remarks* (London 1722).

3. Algardi's *Sleep* is still in the Villa Borghese, Rome.

4. Both Thearion and Sarambus appear in Plato's *Gorgias*, 518, together with the writer of a cookery-book, Mithaecus, as examples of 'ministers of the body, first-rate in their art'.

5. 'Choose as the bees who collect honey from bitter plants' is the metaphor used by Félibien in his tenth 'Entretien' in *Entretiens sur les vies et les ouvrages des plus excellents peintres anciens et modernes* (second edition Paris 1685–8), one of the most important publications of French seventeenth-century academic theory.

6. Winckelmann does not make it clear that it is only in the fourth century B.C., with Praxiteles and his contemporaries, that the female nude becomes common; such sculptures had been rare in the fifth century B.C.

7. Le Brun, *Le méthode pour apprendre à dessiner les passions* (Paris 1696), a widely read treatise on the expression of the passions by the head of the French Academy.
8. Note in original text refers to 'Dissertation sur les Effets de la Musique' by Burette, printed in *Mémoires de l'Académie des Inscriptions*, vol. V, p. 133.
9. Winckelmann wrongly identifies Guglielmo della Porta's *Justice* as *Prudence*. Duquesnoy's (Fiammingo's) *Susanna* is in Madonna di Loretto, Rome. Bernini's *St. Bibiana* is in Santa Bibiana, Rome.
10. Fréart de Chambray, *Parallèle de l'Architecture antique et de la moderne* (Paris 1650).
11. *Niobe and her daughter*, now in the Uffizi, Florence, was part of a group portraying Niobe and her children.
12. Plato, *Republic*, Bk. X, 605.
13. The *Torso* is no longer regarded as that of Hercules, but possibly Philoctetes, deserted on Lemnos by the Greeks.
14. The famous Barberini *Satyr* (*c.* 200 B.C.) is now in the Antikensammlung, Munich. It was first restored by Bernini (1640?), who may have made it more Baroque, and subsequently by Pacetti.
15. This well-known mosaic is in the Museo Capitolino, Rome.

5. Attempt at an Allegory

1. Bibliography No. 13. Extracts translated for this anthology by Susan Powell. See also pages 82–5.
2. The turnips are placed prominently in the foreground of Guido's painting, still in the palace, now Galleria Nazionale d'Arte Antica, Rome.
3. The 'Spartan' is the famous Lycurgus, who traditionally founded the Spartan constitution. His system is praised for its emphasis on moral education in Plutarch's *Life* of Lycurgus, the source which Winckelmann doubtless has in mind. The Spartan ethos was idealized in eighteenth-century Germany and in France during the Revolution; Lycurgus was seen as a wise and benevolent moralist and legislator. Sparta's role as a bloody oppressor was overlooked.
4. Horace, *Odes*, Book I, XXXV, lines 17–20, describes how before Fortune 'ever stalks Necessity, fierce goddess, with spikes and wedges in her brazen hand; the stout clamp and moulten lead are also there.'
5. Petronius, *Satyricon*, a fragment of a prose novel on contemporary life. 'Poetic discord' could either refer to the novel's loose, rambling structure moving on without any moral, or incidents in it such as the dinner given by the wealthy Trimalchio, who sings songs out of tune from a recent musical.
6. The Gorgons are mentioned in Aeschylus's *Choëphorae* (*Libation-Bearers*), line 1048, where Orestes imagines he sees heads of serpents he has killed 'like Gorgons, stoled in sable garb, entwined with swarming snakes'; also in *Prometheus*, lines 799–800, when Prometheus warns Io to beware, whilst wandering, of the 'snake-haired

Gorgons, loathed of mankind, whom no one of mortal kind shall look upon and still draw breath'.

7. *Aeneid*, I, lines 294–6: Jove is speaking: 'Unnatural rage, throned on fierce arms, / savage with blood-red jaws shall roar within, / His hands behind his back fast tied with bronze.'

8. Winckelmann here quotes, in Latin, from Prudentius's *Fight for Man's Soul*, lines 113–14: 'swelling Wrath, showing her teeth with rage and foaming at the mouth, darts her eyes, all shot with blood and gall.'

9. Democritus is quoted by Aristotle three times as believing in 'truth in sense-appearance', e.g. in *Metaphysics* (1009 b): 'Democritus says that either there is no truth or to us at least it is not evident. And in general it is because these thinkers suppose knowledge to be sensation, and this to be a physical alteration, that they say that what appears to our senses must be true.'

10. Winckelmann has mistaken a figure of *Amicitia* for one of *Veritas*. The attributes he mentions, including the bearing of the heart, belong to *Amicitia*, described in Ripa's *Iconologia*, deriving from medieval imagery. The statue was carved by Cristoforo Stati, but was later attributed to Pietro Paolo Olivieri, under which name it passed into the collection of the Louvre.

11. Hippocrates, the famous fifth-century B.C. 'father of medicine', traditionally the author of the *Hippocratic Collection*.

12. Jacob Spon, *Miscellanea eruditae antiquitatis* (1679–85). Spon was the leading seventeenth-century French archaeologist, who travelled to Greece and Asia Minor.

13. The Villa d'Este decorations are partly by Federico Zuccari, and include several ceiling frescoes.

14. Johann Evang. Holzer (1709–40), painter, who decorated several Augsburg façades.

15. The ceiling of the Gran Salone is filled with the fresco of the *Glorification of Urban VIII's Reign* (1633–9).

16. Giovanni Bologna's 1580 version of his famous *Mercury* is now in the Museo Nazionale, Florence.

17. The poet Simonides' famous aphorism, quoted by Plutarch, is frequently cited in discussions, from the sixteenth to the eighteenth centuries, on the close relationship of art and literature. The important concept of 'ut pictura poesis' ('as is painting so is poetry'), a phrase deriving from Horace's *Ars Poetica*, is discussed at length in the excellent study by R. W. Lee, *Ut Pictura Poesis: The Humanistic Theory of Painting* (New York 1967), originally published as an article in *Art Bulletin*, 1940. See also page 158, note 10.

18. The pastels for this Parisian marquis are correctly entitled *Vanity* and *Wisdom*. See Introduction pages 45–6.

19. Bernini's large, famous fountain of the Four Rivers (1648–51), of which the Nile is one, dominates the centre of the Piazza Navona.

Bibliography

I. WORKS BY WINCKELMANN

Sämtliche Werke, 12 vols, edit. Joseph Eiselein (Donaueschingen 1825–9). Standard edition of complete works.

Briefe, 4 vols, edit. W. Rehm (Berlin 1952–7). Best edition of letters.

Separate works with English translations. Last date in brackets is that of facsimile reproduction of original edition (Baden-Baden 1962–7):

1. *Gedanken über die Nachahmung der griechischen Werke in der Mahlerey und Bildhauer-Kunst* (Dresden 1755). (1962 facsimile of second edition of 1756.) English translation, Henry Fuseli (London 1765, 1767): *Reflections on the painting and sculpture of the Greeks with instructions for the connoisseur, and an essay on Grace in works of art*; and anonymous (Glasgow 1766): *Reflections concerning the imitation of the Grecian artists in painting and sculpture. In a series of letters.*

2. *Erinnerung über die Betrachtung der Werke der Kunst* in 'Bibliotek d. schönen Wissenschaften u. Künste' 1759. English translation in Fuseli listed in 1.

3. *Von der Grazie in Werken der Kunst*, in same issue of periodical as 2. English translation also Fuseli, 1.

4. *Beschreibung des Torso im Belvedere zu Rom*, in same issue of periodical as 2.

5. *Beschreibung des Apollo im Belvedere*, in same issue of periodical as 2. English translation by Fuseli in periodical *Universal Magazine*, February 1768, pp. 56 ff.

6. *Anmerkungen über die Baukunst der Alten Tempel zu Girgenti in Sicilien*, in same issue of periodical as 2.

7. *Description des Pierres gravées du feu Baron de Stosch* (Florence 1760).

8. *Anmerkungen über die Baukunst der Alten* (Leipzig 1762). (1964 facsimile.)

9. *Sendschreiben von den Herculanischen Entdeckungen* (Dresden 1762). (1964 facsimile.) English translation anonymous (London 1771): *Critical Account of the situation and destruction by the first eruptions of Mount Vesuvius of Herculaneum, Pompeii, and Stabiae.*

10. *Abhandlung von der Fähigkeit der Empfindung des Schönen in der Kunst, und dem Unterrichte in Derselben* (Dresden 1763).

11. *Geschichte der Kunst des Alterthums* (Dresden 1764). (1966 facsimile.) English translation of Greek art sections only by G. H. Lodge (Boston 1849): *The History of Ancient Art among the Greeks*; complete translation by G. H. Lodge (Boston 1880): *The History of Ancient Art*. Reprinted, New York 1966.

12. *Nachricht von den neuesten Herculanischen Entdeckungen* (Dresden 1764). (1964 facsimile.)

13. *Versuch einer Allegorie, besonders für die Kunst* (Dresden 1766). (1964 facsimile.)

14. *Anmerkungen über die Geschichte der Kunst des Alterthums* (Dresden 1767). (1966 facsimile.)
15. *Monumenti Antichi Inediti* (Rome 1767). (1967 facsimile.)

II. LIFE AND ASSESSMENT OF WINCKELMANN

C. Justi: *Winckelmann und seine Zeitgenossen*, 3 vols, fifth edition (Cologne 1956). The only full-length biography, first published 1866.

W. Leppmann: *Winckelmann* (London 1971). The only biography in English, disappointing, especially from the art historical angle.

Goethe: *Winckelmann und sein Jahrhundert*. Most recent edition, edit. H. Holtzhauer (Leipzig 1969). A classic assessment.

A. Schulz: *Winckelmann und seine Welt* (Berlin 1962).

G. Baumecker: *Winckelmann in seinen Dresdner Schriften* (Berlin 1933).

H. C. Hatfield: *Winckelmann and his German Critics 1755–1781. A Prelude to the Classical Age* (New York 1943).

H. C. Hatfield: *Aesthetic Paganism in German Literature from Winckelmann to death of Goethe* (Cambridge, Mass., 1964).

III. BACKGROUND

E. Panofsky: *Idea. A Concept in Art Theory* (Columbia, S. Carolina, 1968). Important discussion of the concept, first published 1924.

C. Vermeule: *European Art and the Classical Past* (Cambridge, Mass., 1964). Excellent analysis of the changing knowledge of antiquity.

N. Pevsner: *Academies of Art* (Cambridge 1940). A good history.

G. Daniel: *Origins and Growth of Archaeology* (Harmondsworth 1967). Good account, with lengthy quotations from archaeological writings.

R. Rosenblum: *Transformations in Late Eighteenth Century Art* (Princeton 1967). The best detailed study of Neoclassicism.

H. Honour: *Neoclassicism* ('Style and Civilization' series, Harmondsworth 1968). A clear, up-to-date survey.

M. Praz: *On Neoclassicism* (London 1969). Provocative essays, including one on Winckelmann.

Bibliography

R. Zeitler: *Klassizismus und Utopia* (Stockholm 1954). Interpretations of five artists, including David and Canova.

H. Hawley: *Neoclassicism. Style and Motif* (Cleveland 1964). Good catalogue of plates of exhibition in Cleveland.

J. Locquin: *La Peinture d'Histoire en France de 1747 à 1785* (Paris 1912). The standard account of history-painting in France.

J. A. Leith: *Art as Propaganda in France 1750–99* (Toronto 1965).

D. Irwin: *English Neoclassical Art. Studies in Inspiration and Taste* (London and Greenwich, Conn. 1966).

E. Kaufmann: *Architecture in the Age of Reason* (Cambridge, Mass., 1955).

D. Wiebenson: *Sources of Greek Revival Architecture* (London 1969).

L. Hautecoeur: *Histoire de l'architecture classique en France*, volumes IV and V (Paris 1952, 1953).

L. V. Meeks: *Italian Architecture 1750–1914* (New Haven, Conn. 1966).

Index of Names

Index of Names

Index of Names